Religion and Art in Conflict

Religion and Art in Conflict

Introduction to a Cross-Disciplinary Task

Samuel Laeuchli

Fortress Press
Philadelphia

Published by Fortress Press
Philadelphia

First published 1980

Library of Congress Cataloging in Publication Data

Laeuchli, Samuel.
 Religion and art in conflict.

 Bibliography: p.
 Includes index.
 1. Art and religion. I. Title.
N72.R4L33 1980 701 79-23711
ISBN 0-8006-1635-9

8288D80 Printed in U.S.A. 1-1635

To my friends
of the Monk's Inn Athenaeum
our Philadelphia discussion group
on art, science, and religion

Contents

Acknowledgments

This book emerged from my work on Religion and Art at Temple University, and above all from my courses on Icon and Idea, given over the last years as visiting professor at Barnard College and Union Theological Seminary in New York. I express my gratitude to Elaine Pagels at Barnard and to Robert Seaver at Union for their encouragement and support. I am grateful for stimulation which I have received at Temple by my department and in the course of several cross-disciplinary ventures in which I had the privilege to participate.

Marcia Hall, the chairperson in Art History, read my manuscript with great care; I appreciated her suggestions. The Monk's Inn Athenaeum was always a delightful forum in which to try out interdisciplinary experiments. I also want to thank William Lynch, the author of *Christ and Apollo,* for many good luncheon discussions on language and vision at the Penthouse Restaurant; and Conrad Bettler, my painter and writer friend from Avegno in the Ticino, for many hours of valuable conversation on culture and art. The literature is immense; I have quoted a few works that seem to me to contribute to the issues presented in my book.

Philadelphia, May 1979. SAMUEL LAEUCHLI

Preface

I came to the United States as a student and was traveling for the first time through the Middle West. Since I had great difficulties with my English, I was glad to be invited for a week to visit a family that spoke my native language. They had emigrated from their Swiss village decades ago and lived in Central Illinois. The man was a farmer, and also a lay preacher in a small and rather militant church.

We were only slightly over one hundred miles from Chicago, and I wanted to get to that city badly. I approached the man one day, asking if we perhaps could drive up there. He had several cars and the harvest work was light at the time. Why did I want to go to Chicago, he wanted to know. Well, I had heard about that famous city all my life; it was supposed to be quite beautiful and located on Lake Michigan and there was also an art museum.

"*Beautiful?*" the man repeated incredulously. "*Art Museum?*" He made a fist toward me: "I preach nothing but Jesus Christ Crucified," he exclaimed. He looked at me in disgust and told me a secret: some day, and it wasn't very long from now, the Lord would come down, on the clouds of heaven, and the fire would fall on Chicago and all the godless people would perish and the beautiful houses would collapse and the ashes would fly right down here and we would smell the burning flesh. He stood with his hands pointing north, yelling in his strong European accent and it was as though he smelled the flesh and felt the ashes, a stubborn survivor on his nine hundred acres next to that tiny wooden church in which he preached his flames on Sunday mornings.

"*Beautiful?*" To the end of my life I shall not forget the hateful glee in his face.

It was many years later that we were standing in Audincourt, in that Roman Catholic church near Montbéliard for which Fernand Léger had created that spectacular cycle on the Sacré Coeur, a group of students, ministers, and professors on a traveling seminar on history and art. One of the participants had given an introduction to the stained-glass windows when suddenly another interrupted, visibly upset. The whole problematic of that seminar had dawned on him. The passionate exchange that took place between the two shook that

1

seminar so badly that for several days it was difficult to reestablish some kind of rapport.

A: "These windows do not belong in here!"

B: "What do you mean?"

A: "From what we just heard, Léger was an apostate, an unbeliever, and as unbeliever he had no right to create these windows."

B: "It does not matter if Léger was a Christian. This cycle is not only great art, it is a tribute to the Roman Catholic church of Audincourt that it accepted it gratefully."

A: "It does not matter if Léger is a superb artist, it matters to me what a man believes. Are you telling me it no longer matters what a man believes?"

B: "Look, we went through that battle before, with Augustine and against the Donatists, and now you are telling me we have to start the bloody mess all over on the issue of art and belief."

A: "I am not willing to give up Christian faith for art!"

B: "I am not willing to sell art for dogma!"

On and on it went and the two people would not speak to each other for the remainder of the day.

The issues between art and religion are not academic squabbles about esoteric problems; they begin in real life and are experienced in real life. We are not debating how many imaginary angels might be able to dance on the tip of a Brancusi sculpture.

One Saturday night I went to a play, *Moon for the Misbegotten,* starring Colleen Dewhurst. The house was full. The great American actress touched the audience with her brilliant performance and received a standing ovation at the end, tears streaming down her face. I left the house dazed, as if by my own past, filled with the images of O'Neill's lyrical work. For hours we drank at the Scandia House and pondered the tragic predicament of human relationship.

The following Monday afternoon I sat in on a doctoral examination. Locus: the humanities highrise building of the university, sixth floor. Topic: some aspect of Kierkegaard. I had taught morning classes and now faced one of those grueling two-hour examinations

that are part of my job. On this Monday afternoon a realization came upon me, and it disturbed me greatly. I became aware that something had happened to me between play and exam. I had worn one mask on Saturday, and now I wore another on Monday. And I had exchanged these masks without actually being aware of doing so.

I am not the first to use the term "mask" for religion as well as for art. Greek drama was played with masks, and the term for mask is *persona, prosōpon.* The intense trinitarian debates of the fourth and fifth centuries employed the word "mask" frequently. Does God wear one mask or two? Are the two *personae* separate or one? The antique meaning of *persona* and the modern meaning of person are far apart, and yet theologians still quote the antique word, and the catechumens still recite the ancient formula, "One God in three masks."

Nor am I the first to exchange my masks at regular intervals of my life. The medieval theologians belonged to Dominican, Franciscan, or Benedictine orders and shared in the liturgical life of their communities, while feuding with each other about *res* and *relatio.* They too exchanged their masks, singing first the Gregorian antiphon and then setting out to prove the existence of a God *quo maius cogitari non potest.* In retrospect, that shift from the eucharistic to the scholastic arena does not seem as crass as the shift from the Broadway theater to the state university, but that is only because time tends to put a romantic haze over man's discordant experience. At the end, Thomas Aquinas' *Summa* seemed to him like straw.

The dilemma thus posed is no laughing matter. I cannot take the Kierkegaard examination as straw. A student's life is at stake, and although a sense of humor and some distance help a great deal, the debate takes place as an academic procedure, with methodological ground rules appropriate to humanistic or social studies in the field of religion. The dilemma returns, though, as we deal with Kierkegaard himself, a man who was caught as deeply as any one of us by the uncertainty of what he was doing. *The Sickness unto Death* and *Either/Or* are surely not only theological treatises, monographs on a "problem," but literary expressions—emotional, desperate, highly ambiguous, and passionately provocative. Kierkegaard was deeply troubled by that proximity between theology and form. He tried to safeguard the apostle from the genius, as if to prevent that dangerous amalgamation of religion and art from taking place in his own life. But

of course it did take place. Two thousand seven hundred years before him, Amos had exclaimed that he was no prophet, yet he certainly was.

The examination must go on. It deals with religion and it is carried out by members of a department of religion. But it surely is not a religious assembly. People do not sing or meditate or genuflect, although there have been times when professors of theology, in a structural mediation of polar experiences, would pray or cross themselves at academic events as if to unite by a gesture two incompatible worlds. What takes place during that examination is investigation into religion, analysis, doubt, critique—our attempt to understand. It is neither religion nor art.

As I begin to ponder the problem of my own different masks, I am led not only into the polarity between religion and art, but into that between the study of religion and the practice of religion, and the study of art versus the practice of art.

As I try to sort out my experiences relating to the interaction between religion and art, I am struck by the fact that positive and ominous recollections alternate constantly. When I took American students for seminars in Europe, I witnessed how in confrontations with Vézelay and Sunion, with Piero della Francesca and Corbusier, students came alive. An entire curriculum began to make sense in one summer's journey: religion became meaningful as history opened up.

I have also seen students crack because the confrontation with art—past as well as present—became intolerable.

In a large Protestant seminary, we had organized an art exhibit by the young Chicago artist, Gerald Hardy. At the time his work appeared quite avant-garde, but compared to Picabia, Duchamp, or Joseph Cornell, Hardy was certainly not risqué, for he painted in the tradition of American abstract expressionism. He also combined oil with gesso and glass, creating associations with stained-glass windows. Some students were fascinated, others were offended, just as it should be in any display of modern art. One was so offended that he cut a hole with his knife into one of the canvases. We had to ask the insurance company to pay for the damages.

The interaction between religion and art in the framework of academia can have surprising results. In our department at Temple we

showed *Marjoe,* the documentary about the revival preacher who gave up his vocation and made a film about his final pentecostal crusade. After the film we had what we call a department forum, a confrontation among faculty and students on a given topic. Now these forums are frequently doomed from the outset because most of us know what the others are going to say. The lines of defense are drawn quickly since we all safeguard our own turf against outside assaults. However, during that debate on *Marjoe* something unexpected happened, especially among the faculty: fronts were abandoned. People did not enter the debate from the traditional shooting ranges of the philosophy of religion, Muslim studies, Catholicism, or radical theology. Instead, the faculty members reacted spontaneously to the experience of a visual confrontation. I do not claim that this spontaneity, this ecumenical détente lasted very long. But it did last for a remarkable Wednesday afternoon forum.

The interaction between art and the study of religion can also fail. Twenty years ago we saw *Waiting for Godot* for the first time. It was a stunning experience, that first encounter with Vladimir and Estragon. The symbolism of the play has become commonplace in today's religion courses, but back then we were baffled. We felt that a statement had been made about our lives, about our civilization, and that we needed to talk about it. We did not even know who Samuel Beckett was. Fortunately, a dinner party was to take place the next night, and several of the guests, professors of ethics, psychology, and the Bible, had also been present at the Beckett production. We could hardly wait for what surely was going to turn out to be a fascinating discussion. But there was no discussion at all. No one wanted to talk about the play. One woman said she went to sleep. One man waved his hands in something like contempt or disgust. It bored him so, he said. Someone suggested we talk about the play after dessert. We did not.

It could be, of course, that in the long run the play is a minor one, and that this accounts for the silence of the evening. Yet even a minor play, especially a minor play, normally leads to some kind of a reaction. It could be that the play spoke to a limited audience. However, it turns out that in the last two decades, *Waiting for Godot* has found a ready reception, especially by just such a theological audience. It could also be, therefore, that as is the case so often in our lives, these people could not speak about that play because it hit too close to home.

I experienced the conflict between religion and art at the very beginning of my career in Switzerland. In the early fifties, a number of frescoes were discovered in the Gothic church in the village of Pratteln near Basel. These frescoes had been whitewashed in the Baroque age as had countless others, and they were accidentally discovered when the church walls were repaired. Now these frescoes were not of the highest quality. They were damaged extensively, and the Museum of Art in Basel was not interested in acquiring them. What should be done with these fifteenth-century paintings? Leave them on the walls, of course, one would think. In this day and age these frescoes would certainly be restored and preserved as a sign of the town's rich past.

However, we had just come through the Nazi nightmare. Barthian theology had returned to the Protestant heritage as a base from which to fight fascist ideology, and that Protestant heritage contained a good dose of iconoclasm. A storm broke loose, was carried into pulpits, press, and radio: What have these godless frescoes with their Catholic iconography to do in a Reformed house of worship? Professors of theology joined battle even to the point of name calling; could authentic Protestantism tolerate visual art?

The problem of the frescoes of Pratteln was solved in a familiar Judaeo-Christian way. Some young people from the youth organization of the Pratteln parish broke into the sanctuary one night, and with hacks and picks and rakes destroyed the wicked idols. It was a brave display of old-fashioned evangelical zeal.

We have heard the story before, with other iconoclasts and with other objects of art. The Philistine god Dagon lay with his head and limbs severed outside his own temple. The Christians broke into the Mithraeum of Santa Prisca and destroyed it. The statue of Babylon with its feet of clay came tumbling down. And one day the Gothic sculptures of Nôtre Dame were pulled down by ropes. When the sandstone figures crashed on the pavement, the people of Paris applauded in frenzy.

It is astonishing that in pursuing the relation between religion and art, we often meet violence.

Chapter 1

Religion and Art, the Problem

Durch jede Stunde,
Durch jedes Wort,
Blutet die Wunder
Der Schöpfung fort.
 Gottfried Benn

Some people get quite excited when they hear the title, "Religion and Art." It stirs curiosity in them, the lure of not yet explored worlds, of forgotten ties. Others do not like the sound of that title. It reminds them of clichés like "spontaneity," "creativity," "imagination." Who can be against them? "Religion and Art" is a topic that attracts and disappoints, and it disappoints not because we ever run out of material or ideas, but because difficulties increase the longer discussions go on. It is infinitely easier to make a concrete presentation on some aspect of religion and art than to lead or participate in a theoretical debate on that problem. And no wonder. As soon as we begin to think about this duality, the problems flood in from everywhere. I shall begin with a number of observations on the relationship between religion and art.

a) Religion and art have been related to each other for a long time.[1] The earliest Greek epic is full of religious symbolism, of sacrifices, vows, gods, and prayers. The first literary artists of Hebrew civilization, the prophets, likewise employed an abundant religious imagery of covenant and doom, Yahweh and Baal. Boethius, condemned to

die in Ravenna more than a millennium after the fall of Jerusalem, wrote his *Consolation of Philosophy,* a work which alternates constantly between philosophical (prose) and religious (poetry) passages.[2] A thousand years later, Martin Luther carried out his Reformation, not only with ideas like justification by faith, but with powerful hymns that conquered the German lands: *Aus tiefer Not schrei ich zu Dir.*[3] After so many centuries of secularization, religious imagery is still present in Chagall, Eliot, and *Godspell.* There are countless affinities between religion and art, from Christianity to Hinduism, from Arabia to Japan, in architecture as well as in literature, in ancient as well as in modern times.[4]

b) Every freshman is taught that the divorce between religion and art is one of the fundamental trends in civilization. The process began in antiquity and took on great impetus in the Renaissance. It can be observed in Christian Europe as well as in Southeast Asia, in Muslim Turkey, and in Christian New England.[5] A world of art has arisen which no longer possesses religious symbolism and which does not want to be counted as belonging to religious tradition.[6] A Beethoven symphony does not belong to a liturgy. For a long time most paintings have had little to do with traditional religious motives.[7] Only in certain individuals do we still have an external fusion of religious and literary traditions.[8]

The connection and the divorce between religion and art do not represent fixed periods in history. Processes of enhanced secularization took place in Periclean Athens and Republican Rome, in Renaissance Italy and eighteenth-century France, and they have been widely present since the coming of the industrial age; but processes of religious reintegration have also occurred, in Christian antiquity, in Italian Baroque, in German Romanticism. The two can take place simultaneously: while there was a strong tendency toward secular, even nonobjective art, in the third and fourth centuries, as witnessed for instance by the grandiose mosaics in the Museum of Timgad, there was also taking place, as we all know, the simultaneous emergence of Christian symbolism.[9] While Chagall and Rouault employ religious elements, Picasso and Renoir do not. It would not now occur to an Italian painter to create, as a famous Venetian predecessor did, a canvas celebrating "the triumph of religion."[10] It might well occur, it seems to me, to an artist in Saudi Arabia or Iran.

c) We see not only historical periods alternate between such fusion

and divorce; religious traditions vacillate between the acceptance and the refusal of certain forms of art.[11] Religion has been pro-iconic and anti-iconic for a long time. An inquiry into the relationship between religion and art has to take seriously the constant duality of these trends, and it also has to take seriously the different emphases which some religious movements place on certain forms of art while at the same time rejecting others. Protestantism turned against visual art but created a hymnic tradition of its own.[12] Islam allowed no figurative imagery, but produced superb abstract art together with its calligraphy.[13]

Religion has been on the side of art, even visual art, from the basilica and mosaic of ancient Christianity to the French priests who gave us Audincourt and Ronchamp; and religion has also been the enemy of art from the bishops of Elvira who did not want pictures on the walls of basilicas, to the Vatican bureaucrats who attempted bitterly to prevent the building of Assy near Chamonix.[14] As we examine the history of civilizations, we observe that religious movements create fear, and sometimes seek even to destroy art.

d) The relationship between religion and art has several components.[15] We talk about literature (the Book of Psalms, *Pilgrim's Progress*), architecture (the Temple of Jerusalem, the Gothic cathedral), iconography (manuscript illuminations, the Good Shepherd), and music (the Gregorian chant, the chorale). We face liturgy, the sacred dance, the passion play; but we are also dealing with religious components in daily life or in secular spheres (the Negro spiritual in a night club, the Christmas imagery in a contemporary city).

These different components have justifiably been dealt with differently.[16] We can examine religion and literature, religion and fine arts, sacred music. But the different components are related to each other. The liturgy is celebrated in a church. The Greek tragedy is sung. So are the psalms. The crisis of religious literature and the secularization of painting belong together. A tradition that fights images might create poetry. Word and vision, sound and thought are related. The mind and the body are not separable. It is helpful, especially for the beginning student, to identify and treat separately specific manifestations of that interaction; but it is imperative that at some stage of his growth he realizes how interlaced the particles in fact are.[17]

e) Neither religion nor art is a concept on which there is universal agreement as to meaning. As we examine research literature in both

fields, we discover extreme discrepancies on definitions. Theology, philosophy of religion, and religious anthropology operate with different concepts. While some theologians separate "religion" from "revelation," and refuse to call authentic Christianity a religion, for social scientists Christianity is, of course, a prime example of a religion.[18] Scholars do not operate with one monolithic concept. Neither do churches, religious individuals, or the secular world. Is a Christmas tree at Gimbel's "religious"? There exists a similar discrepancy in regard to art. There is no general consensus as to what art is. Is designing a Buick "art"? To be sure, there are many who "know" exactly what religion is and what art is and do not hesitate to tell us dogmatically. In the arena of academic definitions there is frequently fought, as in the rest of life, one more war, the last, to end all wars, to solve the questions of what is religion and what is art. As we view the two fields, there exist huge discrepancies of definition and it is precisely these discrepancies that I shall take as the starting point of my investigation.[19]

f) The task is a precarious one. It is interdisciplinary, i.e., it must cross established fields of history, religion, art history, and philosophy. A Renaissance task is not actually welcome in contemporary academia, even though many faculty members and students urgently demand it. There are dangers in this: the cross-disciplinary enterprise must guard against fuzzy thinking, against methodological shortcuts, and a lack of rigor. The cross-disciplinary task cannot be forced into one specific academic methodology. It just might not be possible to establish categories, or to come to results which satisfy all possible participants. The works of Campbell and Goodenough have met violent hostility from all academic quarters,[20] and one of the easiest attacks against such approaches is the accusation of dilettantism or lack of precision. No one should have to apologize for not being able "ultimately" and "conclusively" to establish models by which to combine or separate religion and art.

In such a task we want to acknowledge Wittgenstein's suggestion that concepts are like pictures with torn-off edges, i.e., that the models we establish are fluid, may work for some comparisons and not for others. One must grant that comparisons can always be slanted in one or another specific direction. The problem of dilettantism is surely present. But one must also be aware, and without apology, that the accusation of dilettantism is an academic modification of the age-old

heresy hunt. In a sense every academician is an unacknowledged dilettante. The cross-disciplinary enterprise is frequently carried on with so much caution and apology because there exists a fear of academic witch hunters; it becomes a bizarre contemporary parallel to the fear of thinking in dogmatic churches.

g) Religion as well as art has existed for a long time antithetically in practice and analysis. Worship is different from thinking about liturgy; painting and writing poetry are different from learning about art and literature. Practice and study are not necessarily opposed: the painter studies his tradition, the priest learns about God. But the act of practicing and the act of analyzing represent two distinct processes in both fields.[21]

Hence, we are dealing with the following fourfold basis to our task:

Praxis	**Theoria**
The practice of religion, individual and corporate, in synagogue and church, in temple and shrine, as an act of worship, meditation, or ascetic discipline.	*The study of religion,* either in the context of a religious community, or in a secular context.
The practice of art, from the play of the child to the artist's studio, in academia as well as outside, in visual, verbal, and auditory forms.	*The study of art* in its many forms, historical, philosophical, descriptive, carried out by both artists and nonartists.

h) Disciplines have emerged in the universities which have polarized the task. There is no longer religion, or theology, or history as the field in which the comparative task could take place. Instead we have a field of religion that is quite far removed from the world of art, despite the fact that in Amos, Genesis, Aeschylus, Prudentius, in Delphi, Vézelay, the Blue Mosque or the Book of Kells, religion and art were intimately connected. And we have realms of art, themselves separated into distinct enterprises, literature, visual art, music.

What complicates the interaction further is the fact that on the side of art we are dealing with two quite distinct approaches; on the one

hand description and analysis of art, on the other hand thought about art, esthetics. In that strange fragmentation of academic life, art history and esthetics, so intricately related to each other, are taught in different departments.[22]

Similarly, on the side of religion there has developed an extreme fragmentation of the religious enterprise as it engages art. We can talk about religion and art, theology and art, we can analyze the literary aspects of Scripture, the relation between religious history and architecture.[23] We can write on faith and art, on artistic symbolism, or we can create a religious esthetic, a religious philosophy of art. Brandon chose a very broad topic for his last work: *God and Man in Art and Ritual.* David Harned has chosen a theological one: *Theology and the Arts.* Coulton wrote on *Art and the Reformation.*[24] We can confront religion and art on many planes, with various methodologies and distinct concepts of both art and religion.

i) There are several kinds of interaction between religion and art, and each can take place in realms such as music, architecture, fine arts, literature, or symbolism.

The first are *practical interactions*: art exists in churches, synagogues, or temples, from a Gothic cathedral to a Shinto Temple in Japan. Artists belong to a religious community (Brother Mark at Taizé) and work in the service and with the imagery of the community. Some people call such art, and only such, "religious art."

However, interaction between religion and the artist exists without such strict definition. Artists use religious imagery without belonging to a religious community, or even without the slightest desire to have anything to do with a religious tradition. Léger's cycle on the Catholic creed in the Church of Courfèvre is an example of such connection. Léger had repudiated the Roman Catholic Church thoroughly. Or a religious community may have its building designed or its sanctuary adorned by an artist who does not really create in the tradition or with the full approval of that church: Ronchamp's church by Corbusier, or the Nevelson chapel in New York.[25]

If these two latter interactions are possible, we must reckon with the possibility that what the artist understands of his creation, and what the religious community understands this creation to be, may be two different things. An example of such divergence is the window cycle of Audincourt, for the church a representation of *Sacré Coeur,* the Passion of Christ, for Léger but a demonstration of the suffering of man.

Second, there are *theoretical interactions,* as seen from the viewpoint of religion. The datum of art is taken seriously in the description of religion. The Huguenot Psalter, Muslim calligraphy, the mosaics of Ravenna are each integral elements in the analyses of Calvinism, Islam, and ancient Christianity.[26]

There also exists a parallel interaction on the side of art: the religious datum is taken seriously in a description of art. The student of ancient Christian art studies the Trinity, the history of the church, the sacramental events in order to comprehend the ancient churches and their art.

There thus exists an interaction between the study of art and the study of religion. Since religion and art have been so closely related in the past, since data from both are so often found together, and since the symbolic codes of the two fields are frequently related, it is valuable to study the data in juxtaposition.

Such a process of juxtaposition is also one of confrontation and partial cooperation: the partners from the two fields discover that they have a strange kinship. Both exist within the sharp tension between praxis and theoria, between creation and reflection, immediacy and distance, intuition and critique. In both fields voices have been raised which deny the validity of their enterprises, both in regard to the artistic creation and the academic reflection. There is anti-art and anti-religion in the practical field, and there are claims that art as well as religion might better be studied in other departments than those of religion and art. No matter how we respond to that latter problem, it is a fact that both art and religion are studied in philosophy, psychology, anthropology, and sociology.

In this interaction with art, one observer from the field of religion might see "religious" aspects in a given object while another observer might not. Definitions of religion have become so varied that it is no longer possible to agree on a given definition. The spectrum in symbolism, art history, and esthetics offers a similar lack of consensus, from Joseph Campbell to Susan Sontag. The scholar of religion dealing with art is in the same boat as the interpretative scholar in art and he has the same clamor of approval and scorn around him.[27]

j) Religion and art are no longer "safe" categories with which to operate, either in academia or in the world at large. For a long time there seemed no doubt as to what "religion" was. One knew about it, one saw it, one lived in it. Now, the comparative religious enterprise has shaken the parochialism of the Western scholars on religion and so

has the work of social scientists, and, so has the whole trend toward a postreligious understanding of life and of religious traditions.

Similarly, to the shock of the educated world, it is suddenly no longer so clear what "art" is. We have seen shapes where the traditional borderline between art and not-art is no longer clear: the preserved half-finished dinner, the packaged palace, the nails on the wall. Duchamp's laughter at art, his anti-art that itself turned up in the art museums, has sounded through our century.[28] If religion is challenged by counter-religion, art is confronted by anti-art.

k) The dilemma between religion and art is related to concrete experiences and movements in daily life. For instance, we must understand the way a person or group relates to the body: the medieval church in its asceticism allowed no nudity, and only the secularization of the Renaissance, parallel to the re-creation of visual perspective, reintroduced the nude into the Western world. The dilemma is traditional: a certain kind of iconography belongs to the very character and history of some churches and hence may dominate the thinking and practice of individuals vis-à-vis other kinds of art. The dilemma is economic: the galleries on Madison Avenue have a strong say as to what is art, and the observer cannot altogether free himself from such a financial hold. The dilemma is social: to be a Quaker means to worship in meeting houses where a strong anti-iconic trend permeates the space. To be a Muslim means to worship in a mosque that has the Quaker's anti-iconic distance combined with a feeling for color, light, space, and material. Both the Quaker and the Muslim deal with art in their ways because their religious traditions and cultural heritages gave them specific frameworks.

l) "Religion and Art" is a volatile field, and this volatility exists both in practical and in theoretical realms. The academician has been better trained to hide his bigotry or preferences, but it does not take long to realize the hidden agenda frequently present as we talk about religion and art.

A description and reenactment of the interaction between religion and art must admit that such interaction can hardly be void of personal involvement, of conviction, option, and perspective. Perhaps in this one task of a cross-disciplinary enterprise, at least, we might admit of hermeneutic tension. Neither in art nor in religion, and certainly not in interaction between art and religion, do we stand outside historical flux. The confrontation between religion and art, no matter

how carried out, from Amos and Plato to Kierkegaard and Nietzsche, has always been an act of the emotions as well as of the mind (we think of Plato's fencing off the artists while being an artist himself), an event of cultural confrontation and historical conflict.[29]

Such tensions, frequently unsolved and yet affecting the daily life of people, lie at the heart of the complicated relationship between art and religion. The problematic of the relation is intricately tied to the problems seemingly endemic to each of these fields. I shall first describe the structural problems in both fields, and then proceed to examine the ancient roots of the contemporary dilemma in Hebrew and Christian history. To be sure, the dilemma could be demonstrated in many other parts of the world, from classical Buddhism to the iconoclastic passion in contemporary China.[30] The tension between religion and art, a powerful parallel to that between science and art, and between religion and science, is built into the very structure of our civilizations.[31]

Religion and art, so closely related to each other, are in conflict with each other. The issue for this study, however, is compounded by the fact that religion and art are also in conflict with themselves.

Chapter 2

The Dilemma of Religion

All alive religions are many things.
Mary Douglas

Everyone knows what "religion" is. Take a poll, in New York's Times Square or in Omaha, Nebraska, and ask people what they associate with religion. The answers will come quickly: a priest in clerical garb; the Presbyterian church on the corner; the Bible; the Episcopal wedding we attended last Saturday; the prayer at the Inauguration of the President; the Yom Kippur we just finished observing.

Some people point to their own lives: religion is what I practice, reading the Bible, believing in Jesus Christ or the Torah, observing Lent or Ramadan or Sukkoth. Others do not believe in religion, but accept it as a presence in society, biblical images, parochial schools, the kosher delicatessen. Some are negative: they might, or might not, come from religious backgrounds, but they certainly would not want it anymore, neither church, rabbinical authority, nor public prayers. Others again are attracted to certain religious ideas or practices although they did not grow up in a religious community. All of these people seem to operate with a clear idea as to what religion is.[1]

The same is true of our laws. We read about the separation of church and state. The state cannot support religious schools and prayer cannot be enforced in public schools. With an amazing convictional simplicity, the members of the highest court and the ACLU

"know" what religion is in this land. And they seem to reflect public consensus. We all know that Christmas and Hanuka are religious holidays. At one time or another we all confront Catholic or Jewish marriage laws, abortion, capital punishment, or blue laws in relation to religious sensitivities. The presence of religion forces us to make decisions. As Catholic parents we send or do not send our child to a parochial school. We mind or do not mind if our child dates a member of another faith. We hear a religious radio broadcast, and we turn it off or we listen.

Yet, as soon as we look at religion, it is not clear what we mean by such a word. Many people in our Western world, for instance, point to God as the major determinant for a religion. But not only are there mystic traditions in which the concept of God is so transcendent that he hardly matters; there exist large world religions for which God is not really necessary. Confucianism and Buddhism, despite their atheistic components, are certainly authentic religions. Likewise, some demand that the concept of religion be based on a ritual. Does that mean that no "ritual" is not religion? What about Holy Scripture, mythic imagery, meditation? Is a religion that has meditation instead of prayer not a religion? My neighbors are good Roman Catholics who sometimes assemble, with some of their friends, on a Saturday or Sunday night, enjoy wine and food, talk, sing, and dance. They understand their happening to be a kind of eucharistic event, breaking bread together. Is their event really religious, or is it a party?

If this sounds extreme, history quickly shows that it is an old and widespread problem. If we had asked a believing Catholic in the 1520s: Do you think the services in Wittenberg or Zürich are religious? The answer would probably have been: They are godless! If in turn, we had asked a main-line Lutheran three centuries later if a Unitarian Assembly of the nineteenth century, or a Quaker period of silence, were religious events, he might likewise have denied it. To a conservative evangelical, the faith of Tillich was as false as Luther's faith was to Pope Hadrian V.

Distinctions have been made, long ago, between true and false religion, distinctions that seem to solve our problem.[2] But what is a "wrong" religion really? The term makes sense from the viewpoint of an exclusive religion: it is a religion that threatens power, the status quo of a group. Hence, Christianity was a false religion to the Roman Empire while paganism was a false religion to the Christians. As soon

as we examine such claims from comparative material, the concept of a false religion becomes exceedingly precarious. A false religion means a rival cult, a competing ideology, a psychological and social enemy.

Scholars talk about the "decadence" of classical pagan religion in the first centuries of the Christian era. Is decadent paganism still a religion? Is that prefabricated, pompous, and eerie imperial cult a religion since it is primarily born of political expediency? But if political expediency is to exclude "authentic" religion, a large amount of religion in the past has to fall by the wayside. The lines between religion, false religion, decadent religion, and nonreligion are extremely difficult to defend.

How hard it is to draw such lines can be seen in contemporary examples. Are Marxism and psychoanalysis, as has been stated, two of the new religions in our century? From a distance, neither of them seems to be, since they are religiously neutral or even blatantly antireligious. They do not operate with God, prayer, liturgy, or Scripture. Yet both have belief systems, both have rituals (the singing of the Internationale, the ritual on the couch before the new, secular priest), both have a kind of exclusivity that reminds us strongly of religious prototypes (you can only speak about psychoanalysis once you have been initiated and gone through the rite of passage, and you can only be an authentic member if you belong to the Party), and both have eschatology (the promise of making you into an authentic being, and the promise of the new earth). Like true religious sects, both are branching out into denominational factions. Whether Marx and Freud themselves should be held accountable for their subsequent movements is as debatable as to what degree Jesus of Nazareth is responsible for the course of Christianity. While Communism and psychoanalysis claim to be nonreligious, the analogies and parallels with religions are stunning.

The more we reach below the surface of things, the more perplexing do the problems of definition become. Are the ceremonies with which West Point raises its flags, the folding and hoisting, the attitudes of the cadets, the salute and gestures "religious"? In some election speeches, religious language is unashamedly used and "God" invoked for support and rationalization. In others, the language does not overtly use religious references, but the voice, the emotional manipulation, and the insinuations remind us of the technique in revival meetings. We share in a group dynamic session: neither form nor content may be

religious on first sight, but the processes, the baring of the soul, the expectations, the priestly attitude of the leadership are remarkable parallels to the group dynamic developed by religious communities.

How serious the dilemma of religion really is, can be shown by examining the structural problematic in the academic study of religion.

I

The discipline of religion seems to be in a precarious state. If we survey, for instance, the several hundred papers given at the annual meeting of the American Academy of Religion and add to them those presented in groups such as the American Society of Church History, the Society for Pastoral Theology, the Society for the Scientific Study of Religion, and so on, we face a labyrinth of topics, methods, and goals. The pluralism of approaches does not appear anymore as variations of one basic task. The seriousness of the problem can be felt more and more in doctoral committees and tenure cases, where it is becoming more difficult if not downright impossible to determine what counts as capable academic work beyond mastering expository English prose. There might be fewer of these frictions in more homogeneous academic bodies—General Theological Seminary, Harvard Divinity School, or Perkins School of Theology—yet as soon as we find ourselves in truly ecumenical situations (in religion departments that reflect the pluralism of the university around them) serious conflicts become inevitable.

As we examine the diverging trends in the study of religion, we nevertheless discover certain patterns within which scholars operate. Polarities recur, at times complementary and at times contradictory, even though individuals put themselves on one side or the other of a given polarization and even discredit their opponents. These polarities are not restricted to any given subfield—say, New Testament or Comparative Religion—but can be detected throughout the entire field.

a) Take, for instance, the primal problematic behind all academic study of religion, that of *sympathetic* versus *critical* scholarship.[3] A person is intrigued by Martin Luther, he begins to do research, writes a book, or teaches a class on the man. He wants to communicate his fascination and the results of his inquiry to his readers or hearers. He feels his way into the world of Luther and identifies either with the person or with the people and problems around him. Many a doctoral

student speaks in the language and models of his academic heroes and continues to do so throughout his academic career. If such a willingness to get caught up in his subject matter is not present, the scholar will remain aloof and his lectures will be boring.

But there is also quite a different task at hand: to look at the man Luther critically. There are contradictions in his writings, discrepancies in the text. We do not believe all he says. And we might not like all he did. The academic task consists of examining critically the texts as well as the research done about these texts, and of finally coming to independent conclusions about the primary evidence. There is no agreement as to how far critique may go. When it comes to sacred texts ("sacred" to a person's belief or religious affiliation), many scholars are reluctant to carry their critique to the core of their religion. The Mormons will not really examine the age of Joseph Smith critically, and the Muslims will stop at the Koran. Yet, some of the most important contributions of critical scholarship have been precisely in the realm of the sacred texts themselves, e.g., the source analyses of the Pentateuch and Synoptic Gospels.

For a long time books have been written from both vantage points. Rudolf Thiel's biography is a powerful presentation of Luther from a sympathetic observer.[4] Erik Erikson's work is an equally powerful critical vision of the man from a psychoanalytic perspective.[5] Dunne's theology is a sympathetic presentation of religious fragments—experiences and models from many different religious traditions.[6] Franklin Littell's *Wild Tongues* is a highly critical analysis of right-wing movements in America, so critical, in fact, that William Buckley sued him for it and forced Macmillan to withdraw the book from the market.[7] Wellhausen's work was highly critical; Eichrodt's was extremely sympathetic.[8]

It would seem that a combination of the two approaches should lie within the realm of possibility. One could be critical, eclectic, and sympathetic at the same time. In many instances, such balance is surely practiced; at intellectually and religiously divisive issues, however, the balance is hard to maintain because people violently disagree about what is a permissible critical methodology. The judgments implicit in using a critical methodology not only touch on the nonreligious world, but on religion itself. There has been within religious traditions from Amos, Socrates, and Porphyry to Jesus, Luther, Freud, and Loisy, the passion to criticize the failure of

religion, its illusions and deceptions and tragic flaws for which mankind has had to pay so dearly.[9] The Day of Yahweh allows no compromise. If one part of the discipline of religion consists of describing the religious phenomena, another part consists of criticizing them, and such critique includes making historical, intellectual, and moral judgments.

A combination of sympathetic and critical analysis of religion becomes so difficult because the critique of a religious topic tends to attack (from the dietary habits of Paul to indulgences in the time of Luther to God language in the twentieth century) what is, or seems to be for the believer, the substance of his religious tradition or faith.[10] The dismissal of David Friedrich Strauss from the University of Zürich and the firing of almost an entire faculty at Concordia Seminary in St. Louis, two events almost a century and a half apart, witness to the danger which the study of religion presents to religious emotions and religious bodies. The scholar who examines a religious phenomenon critically risks offending the people who are believers in that phenomenon, whether the scholar deals with papal encyclicals, scriptural texts on the miracles of Jesus, or Buddhist poetry.

Both sides can make solid arguments against each other. The critical scholar accuses his opponent of bigotry, fundamentalism, of, at least, an uncritical bias. And indeed, a great deal of what passes for Jewish, Christian, or Muslim scholarship is more or less cleverly-disguised apologetic. However, critical scholarship alone does not suffice. Without a feeling for the subject matter, without conviction about the religious dynamic, scholarly work remains distant and cold. The antinomy between apologetic and critique often cannot be bridged.

There are ways of dealing with the problem. The most widespread solution is to be critical of someone else's tradition and apologetic about one's own. Jewish and Muslim scholars are on the whole highly critical of Christianity and defensive about their own traditions; Catholics and Protestants have slandered each other for centuries while defending themselves. Or we can safeguard our faith by allowing some critical perspective at carefully guarded places. Oscar Cullmann used to open his "Introduction to the New Testament" by affirming *textual* criticism while denying anyone's right to practice *literary* criticism. He meant to allow a touch of critique at the fringes and protect the center where critique would hurt the substance of his belief. Similarly, a liberal Catholic scholar can be expected to be critical on

issues such as the papacy, indulgences, and celibacy, yet defensive about others such as God, salvation, and Scripture. The scholar seems to determine, and not fully consciously, which realms may remain open for analysis, and which must stay taboo.

This taboo of critical analysis is especially present in the scholar who has converted to some new religious position or group. Many Christians who have been attracted lately to oriental religions and philosophies remain extremely critical toward their Western heritage while becoming highly uncritical toward its Eastern counterpart. For Cardinal Newman, the Catholics were right and the Arians wrong, and his opinion was coeval with his conversion.[11]

The ambiguity between apologetic and critique is not reserved to the circle of religious studies. The university outside faces the same dilemma, even though it hides it more cleverly under the pretense of scholarship. The work on George Washington and early American history was frequently presented in great political reverence until the Revisionists came along and put a different face on the Age of Independence. While scholars in the traditions of Malinowski looked critically toward the phenomenon of primitive religion in terms of magic, along came Lévi-Strauss and his followers with a new romanticism vis-à-vis primitive tribes. As a matter of fact, *The Savage Mind* is a prime example of the separation between sympathetic and critical attitudes: while Lévi-Strauss deals with the Bororos in great sympathy, he attacks his French rival Jean-Paul Sartre venomously.[12] A member of the Académie Française is not really different from the Catholic priest or the fundamentalist preacher who has converted to Lao-tse or Buddha.

And thus, I must leave the antinomy in a deadlock for the time being. On some issues I become critical, on others I cannot. It is difficult to agree how far critique can go, and it is even more difficult to establish what kind of critique is pure venom and what kind is earnest inquiry. On some critical issues I have changed my perspective, and I have watched others change their perspectives. The tension between sympathy and critique is built into our task.

b) A second tension, as serious as the first, goes through our work, between *positivistic* and *hermeneutic-interpretative* principles. The historians of the past asked the question that has remained the basis of all academic work: *what really has happened?* From the inquiry into the miracles of the New Testament in the eighteenth century to the

detective work of Woodward and Bernstein on Watergate, within academia and outside, scholars and reporters are caught up in the Socratic passion to examine life, to get to the kernel of things. The positivistic principle lies behind all exegetical, historical, and theological work: What is Shamanism? Who was Jesus? What are the Sufis all about?[13]

Both desires of our first antinomy have been employed in the service of this positivistic principle. Whether by sympathetic *Einfühlung* or by critical analysis, the scholar must find out. He may have to distinguish between surface and underlying causes. The goal of his work is the description of the truth, and of nothing but the truth.[14]

But does the scholar have a chance? Since Dilthey, Heidegger, and Bultmann and on to Gadamer, Ricoeur, and Adorno, a hermeneutic school has examined what kind of a chance he has.[15] Already Mephistopheles laughed at him: "for what you call the 'spirit of the times,' remains in fact the spirit of professors." And Albert Schweitzer has shown that the Jesus which the scholars in the nineteenth century "discovered" was actually their own Jesus, their own projected man. The hermeneutic school debated mercilessly the fact that we cannot come to our religious or historical evidence without preconditioning, that our categories are not timeless but historical and cultural, that there exists no historical *Ding-an-sich*. The hermeneutic insight taught us that if we really mean to get to the kernel of things, we may have to take the texts out of their contexts, since they would otherwise remain archaic, repeated but not understood. Hence, the process of translation without which there can be no understanding. Only when deeds, ideas, models are transmitted into our categories do we begin to comprehend them. In this process the original context and therefore the original text may be violated.[16]

The hermeneutic debate, which has gone on now for some time and received strong new impetus by Marxist participation, sounded somewhat esoteric to American ears — partly because of its difficult German and French phraseology — until it was applied to the interpretative task of the social sciences. The social and psychological tools produced a hermeneutic translation par excellence: from Kautzky and Troeltsch to Bloch and Geertz, the religious material was translated, interpreted, examined in its kernel through categories that are not originally in the documents but arose from the scholar's own cultural biography. Richard Rubenstein (*My Brother Paul*) took the experi-

ences of his own psychoanalytic process and comprehended Paul of Tarsus with the tools he had learned *and lived* himself.[17]

The state of our discipline in regard to these hermeneutic insights is confusing.[18] A great many scholars go on with their work ignoring the hermeneutic issue altogether and acting as if the social sciences did not exist. Major addresses of the quadrennial International Patristic Conferences, to give only one example, could have been written, as far as their academic, philosophical, and cultural scope was concerned, prior to World War I. Many exegetical, historical, and linguistic studies are published in detachment from any hermeneutic or interpretative burden.

The positivist camp is uneasy about interpretative work and not without reason. Interpretations contain, by nature, a strong subjective danger. From the beginning, the Bultmannians appeared as heirs to the German subjective, pietistic tradition, who looked at the New Testament through their own, existential faith, the *Deus pro me*. And the fears seemed justified. The positivists wanted historical truth, accuracy, objectivity. What objectivity is there to be found if each scholar, or at least each discipline or subdiscipline, interprets the data by one peculiar set of models, and if the interpretative options chosen by these groups and subgroups (psychological, sociological, existentialist) are often blatantly at odds with each other?[19]

The positivists, however, are themselves part of the same hermeneutic process they fear so much. The great scholars of the nineteenth century were by no means beyond time; they performed their seemingly positivist work with their own cultural preconditioning, on the whole a professorial world of German, French, or British universities and their upper middle-class life-styles. The New Testament and Jewish scholars, who have so strongly evaded coming to grips with the interpretative problematic of "exegesis" and historical understanding, represent very often a Catholic, Protestant, or Jewish cultural background that they take, all unaware, for historical objectivity.

The passion for objective truth is also present in the camp of the hermeneutic representatives. Adorno rightly pointed out that the dialectical thinker would never give up—even less than the positivist who slanders him—the positivist goal.[20] It therefore seems that the positivist passion for truth and the existentialist passion for meaning should somehow be joined in scholarship: the two tasks of describing the truth and of understanding the truth should both be part of the

scholar's work.[21] It does not turn out to be this way. We have here Hans Jonas' *Gnosis und spätantiker Geist,* an interpretative work that reads as brilliantly as when its first volume came out during World War II, and we have there Puech's work on the Chenoboskion texts based on strictly historical grounds.[22]

c) A third polarity goes through our work: *reenactment* and *reduction.* The student of religion employs constantly a process of reenactment. Collingwood introduced this term to explain how a historian achieves his results: by reenacting, mentally, the story under investigation, by putting together the clues in the documentation, and by imagining how it could have happened. The events take place again, reenacted in his mind.[23]

Reenactment within the study of religion, however, is more than merely such a mental process. Religion presents us with ritual reenactments, the Seder, Baptism, the Mass. As we investigate Judaism we can participate in a Seder which is itself a reenactment of the Exodus. As we study Roman Catholicism we can go to a Mass and experience its structure, its language, its music, and its gestus. Whoever has taught introductory religion to undergraduate students knows how revealing it is for them to share a Seder or attend a Mass, perhaps for the first time in their lives.

Reenactment takes place in all research that has to do with art, archeology, and cultural observations. It is not only mental but physical as well. We walk over the ruins of Timgad and experience the layout of a Roman colony in the hills of ancient Numidia. We enter the Cathedral of Amiens and experience the space and color, and luckily even the music, in a medieval sanctuary.[24] We watch Muslim life come to a halt in a Libyan village when the people suddenly bend down in prayer. Reenactment may go further: we may live on Mt. Athos or sing in the choir that performs a Gregorian chant or a Huguenot Psalter. We may have a part in the *Play of Daniel* as it is performed.

To be sure, we are never a totally integral part of the subject matter under investigation. Academic study is investigation and never mere participation, for in total participation we do not observe. When Thomas Merton wrote his famous first book, he had experienced already some initial distance from his ascetic life.[25] Yet even the partial experience, the sharing reenactment as a means of reflection and observation, is frequently more authentic than a mere mental process by which we examine religions, especially when it comes to sanctuaries, rituals, and art.

Reenactment as research tool is both imagination and experience. The two are at work in the lecture where we present in a combination of words and visual images, the man Martin Luther, or where we capture a scriptural story. Lecture and seminar are not merely means of communicating information, nor are they simply exercises in thought: they are acts of confrontation, i.e., learning experiences from which the teachers profit as much as the students. The classroom is one of the loci of reenactment as well as of reduction.

The technique of reduction is also used in the study of religion. When Augustine sat down to write his *Enchiridion,* an introduction to Christian faith, he reduced that faith to abstract terms, even in his title: *De Fide, Spe et Caritate.* Paul had coined that triad for him at the end of 1 Corinthians 13. There were several kinds of structural reduction in antiquity, philosophical (the reduction of all life processes in the Aristotelian *entelecheia*), scientific (the atom of Democritos), and theological (*Ruach, Sophia,* and *Logos* as *Hypostaseis* of Judaism). In the earliest Greek reductions (the water of Thales), scientific and philosophical processes were still one and the same.[26]

One cannot imagine studying religion without constant attempts at reducing data to models, concepts, abstractions—without speaking about Renaissance, Enlightenment, Romanticism, Animism, Pentecostalism, Theravada Buddhism. There is a trend among conservative theologians to slander social scientists as "reductionists," as if to label personality theories, social classes, or economic and political principles is especially heinous, or as if these endeavors are antireligious. They forget that our forefathers created reductions of their own without end: infralapsarianism and supralapsarianism, *via antiqua* and *via moderna,* realism and nominalism. The ethical debates, from Augustine to Ebeling, have always been carried out with reductionist models—*summum bonum, moral imperative, tertius usus.* In the great confessional conflicts of Europe, Protestants and Catholics fought with reductionist models like the priesthood of all believers, *una sancta.* Today, a graduate student must learn, both in regard to his dissertation and in view of his future as a teacher, what kind of reductions can be used meaningfully and consistently.

Reenactment and reduction are tools of research that stand in a strangely opposed yet complementary relation to each other. Reduction is a process that leads to less and less: the Bhagavad-Gita, the life of Buddha, the teachings of Buddha, the eightfold path, the fourfold truth: Buddhism. We finally create a term which comprehends an en-

tire field. The Weimar Edition of Luther's works consists of over one hundred volumes. Out of this immense opus we create code terms by which to get hold of the phenomenon "Luther": the 95 theses, justification by faith, scriptural principle, renewal of the church, priesthood of all believers; finally, we have Reformer, Reformation, Humanism, Lutheranism.

Reductionist models are by no means the product of the universities and academic demands. There had been at work for a very long time a reductionist process in terms of God—less and less was said about him: Dionysius' negation, the name "Allah," the enigmatic Tetragrammaton which could not even be pronounced. The sources for reduction were theological as well as philosophical, and were rooted not only in the philosophical and scientific desire to explain the world by general codes, but also in the psychological tendency and longing for unity. Both of these aspects of the reductionist mechanism have been operating to this very day.

The more we reduce a subject matter, the more we must speak about it. Pseudo-Dionysius has a great deal to write in respect to a God of whom he has really nothing to say. The Thomistic *Summa* contains huge questions about a God of whom Thomas spoke in only five ways. Reductions can only stand when they are given flesh and blood, when they are seen not as abstract nouns but as concrete examples and evidence of the variety of life. We must at all times make clear that they are only tools. They are not really accurate. We speak about the "Middle Ages" because we need the reduction to introduce students to the medieval world. But once we have introduced them to the Middle Ages, we must explain that the Middle Ages do not really exist. Reductions are absolutely necessary to the scientific task, but the student must understand that the reduction stands for an immensely pluralistic reality.

Reenactment, on the other hand, is the process that leads to more and more. Each time a ritual is enacted, each time it is brought to a new town, a new country, a new language, it becomes new. The people are new, the locus is new, the language may be new. The people hear it anew, like the drama, like all art that has the power to address us. The Christian ritual has been in a cycle of frequent change, and this despite the fact that the ritual is one of the most conservative parts of a religious tradition. Its music has changed from Ambrosian to Gregorian to Renaissance to Baroque. Its language has changed from Greek to

Latin, from Celtic and Spanish to Latin (not always without clashes), and finally to German and English and Italian.

Reenactment arises from the reductionist insights. It profits from and expresses what the reductionist task achieved. To hear Etienne Gilson lecture on a medieval topic was to witness a reenactment, carefully hewn in superb French; but the lecture presented issues which had been worked through by scholars in a long reductionist task: nominalism, ontology, double relation. Seder and Mass are reenactments; but on the academic level, they are prepared by intellectual work which employs the reductionist approach on the problems of translation, *gestus,* and ritual meaning.[27] The man who produces the *Play of Daniel* has to have a vision, an idea about medieval drama, and about that specific mystery play. The antithesis between reduction and reenactment cannot be solved in either direction.

d) A fourth methodological polarity has received a good deal of notoriety of late, namely that between *synchronic* and *diachronic* principles of observation. In synchronic methodology we treat the data from a group, a tribe, or a culture as a unity, without any presupposition of historical change.[28] Leaving aside the specific linguistic applications of the synchronic method in the tradition of De Saussure, synchronic research has been with us for a long time. Aristotle's system was surely synchronic, for the philosopher took the entire physical, cultural, and psychological data available to him as *one* unit and dealt with the data in terms of *one* overarching process. The work of Plotinus, in content as far removed from social science as anything could have been in the ancient world, was void of any diachronic awareness, because Plotinus left no room for historical mutation and presented the entire cosmic reality (and unreality) as one total process. Strangely enough, Plotinus went to Persia in order to study (an early attempt at field work!) alien religions. The great Christian systems must be called synchronic since for Thomas Aquinas the entire data of politics, religion, science, and personality are actually one system, and the same can be said of Calvin. These systems are, of course, not synchronic in terms of modern field work, interviews, and linguistic method, but in terms of time, causality, and history.

The beginnings of diachronic observation also lie in antiquity, in the explorations of history (Thucydides, Herodotus) and language (Hesiod, research in Homer). The Hebrew prophets experienced "culture" in disruption, and for them "right" and "wrong" were by no

means part of one cultural system, but were to be overcome in a radical cultural change. Since the eighteenth and nineteenth centuries, notions of evolution and progress (and its reversal: decline) have been operating in research: Gibbon, Darwin, Spengler, Toynbee, Marx.

A great deal of religious study must be called diachronic, and can only be so.[29] Exegetical studies, historical analyses, the work of Islamic development, the influence of Buddhism in Japan, the emergence of Black religion in America—all of this is done in a diachronic fashion. We examine changes and roots, we presuppose historical development, we assume some kind of alteration of consciousness. Works on the renewal of the church, on liturgical revival, on feminism, on the social gospel assume time and change and history. Yet, not only religious anthropologists but philosophers of religion and psychologists of religion, as far as they treat the entirety of cultural data, must be called synchronic. De George rightly included in his textbook on "structuralism" a large historical evolution in social science and linguistics, from Marx and Freud to Jacobson and Chomsky.[30] Phenomenology is an important synchronic option, quite distinct from the structural trends.

Our work takes place in a constant alternation between the two. Diachronic research is based on the conviction that man and society do change; synchronic research is based on the conviction that all men have the same mental structure and can be comprehended by one symphony of relations. We assume both at given moments of our research. In diachronic convictions we realize that not all life is the same, that religions evolve, that there is hope for change, that no formula works for all, and that some things are better than others. There is hence not just one method, one theology, one structure of the human mind which dooms us to do the same Sisyphean work endlessly. Synchronic research is based on the opposite awareness: Lessing's parables of the rings, the Cartesian ubiquity of the mental situation, the insight that history is a time-bound ideology and not the objective key to life.[31]

The two positions characterize our field. To return to my example in *The Savage Mind,* Lévi-Strauss presented the synchronic method for which he has become so famous; but when in that brilliant appendix he took on Jean-Paul Sartre, his great enemy, all synchronic intentions were left behind and he, Lévi-Strauss, fought with diachronic passion pure and simple.

In the field of Western religion, the first step in the confluence of

synchronic and diachronic methods was taken by the unknown redactor who put together the Book of Genesis. The J-story of creation in Genesis 2 and 3 arose in a nomad tribe and was conceived and accepted surely in a synchronic fashion by the generations who perpetuated it orally. The P-story of Genesis 1 was also experienced in such synchronic fashion by people who transmitted it in urban Israel. But now the redactor had two conflicting stories about the creation of the cosmos. What could he have done? Discard one of the texts? Corrupt the texts by combining them into one story as many a well-meaning Sunday school teacher has done? Write an historical or a structuralist essay explaining the reasons for his including both tales?

The redactor did nothing of the kind. He put the two stories side by side. By doing so, he submitted pluralistic religious data, and left us to deal with them, synchronically or diachronically, depending on the preference. Scholars have had to deal with the nomadic and the Babylonian tales and have been drawn into the structuralist problematic of the J- and P-accounts.

Pluralism was with us. And history was with us.

This chart, in reductionist, synchronic, and critical fashion contains the antitheses of scientific investigation in the field of religious study:

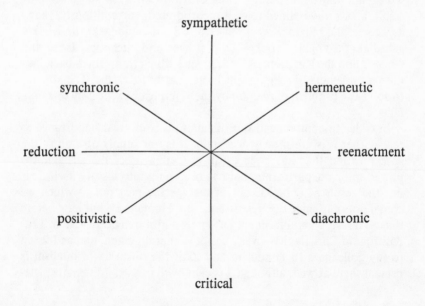

II

There are a number of ways that seem to lead out of the dilemma of religion, and they are practiced both in academia and in the religious world at large. The most common and successful is to adopt a certain definition of religion as the authentic one, and then to judge all other phenomena by whether or not they conform to such a definition. If religion is belief in Jesus Christ, it becomes manageable to the members of the church to distinguish between true and false religion. If religion is ethic, it again becomes relatively easy to orient oneself in the jungle of movements and ideas, having found an axis of judgment from the Decalogue or the Sermon on the Mount or the contemporary social gospel. In academia, this game of establishing a definition and then proceeding from such a platform is widespread. Religion is concern for ultimate reality, or religion is sociological canopy: from such presuppositions we can do consistent research. Karl Barth chose a simple procedure in order to cut the Gordian knot of religious definitions.[32] He declared in Kierkegaard's footsteps that Christianity ("authentic" faith) is not a religion but a revelation. All the painful problems seem to have disappeared with such magic, and the chaos of movements and concepts is left to other departments. But not only did such a *tour de force* reduce the Christian world to an exceedingly small, arbitrarily defined fold; it incorporated, surreptitiously, many aspects of the religious world back into its myopic task: the Kierkegaardian theologians spoke about prayer and eucharist, Isaac and Genesis and the Kingdom of God, images which threw them back into the very dilemma of religion which they meant to escape. The attempt to solve the problem of religion by such simplistic exclusivity certainly failed.

In order to comprehend our dilemma, it is of great importance to realize that it is not merely academic. It is not simply a result of the specialization that has gone on in academia or of the struggle for power among departments, but has been built into history itself. It is not the result of unbelief, but of the specific past out of which we come, not only since the Renaissance and Humanism, but long before that. The very establishment of three major religions—Islam, Judaism, and Christianity—was a result of that dilemma, and as I listen to my colleagues in Hinduism and Zen, the dilemma of dualism is present there as well, although it is dealt with in a very different episte-

mological framework and with other psychological and metaphoric techniques. The dilemma of religion is the most important starting point to a confrontation and interaction with art.

Whatever "religion" turns out to be, we are always led into the duality between the *individual* and the *collective.* As we examine myth, the priesthood, the rituals we face collective forces. When we celebrate Hanuka we celebrate with the worldwide Jewish community; when we make a pilgrimage to Mecca, it is as a member of Islam. But the data which come to us in the realm of religion also speak of highly individual trends. There has existed, from Micah to Plato and down to Berrigan and Whitehead, the individual who deals with religion but sets himself apart from it, critically, seeing his own ideas or convictions as a challenge, socially or intellectually, to society and religion.[33] Social studies tend to emphasize the collective, the tribal and ritualistic elements, custom, myth, taboo, but there has existed, at least since classical antiquity, personal religion, personal protest against cult and order, the Dionysiac overthrow of reason, the individual definition and experience of God and faith. The fight between cult and ethic has been, since Hebrew times, part and parcel of our past, down to contemporary American churches which are torn between functioning as revival assemblies saving the souls of the individuals, or as centers for social change, integration, and feminist liberation.[34]

Next, representatives of religion are caught in the antithesis between *history* and *anti-history.* There exists among religious people an affirmation of history, and there also exists the opposite, an attempt to eliminate or to deny history. We want to remember and we want to forget. When I came to Philadelphia, I was asked to lecture on urban antiquity at the start of a series on contemporary urban problems. A young minister rose up — it was 1968 — and said angrily to me and to the audience: "Would you please stop talking about history, about the past: it hasn't helped us any and we have only two years to solve the ills of this city." It was the apocalyptic call, the biblical demand not to put new wine into old skins, anti-history passionate and merciless. But ten minutes later the same man quoted Jesus and mentioned the body of Christ of 1 Corinthians 12 as a model for living in the city.

The two passions to break with the past and to recall the past have been with us for a long time, at least as long as we can trace literary expression in Hebrew and Greek civilizations.[35] The past is ambivalent: God made a covenant on the holy mountain and God punished the

people of that covenant. The past offers manna and the killer snakes of the desert. The Greeks celebrated the victory of the Achaians over the city of Troy, and they sang of the horrendous deeds that came with that victory: the humiliation of Cassandra, the trials of Odysseus, the end of the house of Tantalus. The texts of the Synoptics have Jesus quote Scripture, and then he speaks of the break: "But I tell you . . ."

The two desires are ingrained in the life of the university. Along theoretical lines, history of science has debated the place of evolution versus revolution in scientific discoveries. The tension is present in our constant attempts to offer the student solid learning and sound knowledge, while at the same time to create an innovative curriculum for him and let him develop on his own. We listen to someone propose a *tabula rasa* solution for the ills of the university, and on the way home from his lecture we find, if not Plato, at least five hundred years of academic history. The tension is present every time I get ready for a lecture: how much historic material to present and where to take issue with it, and even if the taking of issues covers only the final ten minutes, the switch from *memoria* to *amor* draws an entire class into the historical problematic.

This duality of affirming and eradicating history goes through many a career of religious scholarship. We must break with the past in order to comprehend it, since an unexamined past would not be worth teaching. But we also love the past and we want to recall its momentum. Reduction and reenactment, critical and sympathetic scholarship are in fact variations of that one inner dynamic which belongs to the center of our being and appears so powerfully in Paul of Tarsus: the man who was a convinced Benjaminite, who expressed his Jewish convictions in every one of his letters, and broke with his Jewish heritage on such primal matters as dietary practice and circumcision.[36]

The dilemma of religion and of the study of religion is not only that of individual and collective, and of history versus anti-history, but also that of *religion* versus *anti-religion,* an inner dynamic of our history which also will have crucial importance for religion and art. Ever since the beginnings of Hebrew and Greek literature the problem of religion has been with us. For an Indonesian tribe religion itself is not the problem. *Life* is the problem, and the religious canopy, myth, and cult enable society to function. In the emerging ancient world, this very mythic and ritualistic past became the problem of life. Individuals emerged whose belief world clashed with the traditional and political

systems. The agony of Jeremiah came from the fact that his canopy had collapsed. Even the king was no longer sure. Jerusalem fell. What survived were not the prophecies of the priests of Bethel, of the official religion, but the poetry of the prophets, of the rebels. In this case, anti-religion, or what certainly looked like anti-religion to the overwhelming majority of the people, survived.

The tension between religion and anti-religion is not Nietzschean, nor does it originate even in the Renaissance. It is ancient,[37] and we shall return to that problem in Chapter 5. It is enough to become aware at this point that there emerged in antiquity, first in ancient Israel and then in classical Greece, trends which regarded the cult as wrong, or even more seriously, trends which regarded religion altogether as evil.[38] The critical trends have found representatives widely through the entire history of our civilization and have influenced the study of religion profoundly. To what degree is religion, as John Stuart Mill asked, "useful"?[39]

There is a further issue before us that has to do not so much with religion as with the very center of studying religion: *academia* and *anti-academia*. As we set up the structural dilemma of the academic study of religion as a reflection of the religious problematic as a whole, we must realize that the academy can be challenged from without, and has been challenged from without, from the days of Luther and Zwingli to the revolutionary student revolts of the nineteenth century and the Vietnam protests of our days and the overthrow of the Persian Shah.

Academia, in a sense like synagogues and churches, like Salt Lake City and the Vatican, is an island where power and intrigues are played to the hilt and where, despite power and intrigue, study goes on. But the universities exist with a world outside, just as religious communities function with commercial, social, and military life going on at the same time. The world not only sends her children to us and pays in one form or another for that university, it also stands against us, distrusting the intellectual. Anti-academia is learning outside the academy, in protest and spite, in contempt or fear before the institution of learning. The conflicts sharpen whenever the universities become the seedbeds of reformation, in the radical movements of the nineteenth century or the protests against the Vietnamese and Chilean policies of the Government.

Anti-academia exists not only in some of our politicians, but in the

worker who is afraid of the intellectual, in the pious man who fears what the academy might find out about his faith. But anti-academia also is found in people who know quite clearly that the life of the mind is not the whole, in the artist who creates with very different ground rules and who is nevertheless concerned with society, in public leaders who want to change that society and who may or may not get help from the university. Anti-academia from business, labor unions, politics, is a very strong force because it tries to prevent academia from continuing its own narcissistic games. One of the strongest of these forces has come from art.

Such are the magnetic forces within which religions emerge and in which the study of religion is caught. No wonder there exists no consensus about religion, just as there exists no consensus about how to solve life. At times the polarities are experienced as natural, complementary, and organic; at other times they tear communities apart and create great anguish in an individual. Religious movements have led to so much joy and bloodshed because the antinomies of life have returned so concretely in their core.

Chapter 3

The Dilemma of Art

What is art?

when the sun dances with the morning mist
 no?
when rivers carve their rhythm into
fifty-million-year-old sedimentary rock
 no?
cheekbones and pitch-black hair and
graceful limbs we call image of god
 no?

everyone knows what art is of course
the Mona Lisa
Cathedral of Amiens
Hamlet
Paradise Lost
 paradise lost
the B-Minor Mass
Taj Mahal

Buddha
Jesus of Nazareth
Bach Buechner Tennessee Williams
who is an artist?
who is not an artist?

sand castles
the monkey's charcoal drawings
a tree trunk on the Delaware
Mary had a little lamb
are there any limits?

if there are no limits there is no art
drive down the block in your charcoal toyota
Venturi-like-outhouses at the service stations
cracked pebbles from one-time sidewalk cement
if everything is art there is no art

there are answers of course and certainly
if you do not see it my way
if you do not borrow my words
if you do not read my books
if you do not (we know all about the kingdom)

who is to tell us
fides qua creditur
art history
sociology of knowledge
close your eyes and you shall know
 no?

but we can't *not* talk
Tennessee Williams lives on that
someone wants to sell his garages
and it's so much fun to laugh with Lysistrata

perhaps no-art
Kierkegaard would be thrilled
Lévi-Strauss sneers at poetry
Susan Sontag hates interpretations
culture gulch

we could declare a moratorium on poetry
for one century to sanitize mankind
replace all paintings with television screens
associate professorships in no-more-art
graduate programs in no-longer-art

but no-longer-art might make the galleries
 look at Duchamp
no-more-art sells
not-ever-art is worth at least
 a mass

no-art and have the bloody mess start over?
no wonder people seek for a way
a match
bulldozers
one more final solution published

It is with something of a shock that a student of religion, when look-
ing for art across the academic fences, discovers a dilemma not one
iota less severe than that in his own field. The study of religion takes
place amid tensions which have torn apart not only the seminaries and
departments of religion, but also the religious bodies and cultural
circles behind them. The study of art takes place amid similar ten-
sions, and the conflicts likewise spill over into the culture at large.
Exactly as in the case of religion, the tensions have not been created by
the universities as such; they are present in the very phenomenon of
"art," in the artists themselves, in the forces which the artistic
endeavor has unleashed for centuries. "A remarkable aspect of the art
of the present century is the range of concepts and ideologies which it
embodies"—thus does Christopher Finch introduce a book on *Con-
cepts of Modern Art*.[1] In order to enter into a dialogue between
religion and art, it is necessary to consider the artistic pluralism as a
counterpart to the religious one.

I

Take a first problem which goes through the entire field of art as
well as through the entire scope of art criticism, the duality of *creation*
and *reflection:*

create know
spontaneously! what you are doing!

These two demands are operating in both the creation and the study of art.

This problem is not apparent to the layman. The artist creates, so the notion goes, without asking "profound" questions, and without being bothered by problems of definition and meaning. And indeed, the artist often does not get hung up on definition. He does create without always having to justify, explain, or define what he does. But the tension between spontaneous creation and conceptual activity arises constantly. Not only is the very world of art divided—and has been so for millennia—between illusionist and conceptual painting; time and time again painters as well as writers have written about their work. While indeed some have worked out of a natural talent without caring to know what they were doing, others have very much thought about their work, even written about it, from Leonardo's theoretical writings to Jean Arp, from Michelangelo to Cézanne.[2] There also exists a widespread and passionate attempt to express artistic categories in language. On closer sight, the romantic notion of purely spontaneous, nonreflective artistic processes does not hold up.

The problem which thus emerges in the sphere of art is not one of artist versus academician, as it is commonly thought and expounded. It is a problem rooted in the process of artistic creation itself.[3] Paul Klee would look at his canvases after they were painted and give a name to them. The names reveal his sense of humor: "Letter Ghost," "Fish Magic." He identified his paintings thereby, but there is also something of the deed of Genesis in it, of God who brought his animals to Adam and asked him to name them.

That step of looking at one's own work and naming it is the last step of creation.[4] The painter has always stepped back when painting, and now he feels the final distance. In giving a name, Klee continues and concludes the process of creation: I call thee "Fish Magic." But that deed is also the first deed of response. The painter begins to react to his work, he sees a canvas with a name: "Senecio." The process of naming is the first step in the process of reflecting and interpreting, for the name is the first of all interpretations to come, even though—precisely though—the name may be a code, a conscious delusion, a tease.[5]

But not only does that process of reflection take place in that naming: Klee sits down and writes a diary. And, in interaction with that diary, Klee goes on painting. Out of reflection comes new work. "I paint with the dead," he wrote about his own process.

In this duality between creating and knowing we face the fundamental problem in all of art: who has the right to say what there is to know? As in all other fields of life, personal, social, religious, much of what we do is only half-understood by us. The artists have absolutely no superior knowledge over the rest of society: they *do,* and they *do not* know what they are about, or what their work is about. Georgia O'Keeffe finally wrote a book in order to counter her interpreters, "I write this because such odd things have been done about me with words."[6] Everybody does odd things to other people with words. We do so even to ourselves. Georgia O'Keeffe notwithstanding, what other people see in us might be more to the point than what *we* see in ourselves; and what we see in our work might also be seen, perhaps with different implications, by others. O'Keeffe's book shows the intensity with which a great artist speaks about her life, about her colors; her interpretations are, as in every other case, only one piece of evidence in the puzzle of a person, a person's work, a generation's product.[7]

There certainly does exist a potential conflict between the creative act and the academic reflection. In his esthetic theory, Adorno claimed that academic constructs are *eo ipso* worthless because the elements which should be synthesized by academic logic do not even exist.[8] In such a view the logic of art and the logic of discursive speech are incompatible; discursive analysis cannot express the combination of ambiguity, mystery, and dialectic, which for Adorno was the essential characteristic of art. And yet reflection from Leonardo to Stuart Davis has helped the process of artistic creativity. The art student learns about art history; the art historian, even when he does not paint himself, is involved in the creative processes by responding to, contesting, and furthering new movements of art.[9]

A major difference between artist and academic lies in the way theoretical considerations are reached. The artists on the whole have not placed their own work systematically into historical or cultural perspective; neither have they explained their work with the tools of the academic game, with metaphysical concepts or synthetic critical examinations with footnotes and quotes. They write aphorisms, poetry, or pamphlets.[10] Whether they have done their reflections satisfactorily or not is another question, but academic theories have been as limited and unsatisfactory as the artistic explanations.

The tension is not some evil fall from the grace of a primordial

paradise. It is not merely the tension between vision and definition, art and philosophy. The duality of the artistic image and intellectual response lies at the very root of the problem of art, and the academic dilemma, exactly as in the realm of religion, is merely one of the relatively newer manifestations of that dilemma. It belongs to a dilemma most of us have experienced one way or another in the past:

we *cannot* talk about art but we *must* talk about art
we *want* to talk about art

We have two experiences. No talking can ever replace reading the poem or going to the museum. Our explanations are unsatisfactory, and the justifications do not hold up. Most of us have seen a film after which we simply do not want to speak or hear anything. We see a play and drive for an hour without saying one word. But we also have the other experience: we *must* talk after what we have seen. Art history and art criticism are not, as the layman so often claims and the artist at times defensively thinks, transgressions on a holy realm that ought to be left silent. As we learn about art, drama, poetry, or literature, about *techne* and artistic order we gain although we may also lose an element of immediacy. The combination of experience and thought belongs to our humanity, and represents authentic participation and response to art. Consciousness is neither preverbal nor verbal; both nonverbal and verbal reactions form our response, although one of them may dominate.[11]

In the art museums I often read a prohibition that makes me quite angry: Do Not Touch! It is written on every floor of the Hirschhorn. But the sculptures have been created to be touched! Bronze and wood and marble invite the hand to feel the curve: the blind man sees the sculptures with his hands. There is something absurd in such prohibitions: Poseidon lay on the bottom of the Aegean Sea for two millennia, was roughed up by sea water and polluted by dirt, but now you cannot touch him in the Archeological Museum of Athens!

And yet, I cannot expect to touch all that has been created. About a great deal of the past I can only think, because what has been created is no longer concretely available to me. I am a historical being, and I can only experience the past in a mixture of partial experience and reflection. I recall. The artist and the average person are in the same boat: once something has happened, is printed in a book, has been

hung in a museum, or sung in a concert, the immediacy is gone. The distance between the work and us is the distance of time and space, of history and individuality.[12] The experience of art belongs to the historical mystery of man: we have been at a time and place, we are no longer there, and we must learn to bridge the gap. The polarity in art criticism between feeling and reflection belongs to this primal split between immediacy and recall.[13]

The polarity between touching and reflecting parallels the dilemma of religious study. In myth and liturgy we experience both and step back to reflect, and the reflection leads to new religious images and structures. The polemic against the past and the creation of new mythic and social models in New Testament times go hand in hand. It is absurd to reserve "authentic" religious creativity, as some people are tempted to do, only to the experience by excluding reflection. Augustine's reflections were as much a part of his religious life, of his "religious experience," as was his involvement in monastic circles or his participation in the Mass. In religious study we are caught between the Scylla of involvement and the Charybdis of distance: we cannot comprehend unless we have some kind of relation to what we study, but we cannot comprehend it unless we stand at a distance. The pull between creation and reflection in the study of art is a variation on the pull between apologia and critique in the study of religion.

II

There exists a second polarity in art as well as in the study of art, and it is closely related to the first:

art is a creative process art is the product of
 a creative process

When we talk about art, we talk about something that goes on in a person, in a group, or even in an entire epoch. Art is experience, creativity: we take a brush and create *de novo*. We take a piece of marble and hew a face. We take a sheet of empty score and create a song. Art is hewing the marble and creating the song.

In retrospect we may realize (and above all the observer who stands back realizes) that we did not create *de novo,* that we created out of models, traditions, from background and influences and archetypes in

us and around us. For many an observer the criterion for the validity of a man's work lies in that one element: whether or not the work is new, original, hence "authentic." But there exists an artistic experience, personal, physical, and emotional quite beside the finished work. This is why so many books are published on the artistic person, on Giacometti and Edward Hopper and Eliot and Joyce. We describe and want to understand the uniqueness of the personality, the unparalleled individuality, the one moment in time.[14]

But something happens to the work of art: we can break it off from its creator. It becomes something else, it takes on an existence of its own.[15] The artist at times has a strange experience about his own work—he sees it hanging in a museum but it is not his own anymore. He looks at it as the others look at it, as something "someone" has created, and he happens to be that someone. In a second-century gnostic fragment, Valentinus expressed this duality: God created the world, and then looked at it and was afraid of what he had done. The feeling does not have to be fear, but we are all familiar with it, in art as well as in other fields of creativity: we look at what we have created and we do not quite comprehend all of it, we do not recognize it entirely as ours anymore. In our books, children, friends, in our own ideas we experience the fear that what we create takes on a life of its own. The connection between a person and that person's expression is quite enigmatic.[16] Art is not only a process closely related to its creator,[17] it is also the product of that process severed from its creator.[18]

As we lay the groundwork for the interaction between religion and art it is imperative that we recognize the polarity of the artistic structure, a structure which combines an individual, subjective, spontaneous deed with an objective, general distant code or product or symbol. I create and I see a creation; I see an individual's work and I see a product quite separated from that individual.[19] In the artistic creation, subjectivity and objectivity, freedom and rhythm, spontaneity and order are present.

III

The greatest difficulty, however, in both talking about and studying art, results from the fact that there is no overall agreement as to what "art" actually is.[20] Neither the artists nor the scholars agree on a com-

mon definition of art, and this lack of agreement is not due to any competition among them, but to the fundamental dilemma in the realm of artistic creativity itself: both the artist and the critic are caught in the altercation between *exclusive* and *inclusive* concepts of art.

In the more exclusive view of art, only a few products of human creativity are properly called "art," usually products which seem of high caliber to an individual or to a school.[21] The classical school from Winkelmann down had clear standards from which to judge such high art: the classical world of antiquity. The very word "classical" puts all talk about art into a definite, qualitative, historically determined perspective.[22] It is no wonder that for many people schooled in this classical definition of art, modern painting is decadent, degenerate, and has lost its center.[23] In defining art as "classical," we create a distance between art and the rest of man's creativity, *techne,* artifacts, utensils, *Kunstgewerbe.*

In an inclusive definition of art, this qualitative and elitist narrowness is widened.[24] The concept includes not only the Pietà, the Paradise Lost, the *Missa Solemnis*, but many other aspects of man's creativity, the frescoes of the catacombs, the folk art of Brittany, the love songs of popular music, and Duchamp's *ready-mades*.[25] As soon as we broaden the term *art*, immense problems arise. Is a child's drawing art?[26] Is the packaging of cigarettes or the billboard on the highway "art"? In fact, is film art? I was present last fall at two separate dinner parties in New York, and I asked that question of two art historians. In the first case, we received a rather embarrassing ten-minute lecture *urbi et orbi*: that only decadent and uninformed laymen would employ the term *art* for what is a minor cultural phenomenon, the film. In the second case, we heard an equally passionate plea on why film is one of the most incisive art forms of the century.[27] The impasse has an authentic base: if everything is art, then the very term *art* loses its strength, even its meaning.[28] Why not call it "creativity," or even "life" itself, *élan vital,* productivity? If only a very restricted definition applies, art becomes esoteric, Olympian, the privilege of the initiated.

It is not hard to note, as we did on the former points, the parallel between the conceptual dilemma in art and the conceptual dilemma in religion. If practically everything on earth is "religious," the term loses its meaning, its character; if only a few select events and images

are to be called "religious," the term becomes esoteric. The contemporary disagreement as to what is "religious" (Is a hockey game religious? Is folding an American flag religious? Are the Christmas holidays and the evocations of God by politicians still religious?) is strikingly paralleled by a controversy as to what art is (Is creating a cake and eating it as "eat art" to be counted as art?). Is driftwood art?[29] And how about computer art?[30]

Now, one might say that it is irrelevant whether we decide one way or the other. We create, we enjoy, we communicate, and whether what we create, enjoy, or communicate is art or not does not matter. For the one studying art, however, it does matter what scope research has and what object we are dealing with. And in regard to such objects we admit that we must make choices, and that by such choices, we exclude other possibilities. The field of art does not have a consensus about its object.[31] The academician, strangely enough, shares this lack of consensus with the layman. Just as the academicians disagree as to whether or not a full house at La Scala in Milan is "art," so the layman is not sure whether Joseph Cornell's boxes are art. The academician tends to smile at the ignorance of the layman, having looked at Joseph Cornell long enough to appreciate his genius. Yet in the past his judgments have been as much subject to revision as the layman's.[32]

There are two things I must add to this problem. My examples have primarily come from the present, where it is always more difficult to sever the genius from the charlatan than in the past. Few people would argue, it might be said, about the Scrovegni Chapel or the temples of Paestum being art. To be sure, history does give us the distance which we do not possess about our present, and in distance the judgment often becomes considerably safer. Nevertheless, the problem of definition does not disappear with history. The academic personality is often academically conservative. Hence, he or she has less difficulty in calling a medieval love song "art" than calling the Beatles' "Yellow Submarine" "art." It has been said that only history, i.e., historical distance, tells us what is art.[33] Even that restriction does not free us from the dilemma of definition: for some, the paintings of the Roman catacombs are second-rate decorations for an underground city, while for others they are authentic works of art.[34]

The art critics as well as the collectors and the observers at large have, of course, long ago come to make qualitative distinctions be-

tween individual products of art. Piero della Francesca is a better painter than some follower of Gaddi in a Florentine church. Cézanne's *Bathers* in the Philadelphia Art Museum is surely greater art than some amateur beach scene painted at the New Jersey shore. It would be foolish to deny qualitative differences; the question is whether only high-quality products can be properly called art. And it is before this question that a definition of art becomes exceedingly difficult, if not impossible.

IV

The final polarity leads us back once more to our considerations on the study of religion, and it has torn the field of art history apart as much as it is tearing apart the students of religion: the dilemma between *positivistic* and *interpretative* principles of analysis. The art historian, like his colleagues in religion, history, and literature wants to describe his subject matter, in his case in terms of color, material, form, structure, and content; in regard to origins, schools, and parallels.[35] The descriptive approach opens our eyes to historical developments, details, technical skills, individual and collective uniqueness. But a second task exists. Iconic signs are in need of some kind of interpretation, because we never simply see "a picture," as Gombrich has shown us so well.[36] There is no agreement among the specialists as to how far this realm of interpretation can be extended — for instance, whether or not it implies a search for "meaning" (whatever is meant by that word), whether or not we should seek (or even be allowed to seek) for what may lie "in" or "behind" or "below" a work of art, or the works of a school.[37]

Academia in a one-hundred-year evolution has come to divide the interpretative field into several branches: philosophical criticism, psychological criticism, Marxist or structural criticism, to mention a few. The problem posed in these is not merely whether the possibility of criticism should be granted (a question frequently decided by authoritarian assertions) but whether any truth-claim is possible by such criticism.[38] As in the fields of religion and history, this second task becomes precarious as soon as we compare one claim with another; just as the task of comparative religion has undermined and ultimately transformed the claims of one specific tradition, the presence of multiple interpretations comes as a threat to the innocence and security of

the academic turfs. Furthermore, to look in a painting for meaning, archetype, cultural codes, for structure and rhythm, presupposes a task of translation, a kind of hermeneutic courage which may always be qualified by other interpretative processes.[39]

There is absolutely no consensus as to whether such substructure exists or ought to be the goal of research. While for some scholars to interpret art is to project our subjective wishes and idiosyncratic ideas onto another's creation,[40] for others *not* to interpret art would be to miss the very center, the mystery, and purpose of artistic creativity. But even among representatives of interpretative criticism, little consensus has arisen as to the method and content of such a task.[41] It suffices to mention such names as Neumann, Campbell, Goodenough, Jung, or Burnham to show the variety of principles. The only consensus on their part lies in that they see art as a meaning system which must be explored, whether by structuralist, Jungian, or sociological categories.[42]

It is here more than anywhere else that the disagreements about art become frequently cynical and polemic. The most important interpretative positions of our century, the psychological, structuralist, and Marxist ones, are frequently met with a kind of contempt that indicates how serious the disagreements really are. Otherwise, the polemic would not be so venomous. We encounter at times a kind of heresy hunt that reminds us painfully of confessional religious polemic in Arian, supralapsarian, and pietistic times.[43]

And here I must side with the hermeneutic camp. The question of whether or not we dare see in the *David* of Michelangelo or in *The Cry* of Munch archetypal, psychological, or subconscious expressions cannot be answered objectively.[44] The work of art does not tell us whether it allows interpretation or not; only history, individuals, and groups within history have told us so in retrospect, and whether this can be done or should not be done is a matter of historical and individual choice and not of objective certainty. We may feel uneasy about the narcissism of psychoanalytic art interpretation, or about the dogmatism of Marxist studies, but the *right* to do such studies is not denied by the work of art. When the positivistic or descriptive art historian acts at times as if *his* is the objective approach, he is playing the same trick that the religious historian plays when he does not want to allow for a hermeneutic translation. *Not* to raise questions of meaning is an act of personal choice, not a given of history, God, or reason.

Furthermore, it is rather significant to observe that the descriptive scholar himself performs a kind of hermeneutic translation. His hermeneutic principle, his choice, demands a restriction of categories. When we do not see in *The Cry* of Munch an expression of the subconscious, an archetype of loneliness, or the alienation of contemporary man, we have made a hermeneutic decision.[45]

Art exists for its own sake, yet art does *not* exist for its own sake but is a code for social, ethical, or intellectual forces: these two insights not only go through academia but can be found within individuals themselves. The issue is not new, "the form remains, the function never dies," as Wordsworth said. The conflict between the representatives of "l'art pour l'art" and their many opponents is but one more variation of the age-old controversy between ethical and theological primacy in religious life versus cultic primacy, an issue to which I shall turn later in this book.[46] Marxist theories of art have awakened us to the fact that the assumption of an objective art-historical process is a gigantic academic illusion. The professor defending art for its own sake may really defend his own social or economic advantages. The Marxist assertions exhibit that dilemma well: Brecht and Plekhanov preach with fervor a kind of salvatory theory of art, but they also enjoy the play, pure and simple.

Such are some research polarities in the study of art, emerging from the very dynamic in the creation of art itself and from the interaction between mind and creation.[47] These structural antitheses, insoluble as Panofsky realized at the end of his *Idea,*[48] lie at the base of my investigations. The artist may or may not experience these polarities in his life consciously, but the contemporary observer of art is driven toward them if he crosses the boundaries of one specific academic turf. Many conclusions are open: that an art theory is wrong in principle;[49] that values are not binding;[50] that we must distinguish between estimate and truth value;[51] that we want to forget everything else and solve the problem singlehandedly. We talk and communicate; we collect (art and statements about art) and hence come to compare; as we compare we cannot help observing; and in observations we divide, we judge, we employ theories. The fear of theories is on the same level as the dogmatism of theoreticians: both result from the recognition that conflicting truth-claims, an attack on our intellectual rigor, are found everywhere.

As in all other academic and nonacademic fields, the theoreticians

of art have ways to eliminate the antinomies. They will restrict their work to a narrow base and exclude other material as nonauthentic. Neumann, Kris, Foucault are kept out.[52] Such exclusion is one way to safeguard a seemingly pure discipline of art history. The tendency to create a dogmatic, orthodox realm of art study proper is precisely like the tendency to create a realm of proper experimental psychology, or of logical philosophy in which the hellish academic ambivalence is temporarily banned by one "proper" process.

We have, to be sure, lived with that tendency for a long time. It is the most recent reemergence of the religious search for orthodoxy, a belief in a secure method of exegesis and thought, an assertion of an exclusive path to knowledge.[53] The belief in the text has been replaced by belief in verification. The nonchalant claim of Morris Weitz led to so much anger because it pinpoints not the impossibility of a theory of art (who is to tell me I *cannot* have a principle of research?) but the hair-raising pluralism as we step out of our own research hole and survey the field. The research polarities in the field of art go back to fundamental, antithetic, or complementary experiences, however we define or comprehend "art."[54]

For instance, however art is defined, it stands in some double relationship to *culture*, to the context in which it takes place and toward which it is directed. There are many ways to define a work of art. But no matter how we define it, it can be seen as part of that culture, whether in exclusive or inclusive models, whether as creative process, social code, or opiate of the people. The artist belongs to a society and can be analyzed through that society, whether he expresses that society positively (Renoir) or whether he takes issue critically with that society (Goya or Daumier). The artist exists as a member of a society, whatever role he plays and with whatever model we approach him.[55]

But we can look at his work differently and we can see in the work an order of its own, a unit to be analyzed on its own terms.[56] Whether such an order follows archetypal, psychological, or technical patterns is beside the point. We all have experienced this dual character of art at one time or another: we see in a Lukas Cranach, *Renaissance Man,* the emergence of the body, the mystery of Adam and Eve, perspective, humanism; but we also see in a Lukas Cranach painting something that exists quite on its own terms. A person can have a direct relation to it simply by entering the art museum; he can write a critical analysis purely on the technique and structure of the canvas. The approaches

may be mixed, of course, in art criticism, but we observe that they can exist independently. The canvas comes to us from a definite culture in history and time and space, but we can also experience that very same canvas outside of its time. Art belongs to a culture, and art can be seen outside of its culture.

The duality thus posed is experienced academically, in that juxtaposition of diachronic and synchronic methodologies of which I spoke before. There are two ways to look at society and history, and hence also at art: in terms of causality, historicity, and temporality; and in terms of structure, trans-historically, leaving aside all questions of cause and effect. These two methodologies are reflections of polar human experiences. I can look at art synchronically or diachronically because art has that impact on me. As I review the history of art, I observe that it has that impact on a great many people who are not aware that in their work they vacillate between the two.

The dual relation between art and society also means that it might not be possible to give a satisfactory answer to an old question, namely whether art expresses society or whether it creates or influences society. Art reveals the world view of a tribe, an age, an individual. It is an extremely important datum through which to decipher a culture: Periclean Athens viewed through the forms of classical Greece, the ancient Christian church through the mosaics of Ravenna. But art also exists outside society and even helps shape that society. Certain images influence an age, and these images frequently arise from art, visual as well as verbal. Cubist art is a result of technological trends at the beginning of our century; cubist art also influenced our century remarkably in architecture, in living patterns, in designs. As we examine a certain movement in art, we deal with a phenomenon that is the product of a society and that also transforms society.[57]

We experience a second tension in the phenomenon of art and it is a direct analogue to the duality of religion and anti-religion which we dealt with before. For a very long time, the artistic creations have been paralleled either by protest against such creations, or by alternatives that seem to deny the very character of such art. Since antiquity, there has existed a protest against art, verbal or visual, against the human body, against the representation of myth and mankind. This anti-art existed in ancient Judaism as iconoclastic prohibition, a prohibition which does not make it clear whether all visual art was prohibited, or whether only certain cultic aspects of it were prohibited. But ancient

anti-art also existed in Platonism, in the philosophical critique of the artist. Even in antiquity, such anti-art had religious, social, or philosophical roots.[58]

Anti-art can be a general term for evolutions which did not exactly destroy or prohibit the artistic momentum, but which restricted it or turned it into something very different. For instance, the development from expressing classical beauty (Praxiteles) to expressing the ugly (the drunken woman, a man with a wart on his face) existed in antiquity; the development was surely present at the dawn of the modern world from Daumier and Goya to Van Gogh and Francis Bacon. The art theoreticians from Benedetto Croce to Prall were not of one mind as to whether an esthetic theory could appropriate the ugly as a constitutive element of art. Whether we accept the ugly as an authentic component of art or not, the shift from classical beauty to the painful ugliness of man is part of the history of art. Painting the ugly may not properly be called anti-art; yet when theoreticians like Croce did not accept the ugly into their definitions of art, they were close to experiencing it as anti-art, which for Duchamp was the essence of his work.

It is in the contemporary period, from Picabia to Andy Warhol, in dadaism or in pop art, that anti-art has taken on added impetus. The iconoclastic process seems to have sped up.[59] And yet judging from contemporary documents, iconoclastic trends have long been present from Rembrandt and Goya to Corbusier and Dali. Time tends to smooth the iconoclastic harshness, and we experience as "evolution" and "emergence" what to the contemporaries looked like outright revolution. Anti-art frequently leads to new art, as every visitor to the Philadelphia Art Museum with its Duchamp room can witness.[60]

Anti-art is equivalent to anti-religion in that it reveals the closeness between creative historical forces and their opposites, so to speak, their anti-matter, their negations. To deal with the critique of religion from Amos and Socrates to Jesus and Marcus Aurelius belongs to the daily bread of religious study, and we cannot imagine the history of religion without this constant challenge to cult and faith, without Buddha or Paul trying to come to terms with their religious pasts and running into serious difficulties. In the study of art iconoclasm, change, revolution of style are as daily a problem as in the study of religion, even though the dialectic between matter and anti-matter, between creation and destruction has not led to the same external social conflicts, to the same bloodshed as in the world of religion.

The third issue behind the dilemma of artistic studies lies in the rela-

tionship between *art* and *life*. On the one hand, art belongs to life. We build a house to live in, we decorate the walls of that house. We build a larger house to live in, we decorate the walls of that house. We build a palace, a temple, a fortress, and the history of architecture is on its way. We decorate the larger houses, architraves and metopes, and the history of painting is on its way. We create ritual, music, images in the temple and for the temple and these religious customs form a part of daily life.[61] Art is life.

But the contrary statement can be made: art is not life. Art becomes something else. The statue is an abstraction, magical or symbolic, of the human body, animals or mythical beliefs. From the cycladic figurines to Brancusi, and from the bisons of Lascaux to the deer of Franz Mark, we face conceptual statements *about* life, taken *from* life and not simply decorations or illustrations. Abstraction, reduction, and symbol do not merely serve to decorate, to illustrate, to make living liveable. They are created in distinction from daily life, and from the archaic art of the Greeks to the romantic painters of the nineteenth century, men have never been satisfied with simply rendering what is out there. The simple still life is a reduction, in topic, in object, in space.[62] Whatever statement the work of art makes (and art critics seldom agree on any interpretation), it is conceptualized, concentrated, symbolic.

There is no agreement among philosophers and philosophers of art as to the definition of symbol. Cassirer and Barthes go entirely different ways, the first seeing the symbolic forms as a major body for philosophical investigation, the second seeing them as a code for communication. But Cassirer and Barthes have one thing in common with all interpreters of art: the bronze figure of Mycene is not man himself (even though a magical world view might believe it is), but an interpretation of man, a code, a creation, or a reduction. It may be related to man, it may be his self, his image, his Brahman, his Geist, his double. Whatever the religious, magical, or artistic categories are that go with the figurine, it is not organic life, it is not the tree itself, the bison, the god, the Christ. It is a re-creation.

In regard to social reality, to the physical data around us, art reflects the primal tension in our experience between reality outside and our concept of reality. We paint Apollo, the death of Socrates, *Les Demoiselles d'Avignon;* but it is *our* vision that creates, our choice. Hence art is always a choice, a fragment, a limitation. It is born of discipline and it leads to restriction. Hence one of the primal

structural forces in the creation of art is between the experience of chaos and the response of ordering, of creating space and cosmos. If one thing is behind all of art it is not order and chaos as such but the confluence of the two in one fragment, in one moment, or cut, or space.[63]

The polarities are found everywhere in the world of art as of art criticism. The art world does not agree about the role of beauty in a definition of art: while for some beauty is an indispensable category, for others "art has not, as such, anything to do with beauty," as Eric Gill wrote already forty years ago.[64] The idealistic, Kantian or Platonic categories are countered by engagement, feeling, or experience.[65] The differences are theoretical (between philosophical and concrete principles of criticism) and practical (the difference between illusionist and conceptualist art, built into the very creation of visual art itself). What for Erich Neumann is the result of the creative unconscious is for Callier the result of the creative conscious.[66] These differences are not merely an academic squabble between professors of art history versus professors of philosophy but belong, analogous to the disagreements among people in the field of religion, to the very dynamic of art. It may well be that we must disagree on art, if art reflects, stands over, and takes place within the dynamic of life, if art is a process of "continuous oscillation between opposite poles, between joy and grief, hope and fear, exultation and despair."[67]

It is this world of art in all its ambivalence which I want to juxtapose to that of religion in its ambivalence. As we consider the two chapters together, they exhibit many parallel tendencies, and the parallels could be strengthened in observations from daily life. Everybody knows what art is, of course: a sculpture in the town square, a poem we read in a book, a concert we hear on the radio. Everybody knows what religion is: a Presbyterian church on the corner, a Bible on a bookshelf, a rabbi walking down the street. Religion and art are familiar, common words with which we have operated for centuries. If we played an association game and asked people quickly: what do you associate with art, the associations would come spontaneously: Michelangelo, American Gothic, Guggenheim; similarly if we ask for associations with religion, the symbols would come without reflection: God, the pope, Christmas, Passover.

As we begin to think about these terms, all simplistic notions about art and about religion are quickly dispelled. The ambiguity is not

merely a matter of conceptual thinking, as if all problems would go away if we only returned to the authentic and nonverbal act. The ambiguity is rooted, both in regard to art and in regard to religion, in life itself, in our distancing ourselves from our work, in experiencing and thinking about our history, in operating with memory and freedom. Art and religion share the same ambiguity because they share the same historicity.

Originally it did not seem to be this way. We know that art belonged to religion and was an integral part of religion. From the tales of Genesis to the chants sung in medieval cathedrals with their sandstone portals and stained-glass windows, from beehive tombs and mosques to Hindu temples and Shinto shrines, religion and art appear together. Study the Reformation and you are led to the Huguenot Psalter; study the Counter-Reformation and you discover the Baroque in music, literature, architecture, and painting. Whether we examine Homer, Virgil, Prudentius, Delphi, Amiens, or Westminster Abbey, the study of religion and the study of art intersect.

But we also know that a breach has occurred between art and religion. Men of God forbade their followers to shape graven images. Painters were not allowed to join the early Christian church. Byzantine tyrants would not permit images. The churches of Alcobaça, Fossanova or Fontenaye have no icons. The Quakers and the Mennonites have only a minimum of art in their services.

To this breach I must now turn. I do not intend to restore the union between art and religion and thereby create one more metaphysic that combines esthetic and belief. I accept the relationship and the breach between the two as given by our history, and I shall not propose a kind of *summa* by which the breach can be glued over. If art itself consists of immense inner tensions, of contradictions, ambiguities, and open-ended questions, and if the same can be said about religion, then it would be absurd to force into a conceptual prison what in itself only consists of paradoxes. By eliminating their ambiguities, we might make both concepts meaningless. Instead, I want to recall the history of these two phenomena, follow some early evolutions in which the breach occurred, and examine the reason for and the extent of that breach, both in the matters of the mythical crisis and of the iconoclastic trends. Only after we have understood something about that breach can we proceed to suggest certain avenues of interaction between these two fields.

Chapter 4

The Threat of Art

There shall be no pictures in the churches, lest what is painted on walls might be worshiped and revered.

Canon 36, Council of Elvira

Why did man begin to reject art and when? Was it unease about uncontrollable forces brought to the surface by the endeavor of art? Fear of currents that do not coincide with the laws and moralities of society? Was it simply the power of negative thinking, that devilish joy of wrecking what the fathers had created and adored? Or could it be a matter of power and rebellion, since poets have often been rebels, quiet or vocal, and since artists have for a long time known how to defy, surreptitiously or openly, the arrogance of kings and police?[1]

We open a book on art, *Man and God in Art and Ritual,* an impressive documentation on the use of art in religion.[2] From S. G. Brandon's work we are led to expect art everywhere: religion must be permeated with art; religion must be inducive to art; art must be inducive to religion. But then we come upon a decree such as that of Elvira, canon 36, from the first Christian council from which actual canons have survived—it took place approximately in the year 309 in Spain—and we realize that art is *not* identical with religion, at least not in southern Spain in the ancient Christian church. A great deal of art from ancient Christianity has survived; a canon against art has also survived.

The canon, to be sure, is ambiguous. When we begin to deal with art we are bound to encounter ambiguity. We do not know if *all* pictures were banned summarily; if only those were rejected that were inducive to idolatry; if the canonic decision was to be taken at face

value or merely as vague advice, since it contains no punishment (as do other canons) in case of disobedience; if the decision is indicative only for the Iberian Peninsula or met with wider approval.³

But one thing is clear, beyond doubt: canon 36 of Elvira reveals that some leader of the ancient church felt hostile toward frescoes or mosaics in the church. The canon thereby establishes the presence of an anti-iconic trend in the midst of the ancient Christian religion. This trend is not unique to ancient Spanish Christianity. We find it in Judaism whose famous commandment against graven images was the foundation for all future aniconic and anti-iconic movements in Western religions, although, exactly as in Christianity, many synagogues have been found in which pictures were certainly acceptable.⁴ We find it in the North African Tertullian who wrote a vituperative pamphlet against visual art.⁵ We find it later in the bitter controversies of the Byzantine church, but we also find it prior to Christianity in classical antiquity.⁶ The Cistercian movement in medieval Catholicism built abbeys and cathedrals, Alcobaca in Portugal and Fontenaye in Burgundy, without any pictorial art.

Iconoclasm returned with full force in the Continental and British Reformation as well as in the French Revolution when stained-glass windows and Gothic sculptures were smashed by the mob of Europe.⁷ Reformed, Unitarian, Amish, and Quaker sanctuaries witness to the long-lasting efforts of radical aniconic architecture: no ornament, no picture, and hardly any color can be found in the stark Arch Street Meeting House of Philadelphia. The prohibition of figurative art in orthodox Islam broadens the scope of such trends beyond the confines of Judaism and Christianity.⁸

Why did man begin to turn against figurative art? I present a number of considerations on the origins of iconoclasm from Hebrew literature and its Christian followers. We do not know if the Second Commandment is the beginning of aniconic religion or merely one, possibly late, link in a chain of prehistoric religious developments; we can show, however, that the origin of that hatred toward images is closely related to certain steps in the emergence of historical religion.

I

The locus classicus for aniconic faith is, of course, the famous commandment: "Thou shalt not make any graven image!" It was the battle cry for the fanatics of the sixteenth century as they mauled medieval

sandstone sculptures into rubble. To argue the iconoclastic issue from that single commandment presents considerable obstacles: we are limited to one text that served as one of ten basic demands, establishing the social and ethical life of Old Israel. But numerous historical and exegetical problems have come up:[9] Is the text of the commandment Mosaic? Did it mean a prohibition of images or only a prohibition of the worship of images? The second option differs remarkably from the first and would change our view of the old-Israelite attitude toward art. Are there two parts to the commandment — (a) the prohibition of images (thou shall not make any graven images) and (b) the prohibition of the worship of images — and is that distinction a result of historical evolution from a rigorous to a moderate position? Is the text as it stands a compromise or a revision of earlier versions? Who demanded the prohibition and, above all, *who obeyed it*?

Instead of presenting an exposition on the Second Commandment, I suggest that we place the iconic problematic of Old Israel into a larger framework, combining art, cult, and ethic as structural components of a cultural conflict. Whatever the Second Commandment "really" meant to the first oral carriers, to the redactors, to the later generations which quoted it, it was part of an eight-hundred-year religious and cultural struggle between Yahwism, the religion of the Hebrews, and Baalism, the religion of the Canaanites whom the Hebrews conquered. The polemic against visual art is intertwined with a polemic against the cult, against sanctuaries, statues, folk traditions. These issues belong to a polarization which goes through the entire corpus of writings from Genesis to the Song of Songs.

We can distinguish between positive and negative codes. The first includes statements that accept art, ritual, temple, icon, image. The second rejects them. In the second group we find not only passages that warn against or are hostile toward images, ritual, cult, jewelry, but that also express the superiority of ethic, obedience, justice, or idea over the traditions of cult, ritual, or art. Below are a few examples of these two categories in abbreviated form.

+	—
the brazen serpent of the desert saves the people (Num. 21:8)	the golden calf is the epitome of idolatry (Exod. 32)
	"men kiss calves" scoffs Hosea, (Hos. 13:2)

the artist Bezalel (Exod. 31:1ff.)

there were images in Gilgal (Judg. 3:19)
an image protected the tribe, in the days of the old Micah (Judg. 18:24)
Rachel stole a teraphim [and there was nothing wrong with her having that teraphim] (Gen. 31:19)
Teraphim protected the people (1 Sam. 19:13)

Masseboth are taken for granted (Gen. 28:18)

Abraham builds an altar (Gen. 22:9)
Elijah builds an altar (1 Kings 18:30ff.)

Solomon will build a house for God (1 Kings 5:5ff.)
it is sanctified by God (9:3)
it will stand forever (8:13)

"you shall not make a carved image" (Exod. 20:4)
with their silver and gold, people made idols for their destruction (Hos. 8:4)

Teraphim were wrong (Ezek. 21:26, Hos. 3:4)
Asherim were evil (1 Kings 15:23)
must be cut down (Judg. 6:25)
burnt (1 Kings 15:13)
Masseboth are wicked (1 Kings 14:23)
the limbs of the Philistine god Dagon lie outside his temple (1 Sam. 5:1ff.)

altars will be destroyed (1 Kings 13:3)
tear down their altars! (Deut. 12:3)
God stands at the altar with the hammer in his hand (Amos 9:1)

God will destroy the temple (1 Kings 9:7)

the temple mountain shall become a forest (Mic. 3:12)

there are cherubs in the temple (1 Kings 6:23ff.)
they are protecting the people (1 Kings 8:7)
there are vessels, lions, stones, a sea (1 Kings 7:1ff.)
Isaiah sees a seraph in the temple (Is. 6:6)

the image is false (Jer. 10:14)
through their carved images, people make God angry (Jer. 8:19)
people will throw away their idols of silver and gold (Is. 2:20)

lift your hands toward the sanctuary and praise God (Psalm 134:2)
only in one place shall sacrifices take place (Deut. 12:14)
the blood of animals shall be poured out (Lev. 3:16ff.)

God has enough of burnt offerings, he takes no delight in the blood of bulls (Is. 1:11)
God wants love, not sacrifice (Hos. 6:6)

Nehemiah asks for credit for his services done to the house of God (Neh. 13:14)
the synagogue of Dura Europos has extensive frescoes

"and God saw that it was good" (Gen. 1:10)

and God "was sorry that he had made man on earth" (Gen. 6:6)
the vision of a destroyed earth (Jer. 4:23)
God chased man out of the garden (Gen. 3:23)
I shall write my law into their hearts (Jer. 31:33)

God put man into the garden (Gen. 2:15)
the vision of a new temple (Ezek. 40ff.)

The evidence is stunning. There existed throughout the entire Hebrew literature two streams: one pro-iconic and pro-ritualistic, and the other anti-iconic, aniconic and anti-ritualistic. The problem of art and the problem of cult may not be identical and in our contemporary world are separated into two distinct spheres and study; in Ancient Israel the two existed side by side.

II

Iconoclasm in its broadest form belongs to a widespread aggressiveness of human behavior. Conquerors have always mutilated the art of the conquered.[10] To destroy an enemy is to destroy his gods; to destroy the image of these gods is to drive the victory home. One aspect of that savage need to humiliate and destroy is the rape of women practiced in most wars.

Samson wrecked the house of the Philistines with all the Philistines in it: it does not matter whether that tale is historically accurate or a legend. The Greeks went out to deface Troy. The Christians in their long rise to power spoiled Mithraic sanctuaries, Celtic temples, the art of the Maya, the culture of Peru. When the Muslims entered India, they ruined the Hindu temples in what is now Pakistan.

Iconoclasm is rooted in that primal destructive desire in which we want to eliminate from the earth that which threatens us. In my preface I mentioned the episode from many years ago when a group from a Protestant youth organization broke into their church and mutilated the recently found frescoes from medieval times.

The Hebrew texts indicate that the iconic problem is not simply the result of such destructive desires, but that the problem arises when we become aware that art is a problem in our own midst, when the dance of the tribe around the golden calf becomes a nightmare.

III

Two paradigms stand out in the biblical documentation:

+	—
the *Brazen Serpent* is made at the commandment of God, and if people look at it they are saved	the *Golden Calf* is a product of unbelief, and the people are punished for making and worshiping it

The story of the golden calf is the locus classicus for aniconic faith, for the social protest against wealth, for the primacy of ethics over ritual, for a religion of law and revelation over a religion of nature and fertility. That story does not belong where the tradition finally put it: it has no place in the desert. The calf is not the symbol for nomadic tribes, it could not survive on Mt. Sinai.

Instead, the calf belongs to Canaan. It is an agricultural symbol and belongs to the world of fertility and hence of Baal. It is exceedingly important to place the origin of the iconic conflict into proper historical perspective in order to see the ramifications for the future of Western religions. The nomadic tribes of the desert needed no such symbol: their art had been the tent, the ark, the tablets of the Law.[11] The golden calf is a fertility symbol of the land in which the nomadic tribes arrived after breaking out of the desert world. The conflict around the golden calf is a struggle within Hebrew culture in the promised land. The Hebrews made that calf, even in that story, and not the Canaanites! The conflicts of art arise from *within* a culture.

The story of the golden calf also gives clear indications about social aspects of that original conflict. The *people* made the calf, and *Moses* smashed the tablets. From the outset, the iconic tension is connected with leadership struggles, with social control. The prohibition of images was a powerful tool in the hand of the victorious nomadic leadership over the conquered Canaanite population, and of the tribal leadership over its own people. To take away the icon from a world in which figurative art, cultic and political, had belonged to the daily life for millennia was an effective club for the elite, an ascetic *tour de force* like commands to abstain from alcohol, meat, or sex.[12]

We also notice that from the outset the prohibition of art leads to violence. Moses smashed his tablets. The golden calf was destroyed. Josiah ruined the brazen serpent. Anti-iconic violence returned time and time again in history when the Spaniards eliminated South-American art, and when the Soviet Union used a bulldozer to terminate a show on avant-garde painting. It is a shock to an art lover to realize that the issue of art leads so easily to violence, a violence that arises from political and psychological tensions but that is also a direct reaction to the thrust of artistic communication itself. Art invites response, art challenges, and challenge and response can bring about violence.

The tale about the brazen serpent is also old in origin, and may also

have come from Canaanite circles, since the snake has always been a symbol of fertility cultures. Like the story of the golden calf it is placed back in the desert at the time of the Hebrews' nomadic journeys. Hence like the tale of the golden calf it represents a code of the distant past for the subsequent use of the later tribes. The golden calf and the brazen serpent represent the iconic problematic of mankind par excellence.[13] In one, the creation of the icon is condemned, in the other it is approved. In one, the idol seduces, in the other, it saves. In both stories, Moses is the leading figure, advocating the making of the idol, and damning its creation himself. Both stories appeal to Yahweh for justification. The Christian church inherited both sides of that polarity: the iconoclastic violence in its battle with classical paganism (the council of Elvira tells us that people broke into pagan sanctuaries to wreck sculptures[14]) and the story of the brazen serpent which became an Old Testament prototype for Christ![15]

The documentation on this ancient polarity between pro-iconic and anti-iconic tendencies gives us a lesson in methodology on art. The Hebrew Scriptures do not tell us the whole story, and neither does the ancient Christian church. The Pentateuch, for instance, gives us the impression that the Canaanite influence, which was symbolized by that tale of the calf, was only a matter of a short while after the Hebrew invasions, when in fact that influence was still bitterly contested hundreds of years later. The calves were indeed still around in the eighth century, in the time of Hosea and Amos, and the Deuteronomic polemic tells us that the problem was not solved a century later.[16] Ancient Israel did not solve, to the very end of its history, its iconic dilemma.

What happened to Ancient Israel repeated itself in Judaism. Dura Europos and Galilee have art in their synagogues. In our days, Jewish artists have produced extremely important art: Chaim Soutine, Marc Chagall, and Paula Modersohn-Becker. As I shall show in a later chapter, Christianity did not solve its iconic problematic either.

As we enter deeper into the iconoclastic problematic, we always meet violence and ambiguity. Both are direct results of the fact that the iconic problem in ancient Hebrew culture was connected on one hand with the issue of God and on the other with that of man and woman.

Yahweh was a male God. The excavations at Ebla, we are told, seem to indicate that a millennium before the Hebrews' arrival in Canaan, "Ya" had a consort; in historical times, he was certainly

always alone and allowed no other gods beside him. This uniqueness distinguishes him from his great rival, Baal, whose partner was Astarte. Why was it that Yahweh, different from Zeus and Marduk, allowed no graven image to be made? We have pointed to the nomadic culture whose tribesmen could not have carried sculptures on their constant journeys, but this argument does not fully explain the aniconic stance; the Berbers have not created sculptures but they have created fascinating woven material. The nomadic explanation alone does not suffice.

Yahweh does not allow himself to be touched. The theophany at the burning bush has dramatic and even sensual elements, the mysterious fire, the man standing barefoot on the scorching soil. But Moses does not see God, he cannot touch that bush, he only hears a voice. Elijah hears a voice of silence centuries later and again on a mountain; he too does not touch. He who does not allow himself to be touched wants no touchable image. There shall be no icon between Yahweh and man.

Figurative art, especially sculpture, has a sensual character. As a young student I was taken through the Naples Museum by a vivacious, knowledgeable Italian guide who made me touch the bronzes in order to feel the extraordinary character of Greek sculpture. We experience texture, the bronze of Poseidon, the gold of a Mycenaean bracelet, the colored wall of a Pompeian house. Shape and color have a sensuality of their own. I receive the impact of the blue and red of the marble of a statue whether or not someone tells me what blue or red or marble "ought" to mean. I can love a painting even if someone tells me I should not love it, even Manet's *Le Déjeuner sur l'herbe,* which the judges of the Paris Salon did not want to be loved by the Parisian world. As we all know, the judges lost.

But why should man not love *Le Déjeuner sur l'herbe*? For precisely the same reasons that the Second Commandment prohibits graven images. The image has a chance of being appreciated outside any tribal control. Czars and bishops and professors have always fallen into the original trap, trying to tell people what is acceptable and what is not. But art can work despite and beyond social strictures. To be sure, "taste" in some ways can be learned;[17] educational control shapes judgment. But the opposite can be the case: art is a tool for revolt and we love what we should not love. We dislike what we should appreciate. Art is one of the creative forces that can remain free from manipulation.

But not only does art have this potential independence; it receives its freedom because of its primal connection with the human element. Ever since the earliest remains of art, the creativity of our species has been centering not only on the world around us, bisons and oxen and stars, but on man himself. Art deals with man and woman whether in illustrative or conceptual processes. The deity on Mt. Sinai who rejects the graven image—is male. He is exclusively masculine. Many generations later theologians and mystics have downplayed the masculine character of this God and have put him beyond the male-female polarization in favor of a neutral, transcendent "it," a "beyond." The original God of the Torah is not neutral. It would never occur to any reader of sound mind going through Exodus that this God could even possibly be a woman, that the God who fought with Pharaoh, who gave the *lex talionis*, who helped Israel conquer the land from the Canaanites, could be female. It could very well occur to him, before he is trained by Pseudo-Dionysian sophistication, that he is male. Yahweh is a king and not a queen.[18]

IV

A great deal has been written lately on the masculinity of the biblical God and the problems this poses for modern society. I am not about to repeat clichés about polarizations in which the male is all rational and untouchable and the female *eo ipso* sensual, artistic, and idolatrous. After all, neither Zeus nor Baal would fit such categories. The fact is—Yahweh does not allow physical interaction. He invites verbal response, he demands obedience, he promises and loves by promising, but he does not act within any partnership of man to woman. The woman is broken off the natural female-male symbolic cycle, she has no symbol. In turn, the man is broken off that cycle. At the heart of the iconic tension lies the conflict between patriarchal culture and human nature. The two came to a clash in ancient Canaan and have in numerous religions, tribes, and cultures ever since. The threat of figurative art arises from the bitter tension battled out in the Canaanite-Israelite world, between two competing religious and cultural trends: in one, religion was a canopy for a patriarchal nomadic society; in the other, religion was the canopy for an agricultural society. But what the members of the first really feared from those of the second was the collapse of their patriarchal, social, and theological schemes. All we have to do is read the Book of Hosea for a

moving, angry, and often desperate poetic revelation of this impasse.[19]

Art is a spontaneous act. Art is also, at least in many instances, a passionate, sensual phenomenon, in all its ascetic intensity. Figurative art deals with man and woman, birth and death, love and fertility and individuality. A religion that has a strong sexual control over its members is bound to be terrified by the icon. The sculpture that invites to be touched becomes a threat to a society that needs to keep its men—and its women—at a distance. It does not suffice to point simply to the fact that a nomadic culture with its exceedingly precarious survival system would be especially leery of accepting spontaneity and freedom: there have been cases in agricultural, urban, ancient as well as modern settings, where the same terror of visual art, the fear of the human face mirrored in iconic representation, was present to men who desperately sought to safeguard their masculine autonomy.

The sexual hatred of mankind has, of course, many other aspects with which we do not need to deal in this context. But it is astonishing how often iconoclastic expression reveals such hatred. The word "whore" comes to relieve the threatened male. We see in museums countless ancient sculptures from which the penis has been chiselled off. The hatred of the nude, in painting, sculpture and, more recently, in photography, is widespread. Certain aspects of the feminist polemic, tragically, seem to me like the old Sinaitic iconoclastic hatred of the body in reverse. Many of the protests against what is called "sexual exploitation" of the woman exhibit tendencies reminiscent of the anti-feminism in *The Scarlet Letter,* and just as the Christians would not allow Apollo and Venus to be shown naked anymore, the new iconoclasts would like to close down Playboy Magazine for its centerfold, whatever artistic value that photograph might or might not have. As the old masculine assertion against art had personal and political ramifications, so does its feminist successor, on the personal side the valuable attempt to define one's body as sacred, the desire to safeguard the sanctity of the person, on the political side the emergence of the woman as a new economic and social force in society. Once more the relation between iconoclasm and politics is established.

It has been pointed out that biblical texts did have female symbols, the land and Israel and later on the ecclesia, the virgin and the mother.

Indeed, Yahweh loved the land and his people dearly. In the tortured world of Hosea, there is even a love between Yahweh and a virgin. But the virgin is never a goddess. The Christians became aware of that lack and introduced more explicit female imagery, but even their Mary was not a goddess. Theologians have always made it clear that she is *not* the partner of God, she is neither his lover nor his equal. As virgin or as mother, as queen or as suffering woman, she is—once more—kept at a distance. The patriarchal structure did not allow a full mythic symbolization for two thousand more years to come. Thou shalt not make a graven image: could it be that in all its transmutations the icon kept threatening man in his patriarchal cradle?

We cannot separate art from our politics and from our fears.

V

Man feels ambivalent toward the art "he should not have." Do not make graven images . . . and he is attracted to these graven images. The tablets of the law must suffice, the laws must suffice, all we need in life is to live decently and act as ethical persons—how many a Christian has repeated the commandments as he tried to follow that law. But the tablets did not suffice. Man needs a symbol. In the temple of Jerusalem were seraphim. There were cherubim in the image world of Judaism and Christianity. While theoreticians in the classrooms declare the end of the symbolic age, the industrial world around us creates new symbols daily.

An excellent example for the dual attitude toward the iconic and symbolic dynamic is to be found in the person of Isaiah. In powerful imagery he attacked the cult of his people (1:10ff.). For hundreds of years his prophetic predecessors had done the same. And what does Isaiah do? He gives us one of the most stunning visual images of initiation (6:1ff.) in a temple that has often been the target of prophetic rage. The hands of the people are full of blood, but now his lips are cleansed by an imaginary drama. The cultic event becomes a drama of visionary poetry. The cult is wrong, and the cult cleansed the prophet. The difference between the cult of Bethel, so bitterly blasted by Amos, and the cultic scene of Isaiah, experienced and retold in poetic imagination, is not only the difference between Yahweh and Baal, between injustice and ethical passion. The prophet fights against the cult and experiences the cultic fascination in his own transformation. The social conflict is resolved in the ambiguity of art.

Isaiah does not stand alone. Here is the Book of Leviticus, with its Passover, Sukkoth, the Day of Judgment; and there the anti-sacrificial protest. When the modern interpreter answers that the prophets do not really turn against cult, only against "false cults," I do not believe their explanations for an instant. There is a real anger against the ritual in Hosea ("men kiss calves"), and the texts show clearly how desperate the prophet was in his rage. Jeremiah was driven by tensions he could hardly manage: "Woe me, my mother, that you gave birth to me!" The tension between cult and justice in Amos and Hosea, in Isaiah and Jeremiah, is horribly real. Amos was thrown out of Bethel. Hosea almost went insane. Jeremiah was an outcast from his people. For the modern, well-adjusted intellectual, the tension between cult and justice is part of a structural "given" we have learned to accept long ago. For the prophets, the issue was exceedingly bitter. If we want to experience the kind of tension present in these people we might translate the issue into contemporary conflicts on art, and professors, rabbis, and preachers would wake up quickly: paint Yahweh in the nude again? To paint Allah with a consort? To shape God, as Germaine Richier has done in her powerful bronze Christ at Assy, in actual despair? Perhaps the bishop of Grenoble who wanted to throw Richier's bronze out of the Assy church was closer to the prophetic agony than we thought at the time.

The ambiguity of religion: God demands the building of a temple, and God destroys that temple. God arranges for a garden, and he drives out the people for whom he made that garden. Rachel steals a teraphim happily, and Jeremiah slanders women for wearing jewels. The Book of Leviticus offers a whole scheme of sacrifices, and the Christian preacher demands obedience instead. Man created the ritual and turned against it. Man created art and wrecked it.

The people made a calf of gold and destroyed it. Yahweh loved Israel and punished her. At the heart of the iconoclastic dilemma lies the ambiguity of humanity.[20]

VI

The threat of art received perhaps its most incisive metaphors in the prophetic polemic of Old Israel. "Come to Bethel—and rebel! Come to Gilgal—and rebel the more! Bring your sacrifices for the morning, your tithes within three days." The famous words of Amos were a bitter accusation against the cult of Bethel and Gilgal, a social and

political protest against the royal house of Northern Israel. The protest, as we pointed out, was not new: Baalism had been pro-iconic and Yahweh anti-iconic for centuries, and the clash between the two religious factions had been simmering off and on. What is significant is the fact that in the prophetic world that conflict led to a new form of art. The passion for justice, the anger against those who—

flay men alive and tear the very flesh from their bones (Mic. 3:2).

became art. The prophetic unit contains all the components of art: imagery, concentration, enigmatic dictum, passion and ambiguity—

> Does a lion roar in the forest
> if he has no prey? (Amos 3:4).

The prophet created a rich metaphoric world of collapsing altars, of a plumbline in the hand of Yahweh, of Basan's cows and fruit baskets. But he also created, as we shall discuss in the next chapter, heartbreaking units of personal agony—

Alas, alas, my mother, that you ever gave me birth!
a man doomed to strife, with the whole world against me (Jer. 15:10).

What is behind this art? It is, strangely enough, a threat of religion against itself. What the prophets fear is what Paul Bellah and Martin Marty are writing about: civic religion! The prophets create art protesting this civic kind of art, the ritual, the calves of the temples. The units of the prophets are art that has been broken off from its tribal connections, the product of individuals who shape their social protests in new language. The prophets hate Baal's cult. One could make a sound case, that the ritual at the famous old sanctuaries, at the Canterburys and Vaticans and the First Presbyterian churches of Old Israel played an important role in that society. The cult was meaningful to the people and played a cathartic role for them.

It was not meaningful for the prophetic community. Their catharsis is to be found in a poetic rhythm of language, in the metaphoric world they created themselves—

> O Jerusalem, cut off your hair,
> the symbol of your dedication, and throw it away;

raise up a lament on the high bare places.
For the Lord has spurned the genera-
tion which has roused his wrath, and
has abandoned them. (Jer. 7:29).

The prophets were angry. Their protests drove them into that monumental change that became so important for modern society: no longer did they participate in the collective ritual, but they created instead their own rhythm, their own prayers, half-conscious, polemical and lyrical at the same time. Art was no longer an expression of the culture, it was in conflict with culture.

The conflict between artist and society had broken out. One may point out that the prophets did not fight primarily with figurative but with liturgical art. They fought primarily those "who lie in bed planning evil and wicked deeds" (Mic. 2:1). But the connections with visual art are clearly there. The sculpture belongs to the ritual. The cult is a visual form of social expression. "The idols of Egypt quail before him," cries out Isaiah (19:1). People should not go to Bethel and Gilgal but "resort to the Lord" (Amos 5:6). The protest against the cult touched implicitly or explicitly the existence of visual art. All the way down to the Protestants and the Puritans the prophetic anger against the cultic opiate would sound loud and shrill.

But the prophets who protested so vehemently against ritualistic Baalism could not do without the visual themselves. They created a visual cosmos of their own, a verbal realm of two-line or four-line stanzas in rhythmic parallelism, of parables and visions—

the sun shall go down on the prophets,
the day itself shall be black above them (Mic. 3:6).

the polemic against cult and king leads to an art that exists in words alone: trumpets blow toward the cities (Amos 3:6), God lays waste the gardens (4:9). No more cultic deeds, only cultic imagination. The prophets, in fact, became the drama themselves: Hosea's marriage to the whore, Amos thrown out of Bethel, Jeremiah thrown into the cistern. The ritual is rejected, only to be reenacted either by words or by the individual himself.

The move to the art of words alone demanded a serious price. The prophets became outcasts, they suffered greatly, and they were driven at times to loneliness and even despair.

It would be a mistake, of course, to assume that the prophets acted merely as lone individuals. Ever since the age of Saul, prophets had appeared together in bands, dancing and singing. The cult against which the scriptural prophets rage had existed, in different forms, in their own group. They represented a pro-Yahwistic tradition which itself had a rich cultic past. The protest against the fertility cult of Baal was therefore made from a traditional perspective. But the prophets did not oppose one cult to another, and this is what makes their stance so significant. They did not say, "Get out of Bethel and celebrate Passover instead!" They did not, as Deuteronomy would do later, demand that the many sanctuaries in the land close and be replaced by a valid Yahwistic sanctuary. The great prophetic poets from Micah to Jeremiah replaced ritualistic art with art, but with their own art, and that art was no longer cultic in the public sense. It was an art of the word.

We are examining today in many sectors of the academy, as well as in churches, synagogues, and medical groups the healing rituals of primitive tribes, the use of art in therapy, the cathartic aspects of ritual and drama, the need to express ourselves in motion, dance, and *gestus*. These tendencies go through a wide spectrum of religious and secular circles and transcend denominational boundaries. The protests against these tendencies are arising with their impact: are the churches and synagogues which cultivate healing and the groups which experiment with personal growth the nemesis of society or its supporters? It may be helpful to point out that these conflicts go back to the prophetic polemic of the Hebrew scriptures. As we listen to such debates in the National Council of Churches, and in the universities between departments of sociology and the institutes of mental health, we realize that the cultic threat to Amos and the polemic with which Amos wrote his counter-art, have not disappeared.

Is it the job of religion to change society or to heal mankind? Almost everybody will reply that the two cannot be separated. As we begin to inquire into the two tasks, the separation, alas, comes sooner than we like.

VII

It may be instructive to place a contemporary counterpart beside the prophetic experience, Ntange Shange's *For Colored Girls Who Have Considered Suicide When the Rainbow Is Enuf*. The prophetic art was

born of a violent attack against the fertility religion, by individuals in search of a male experience. Shange's poetry on the Broadway stage expresses a modern woman's experience. Hosea had married a whore; the heroine in Shange's poetry is surrounded by men who are traitors, even criminals, and who leave her ultimately in the lurch. She is left as alone as Jeremiah and finds her identity in the final spiritual which sounds like the female counterpart of ancient Hebrew male poetry: "I found God in myself and I loved her fiercely."

What is significant in this juxtaposition is the radical reversal of personal experience together with an extraordinary parallelism of intent and poetic impact. Shange has only women on the stage who quote poetry and who dance. The men are talked about as something outside. The prophets are highly polemical about women, the cows of Basan, wearing gems. In fact they very quickly call disbelief adultery and slander Israel as a whore. For Shange, men are highly problematic, while for the prophets women were highly problematic.

In this reversal, the dance returns, the colors of visual experience. The verbal and the visual are joined again. The poetic lines are part of the rainbow. While the transformation from the old cultic experience into the agonizing experience of prophetic protest led to verbal genius, the reaffirmation of the woman's experience led to a re-creation of the gestus. In Shange, the uniqueness, the idolatry of the word is broken the way the idolatry of the cult was broken by Amos.

What remains constant is the sexual alienation, the feeling in the human individual of being left alone in a self-destructive earth, the necessity of determining in the agony of one's personal hell one's metaphor in life. What has remained constant in that metaphor is the verbal asceticism, poetry as autogenous cosmos in which the individual can breathe again, the limning of an autonomous sphere within a world that keeps crashing in. What is not constant is the acceptance of the body in Shange's dance, the return to the motion as an authentic expression of the self. What Shange offers is actually a cultic re-creation of personal experience in a duality of vision and act, but no longer in any original cultic framework; she resembles Amos in that she does not opt for a Baptist or Muslim ritual. She cries like Amos, she sings like Amos, perhaps more lyrically but with equal bitterness at times. She continues the rage and poetry of social iconoclasm. She also ignores men on stage the way Amos ignored women as authentic partners in historical interaction. And the prophetic protest is reincorporated into drama.

VIII

Christianity also contains two trends, one iconic and the other anti-iconic.[21] On the anti-iconic side the most telling ancient monograph is Tertullian's polemic against idolatry which contains contemptuous sentences about artists: he asks them to change their profession if they want to become Christians.[22] Canon 36 of Elvira, with which I opened this chapter, is unmistakable in its anti-iconic impetus; and shortly after Elvira, Eusebius refused to send the Emperor Constantine a picture of Christ. Through the entire Middle Ages Saint Sebastian was celebrated for entering pagan buildings and wrecking idols. Many Christians not only did not accept images of pagan gods; they did not want images of any kind.

But of course the Christians had art, the basilica as a Christian sanctuary, mosaics on the apse of these basilicas, pictures on their walls. The bishops would not have needed to prohibit the pictures if some Christians in Spain had not wanted them. The sculptures stand, to this day, in classical museums, in the Vatican and in the Louvre, in Cleveland, and in the Forum Romanum.[23] Some may go back to the second century, many certainly go back to the third.

These exist two Christian streams:

X	Y
there shall *not be* any pictures in churches	there *were* pictures in churches, mosaics, sculptures, ivories

The question is not, "Which of these two represents the mainstream of Christianity?" The question is, "What is the relation between the two streams?" We cannot apply quantitative measures to ancient culture. Furthermore, the surviving evidence is often highly suspect since the post-Nicene church condemned with the *damnatio memoriae* much that did not fit into its scheme. Just as in the case of textual evidence, there exists a considerable element of chance in regard to surviving works of art. We cannot ask, "How many people liked art, and how many people were opposed to it?"

We know that the Christian church inherited the dilemma from Judaism and to a lesser degree from intellectual Hellenistic culture.[24] But a problem is not solved by pointing to predecessors. We can iden-

tify theological as well as social polarities within the iconic dilemma of the Christian church itself, without the need to trace each of them back to specific Greek, Roman, or Judaic roots. For instance, a primal theological duality ran through the entire ancient church, a duality that has direct bearing on the problem of art:

X^1	Y^1
God is one, invisible, unchangeable, eternal[25]	God became man, he acted, he suffered, he was seen[26]

There were two codes about God in the ancient church, one of a faraway, transcendent, invisible, the other of an incarnate, historical, human God. The transcendent God has no shape while the God who became man would bring about a new creation and thereby allow manifestation, translation, and concretion. It is of course the second code which encouraged iconic art. Christ was shaped in human form, the Good Shepherd, Jonah, Orpheus, Apollo, the Teacher, the Pantocrator. The structural polarities in New Testament metaphoric language returned in patristic visual imagery: Christ as the Judge and Christ as the Lamb, as baptized young man and as mature teacher, raising Lazarus, and giving the law.[27]

While the theologians were fighting about *theos* and *logos,* the artists modeled and remodeled the God who became man.[28] The more the theologians forced the biblical and early Christian material into a consistent (or what seemed to them consistent) theology, the more did the sculptors and painters of the church (and the pagan executors of Christian models) present pluralistic christological images, not always consistent with the texts (only in the course of the fourth century is a representation of the Crucifixion found), and not really illustrating what the theologians decided. Only after Ephesus (as reflected in Santa Maria Maggiore) can we begin to detect an influence of dogma on the painters, an influence growing strongly with the following centuries in the Eastern part of the church. In its formative stage the art about Christ is not an illustration of dogma but a spontaneous creation.

Even when early Christian painting took the abstract road, it was not abstract in a theological sense. It could not be: how could one really express the transcendent God by an abstract design? The glorious sky in the mausoleum of Galla Placidia is not a rational statement

about the eternal first person of the Trinity, but a vision that draws us into such eternity, encloses us, opens a view of eternal heaven, the dome of night.[29] In retrospect, one might speculate that such a vista is an interpretation of or an analogy to what the theologians meant in the affirmation of the First Article of the creed. But the vista is not declaratory, illustrative, explanatory, it is simply there. It opens up. The visual abstraction is distinct from the verbal abstraction in that an entirely different process of expression is at work. In the theological abstraction we clarify, we reduce, we balance, we weigh. In the visual abstraction, we turn silent. Whatever words are used under the dome of Galla Placidia's tomb come out of us as our response. In a strange way, the visual abstraction is closer to the transcendent God than the verbal statements trying to formulate it.

In order to confront the iconic complexity of ancient Christianity with its theological currents, one could also turn to the scriptural problematic which, throughout its entire history, created immense discord:

X^2	Y^2
truth is revelation, *written* in the scriptural text	our salvation lies in *action*, baptism, coming together, eucharistic event, actions of love
this truth is all there, once and forever, and no revelation is needed[30]	the Spirit will come and teach us the truth[31]

The scriptural problem is both one of historical uniqueness versus historical dynamic, and one of verbal uniqueness versus verbal limitation. Hence, on one hand, the duality of thinking and doing, of intellectual and social reality; on the other, the tension between repeating and translating, a tension that has touched every religion from Judaism to Buddhism. Christian writers have often claimed that the two need not be in tension but belong to the center of Christian faith, and theoretically (structurally!) such might well be the case. In actuality, it has always been hard to combine the two sides because a given age is confronted with painful alternatives. In third-century Carthage, for instance, as Rome launched its first full-fledged persecution against

the Christian church, Christians fought with extreme bitterness for an authentic "Christian" stance. What was now the relationship between scriptural truth and the "truth" represented by competing North-African groups, each claiming authenticity and guidance by the "Spirit"?[32] Was scripture on the side of Berber circles, in the episocopal camp, in any of the compromising Roman groups, or in the stance of the martyrs? Structuralism is of no great help before the Roman inquisition.

Visual art as well as poetry or film offer prime examples of the hermeneutic impasse. Until the nineteenth century, when historical tendencies arose, artists did not do much research on first-century clothes, customs, or weapons. The Good Shepherd was a Graeco-Roman model, Jonah was a Hellenistic-Jewish model. From century to century, the shepherd and Jonah changed their clothes. Byzantine art finally had established iconic codes, Jordan and John the Baptist and Jesus for the baptismal scene.[33] Such historical patterns emerged throughout ancient Christian history, Jesus passing the law, Moses hitting the rock, the three men in the fiery furnace. But the ancient church also left us splendid examples of spontaneous translations, the *stylite* climbing his ladder in the Dahlem Museum of Berlin, the *Christus Medicus* in Timgad, the churches of Santa Costanza and Aquileia, the iconic twilight zone of the Domitilla catacombs, the earliest illuminations.

One of the roots to the iconic problem of Christianity lies in the apologetic impasse which can be observed through practically the entire literature before Constantine, in intellectual as well as social history.

$$X^3 \qquad\qquad\qquad Y^3$$

we are unique, the Christians said to the pagans, and not like you[34]	we are like you, the Christians said, we have what you have, only much better[35]

The first wing of this dual code is aggressive. The Christians rejected the pagan world, the demons and idols and temples. They polemicized against pagan philosophers and meant to destroy the imperial idols.

They saw themselves as a new race, distinct from the pagans, and some were killed for their convictions. But the second wing of that code was irenic. The apologists meant to build a bridge, Paul had given a tolerant speech in the tradition of Acts to the Athenians, and Augustine would proudly compare pagan and Christian martyrs. The Christians pleaded for both, their identity distinct from and their ties with their pagan contemporaries, and while at times the two wings could be socially identified (here the aggressive martyrs who defied the Romans to the point of death, there the collaborators who saw nothing wrong with sacrifices); most of the time such a distinction cannot be made because the individual Christian, beginning with Paul, would vacillate between irenic and militant attitudes towards his contemporaries.

In visual art, this polarity is present everywhere. The Christians fought the pagan religions; but here stands before us, in the Dahlem Museum of Berlin, an Isis statue with her Horus child, exactly as in countless parallels, Mary holds Jesus. Visual art reminds us of the Christians' extraordinary ties with precisely the forces they claimed to have overcome, the pagan religions. Sometimes the words give away what we do not mean to acknowledge; at other times the image does the same. The early Church gives us excellent iconic examples of its cultural ties with paganism: the Good Shepherd, the cross, the anchor, the fish, the boat, the teacher.[36] The iconographic world cannot, at the formative stage, be clearly separated into Christian and pagan avenues.

As time went on, as a "Christian art" was developing, control was slowly established over the iconic directions. At the formative stage, this control did not operate. The bishops of Spain had no code from which they could determine what was allowable and what was not in the confines of their religion which demanded a definition so rigorously. Neither did the bishops dealing with the faith, but they called synods in order to deal precisely with such definitions. Visual art had a breathing spell for a few hundred years, and it is this breathing spell which makes a study of Christian art from the third to the sixth century so rewarding.

"There shall be no pictures in churches," Elvira declared. But there were large numbers of pictures in early Christian sanctuaries, and the two trends belong to the theological and cultural complex we call "Christianity."

IX

The threat of figurative art to religion is not one single matter. What transpires from the Second Commandment of the Decalogue and Canon 36 of Elvira is a large conflict in human history which includes religious as well as political, verbal, and individual trends. Society is threatened by forces which go far beyond the sphere of art. And yet that threat is a rather poignant indicator for social and emotional conflict.

In its old nomadic form, the threat came from the icon: thou shalt make no images, neither of things in heaven, nor on earth, nor below the earth. The Hebrew prohibition may have been purely cultic (you shall not *worship* such images) or total (you shall not *make* such images); the Muslims and the angry Tertullian followed the second interpretation, the synagogue of Dura and the church of Aquileia point to the first. In either case, the prohibition led to conflict and polemic ("men kiss calves" scoffs the prophet), rooted in or justified by a transcendent vision about a masculine God without human body or face, without direct visual access. Such a transcendent, noniconic deity was by no means purely nomadic: the Sinaitic tribesman, the mystic, and the philosopher far apart from each other, join in rejecting the icon as a valid representation of truth. In the iconic controversy, Pascal's God of Abraham, Isaac, and Jacob is on the same side as the Gods of the philosophers.

There is a political threat in art which the bishops of Elvira might have sensed and which the Byzantine iconoclastic emperors surely understood. Visual art can be the carrier of rebellion.[37] Eusebius would not allow the emperor Constantine a picture of Christ:[38] the bishop represented the traditional anti-iconic stance of the Christian elite asserting the right to withhold the image from the laity. The icon challenges authority because it commands attention, it invites direct confrontation. The sculpture addresses us directly, without any need for "explanation," and thereby circumvents political control.[39] As the violent suppression of abstract art in the contemporary Soviet Union and the initial polemic against contemporary art by the Vatican show, any authoritarian regime may turn against certain forms of art in order to assert its power.

The political dimensions of the artistic threat become clear as soon as we examine the play character of art, its experimental and revolu-

tionary dynamic.[40] Art is especially offensive when it is new. Rembrandt's *Night Watch* did not please the burghers, Stravinsky's Firebird was booed. New art in music as well as in visual and literary forms threatens, perhaps more than anything else, the psychological order, the status quo of society. The *new* in art shocks us, from the Third Beethoven Trio (Op. 1) which Haydn did not like, to *Lolita* which no American publisher would touch, and is often especially offensive to the conservative religious personality. Only after a period of time will it be bought and sold as acceptable, traditional art—the impressionist canvases which no gallery accepted at first, finally bring in fortunes at auctions of the Establishment.

However, art represents a threat not only for political but for intellectual and ethical reasons as well. Important currents in society have long affirmed verbal or ethical primacy over vision and emotion. The rationality in the Good Shepherd is not the same rationality as that of Justin Martyr's *Apology*; the logic of Prudentius' poetry is not that of the canons of Chalcedon. The rationality of the vision collides with the rationality of expository writing and deductive thinking. Whether the differences are rooted in two hemispheres of the brain,[41] or in different sensitivities of the human being as developed over long spans of evolution, the rational and emotional, visual and verbal, deductive and intuitive, ethical and cultic trends are frequently at odds. For many an advocate of intellectual and ethical religion, to Kierkegaard and Barth, the polemic against art and the polemic against cult were two sides of the same coin.

One reason the intellectual or ethical representative of religion is suspicious of art, especially of new forms of art, is because of its proximity to the charismatic trends, the Dionysian in religion.[42] The ancient church had many charismatic movements, from Acts 2 to the Montanist enthusiasm. The charismatic outbursts have always threatened the church which reluctantly came to appropriate such movements. The *Schwärmer,* the enthusiastic leftwingers of the Reformation, have become a proverbial danger for Protestantism. Art is not religious charisma but it shares certain revolutionary trends, the freedom to break traditions, the acceptance of emotional play, the lighting of a fire on which the community quickly wants to put the lid.[43] Art is order which carries with it the threat of chaos.[44]

Another reason art represents a political as well as personal threat lies in its ability to express a level of reality different from that of the

accepted social consciousness. The iconic and verbal statements do not necessarily coincide, and when the two are especially far apart, persons and groups are likely to turn against art. If the Nazis tried to destroy or sold major works of contemporary art for peanuts (Kokoschka's *Bride of the Wind* hangs in the Basel Kunstmuseum since then), it was because twentieth-century art in its return to authentic form, to pure shape and color, to the basis of things, was especially offensive to the deceptive neo-romantic delusion, to Brunhildian pseudo-mythical grandeur. Art threatens the politician because it calls his bluff; art threatens the individual because it tends to unveil experiences which he has not been able to digest. Fellini's *La Dolce Vita* and Picasso's *Guernica* were so shocking at first because they brought to the surface matters which we were hardly capable of handling.

One may look at the threat of art from another perspective. Man and society are afraid of art because it makes the same claims as religion and cannot fulfill them. Art has often become a new religion. Does it save us? Does the Beethoven violin concerto which the artist in Elie Wiesel's *Night* plays, only to wake up the next morning on the crushed violin, save him? Or anyone else in that camp? If religion so often makes claims it cannot maintain, so does art.

Speaking about claims, one does not know if a new movement of art has any validity. Not every experiment succeeds. The limitation of the charismatic sect returns in art. America often turns to the new at all costs, as if newness, youth, and innovation were by their very nature valid and good. Newness may simply be sensational, pass quickly, and be forgotten. No one can tell us if the Andy Warhol soup cans will last. We have to hear Duchamp's scorn of art in order to comprehend its limitation.

Religion has been caught between its conservative and its revolutionary forces, between what Desmond Morris called neophilia and neophobia.[45] When we see a work of art for the first time, the question arises quite clearly: Is this good? Will this remain? Major art critics have been dead wrong in their initial judgments. Neophobia is not exclusively a reaction toward art, it appears vis-à-vis new ideas, social change, political transformation, and it is present when man meets an unfamiliar kind of human being, yellow or black, shaven or unshaven. But neophobia is especially at work when art expresses experiences with which people have been struggling but with which they have not

been able to cope, as in the frequent fear of nudity from ancient Christianity to the erotic lithographs of Picasso.

Finally art throws us into and is born from one of the fundamental problems in human culture: What changes us? What can bring about fundamental changes in life? What creates a better world? To tell or not to tell? To preach or to simply let things take their course? Hosea preaches, as does the Synoptic gospel and George Bernard Shaw. But Hosea also offers something quite different, a ruthless self-expression, a desperate baring of his damaged alienated self. If we put Hosea beside Homer we begin to understand why such varied theories and practices have come out of the ancient foundations of art. In its visual or in its poetic form, art has been a threat because it never conforms to literary or artistic demands; the proponents of art for its own sake are therefore constantly angered when they confront art which does not conform to their dogma. Art is not only canon, text, commandment, play: it is all this, yet it is also the opposite of what it is supposed to be.

Poetry is the mother tongue of mankind, said Haman. Perhaps the same holds true for a wide spectrum of art altogether. It is a primal creation, the original playfulness of homo sapiens. And yet, as we trace it through the path of our civilization, from Hosea and Sappho to Aeschylus and Job, over Boccaccio and Urs Graf and Goya to Nietzsche and Bertolt Brecht, it might be wise to add that art is also intricately connected with our loss of innocence.

X

The threat of figurative art to religion takes us back to the origins of religion itself, to the relationship between man and society and to the images he created for that society: the threat of art to religion is the threat of man to himself.

It is astonishing that man created a communal process in which he could express himself and find security, the ritual, and then turned against precisely that ritual, and often quite irrationally.

At the moment of death, man danced, as in that compelling fresco of the Etruscan funeral dance in the Naples Museum.[46] He danced in courtship, at the wedding feast, for the *sacre du printemps,* to celebrate the rite of passage. Passover and Lord's Supper, exorcism and litany and magical incantations, in the cult religious imagination found one of its major outlets. This ritualistic trend has not really

changed in its secular transformations where we can still recognize religious origins in the Mummers' Parade of Philadelphia, the Mardi Gras of New Orleans, or in the football game or the Christmas shopping cycle at Marshall Field's. The scholar may use all kinds of terms like civic religion, secular religion, post-religion, which all demonstrate some kind of continuation of the ritualistic processes.

It is astonishing indeed that man turned against his dance: "I do not want your sacrifice!"[47] In Jewish antiquity from Amos to Jeremiah, in Christian history from Tertullian to the Puritans, in philosophy from Plato to Marx, the shrill call was shouted: We do not want your dance! Unless your play is useful for society, it must disappear! And thus man came to hate the cult, see the ritual as subversive and the dance as an opiate. America discovered recently, having witnessed the mass deaths in Guyana, the "evil" aspects of religion, and people began to pontificate in extraordinarily naive ways against the "cults" in sermons and newspapers and classrooms, as if for the first time in history they had become aware of the negative side of ritual. This kind of ignorance is quite as astonishing as the human fear of the dance itself. As if that anger against the sacred dance had not been voiced, and so much more powerfully, by prophets and philosophers of ancient Israel and Greece. Modern apologists of religion often imagine that the attacks against religion are the deeds of vicious modern atheists, when in fact the critique of religion, part and parcel of the critique of the cult, had been present in antiquity. The conflict between cult and creed was born at the core of religion itself.

The student is shocked at first when he realizes this inner conflict, and we send him to the spectrum of the modern intellectual endeavor to find some explanations for that tension. We send him to study the emergence of human consciousness, the shaping of urban society with the breakdown of tribal structures, the rise of autonomy in and against society. We send him to the great textbooks on religious research, to Watts and Eliade and Harnack, to Max Weber and all his sociological followers, to Freud's dialectic between instinct and society; to the old theological insights and violent disagreements about nature and grace; to the structuralist transformations of these insights, the bipolarity between nature and culture; to the philosophical and theological debates, going back to Plato and the Stoics, on the differences between beauty and value, between truth and deed. We must warn the student: he will meet on his way through these theories a goodly number of

thinkers who will scoff at distinctions others made only to practice them surreptitiously themselves; and he will meet another clan of scholars who propose distinctions only to confuse, if not to erase them in their actual lives. The entanglement of unity and conflict between art and religion, between beauty and ethics, is deeply carved into our past. Man dances and he is afraid of that dance: Hindu mythology was not far from pointing toward the core of our problem with art when it depicted Shiva as creator and destroyer.

What has changed in recent times is not the ritual, nor the rejection of the ritual, only our awareness of what we experience in it and what we experience in its absence. We have learned to deal with unconscious and functional levels below the surface structures of the human drama. Scholars do not agree, as I have pointed out before, on the categories with which to comprehend such deep structures. But on one thing there is some agreement across the wide spectrum of academic research: the ritual process can be understood on other than verbal levels. When the Christian church, for instance, celebrates the Eucharist, it is not only by a specific use of eucharistic language that this ritual can be explained. The Christians have never agreed on their Eucharist rationally, verbally: is it Western transsubstantiation, Eastern presence, Luther's or Zwingli's or Bucer's? The New Testament is ambiguous on the "meaning" of the Eucharist, as the violent debates in the ninth and sixteenth centuries demonstrate. But we can examine (and reenact) the Eucharist below its verbal levels and recognize in all its variations a communal process, a drama with a confluence of symbol and action, a verbal and visual icon interlaced in an artistic event. We comprehend the ritual not only in what it says but in what goes on, and we know that for a comprehension of this level the verbal statements contained in the ritual never suffice.

Many traditional eucharistic theologians do not agree with such understanding still, and so we are back at the threat of art: the polarity between the intellectual and the sensual-experiential strata of life is discomfiting. What we say and what we experience may not be the same. Language does not suffice to explain the mystery of art. To be sure, that painful contradiction between life and language is not restricted to art: Plato gave us *The Republic*, one of the major texts of ancient history, yet in his one political test at Syracuse the great philosopher failed. Jeremiah blasted the cult of Jerusalem only to create symbolic actions himself, carrying a yoke and buying a piece of prop-

erty in the middle of the war. The catharsis of art is not always identical with what the mind imagines catharsis to be. What Martin Luther gave to his culture is much less the often quoted justification by faith than the chorale which has influenced Germany profoundly for four centuries and far beyond circles that believed even marginally in the theological statements of the Reformation. The world of art poses a threat to us precisely because its catharsis happens where we do not expect it. Hence, we do not know how to master it. And the threat happens because we might have to exist without what we thought catharsis should be.[48]

The threat of art to religion, especially for the Judaeo-Christian tradition, has been most pronounced when it comes to the portrayal of the human body. At Aquileia, as we shall see, Jonah was still naked, but soon afterwards, the saints would not appear nude anymore, with some exceptions. When the Renaissance replaced Mary by Venus and reintroduced the nude human body, it challenged the religious tradition of Christianity at the center. For the nude is man and woman at their most vulnerable (the naked baptized Christ at Subiaco has no genitals!), it is the symbol of wholeness, the paradigm of lost beauty and recovered humanity. The nude was evil to the Puritan and catharsis to the progressive: that parting of ways has not really changed in secular society.[49] The threat of art always returns in that explosive issue of the full human body, from the classical sculptures in the Vatican Galleries with their fig leaves to Victorian etiquette and the lithographs of Picasso. While for some to disrobe is to destroy society, for others, from Monte Verità in Ascona to the Esselin Institute in California, nudity represents freedom.[50] Secular society has as little agreement on that issue as religious society.

The threat of art is further connected with Jung's insights into the externalization of evil. In history, evil was always projected onto an external object, frequently an artistic symbol: the golden calf, the icon of a Roman emperor, a magical practice. For the Protestant, evil was a Catholic madonna. For the social revolutionary, evil was the bourgeois canvas in an art museum. For the fanatic Muslim, it was the Christian mosaic that had to come off the walls of a conquered basilica. As long as evil could be externalized it was tolerable.

There comes a point when the externalization no longer works. We experience an identification with a piece of art or literature we are supposed to hate. The hate of men in destroying works of art may be

rooted in such awareness. After all, the *Hebrews* danced around that golden calf. Could it be that in that story Moses felt attracted to the golden sculpture himself, as he threw down his tablets in disgust?

The threat of art to religion and to society at large lies precisely in that final ambiguity of Moses smashing the Law in front of the sculpture of gold. As we all have learned from bitter experiences, when we act in such anger we are not sure about our case! What we think we experience and what we experience might not be identical. We hate in others what we fear in ourselves; this observation in *Tea and Sympathy* is the most serious modern challenge to Amos' angry stance before the sculptures of Gilgal. Art allows us to absorb the human dilemma: Moses' smashing of the tablets is as much our deed as the dancing around the calf. In art, I am allowed to reenact the fall of man once more and I must not apologize for it anymore. Perhaps only in art can I let the foe turn into myself, and myself into the foe.

No wonder that the young people of Protestant Pratteln, upon finding Roman Catholic saints in their evangelical church, grabbed picks and axes and destroyed the wicked symbols as if to solve then and there the dilemma of their own lives.[51]

Chapter 5

Myth and Counter-Myth; the Transmutation of Religion

*There is a relation between the hours
of our life and the centuries of time.*
Ralph Waldo Emerson

Art can be, and has been, a threat to religion. But religion can be, and has been, a threat to society itself. The history of Western man evolved in an often violent conflict between man and his religious past and Vietnam, Cambodia, and China in this century, witness to that same conflict. There is a remarkably small step from the creation of religion to the crisis of religion. In an analysis of the relationship between religion and art, it is imperative to place that relationship into the context of the religious crisis of man, or as I like to call it, the "crisis of myth."

"There shall be connected with my name a crisis which man has not seen nor shall see for a long time to come." The dark sentence by Friedrich Nietzsche sounds like an introduction to the modern world. It is not. The crisis of myth is not merely that of the nineteenth century, although more people became aware of it during that time, nor of the so-called radical theologians who discovered their religious dilemma two decades ago, waking up from our neo-orthodox deep sleep. The crisis of myth is ancient and can be analyzed in some of the most fascinating ancient texts. "If we were oxen our gods would have

to have the faces of oxen," an insight which belongs to classical antiquity.[1] But the mythic crisis may even be much older and it may be built into the very structure of religious life itself, which in turn may well contain the seeds of self-destruction, of autonomous reason and of disbelief in gods and salvation as its inherent counter-force. We do not possess poetic or philosophical texts from the inhabitants of the Lascaux caves forty thousand years ago. But we do have access to firsthand documentation from Greek, Hebrew, and Latin antiquity to which I shall restrict myself in the following pages.

We can trace in the millennium following the Homeric and Davidic epochs a far-reaching transformation of the religious character of society. This transformation led to the emergence of scientific, prophetic, and philosophical literature and parallels the arrival of autonomous, individual art and drama as distinct from tribal art and ritual. The evolution was tied to urbanization, extensive trade, and an unheard-of mixing of cultures and traditions, and changed the character of the world down to our days in terms of religious pluralism and social amalgamation. It is not always possible to show direct parallels between the religious crisis and the history of art, and a detailed analysis would fill volumes, but it is possible to show analogous developments between the gradual crisis of prehistoric religion or myth and the beginnings of a new kind of autonomous art. We cannot really comprehend why there should ever have been a conflict between religion and art without considering the fact that there has been, indeed, an analogous set of conflicts between man and his mythic past.[2]

I

The concept of myth like the concepts of art and religion, has a wide structural polarization. Although the word is constantly used both inside and outside academia, there is no agreement anywhere as to what myth really is, or has been. Myth has been conceived as a tale combining heavenly and earthly images; as a supernatural or magical mode of poetry explaining, supporting, defining, or excusing social reality and individual anxiety; as an archetypal statement about man and woman, about the hero with a thousand faces, about the mystery of birth and death and rebirth.[3] Myth was seen as etiological explanation for the enigma of culture, an early step toward science, a code for social interaction.[4] One can rephrase *myth* in contemporary terminol-

ogy as "sacred canopy," as "charter for social reality," or "adjective response" to the human dilemma.[5] It would be easy to fill a book explaining the spectrum of theories on myth.

The scholastic community is divided on the question of whether myth is a positive or a negative concept. Freud's reading of myth as a reflection of neurotic unconscious disturbances is negative—Freud would like to see the man of the future free himself of his illusions—while Jung is basically positive and affirms the collective stream of archetypal patterns.[6] For Bultmann, the three-story mythic universe must be demythologized and replaced by more relevant contemporary images; for Cassirer, such negative connotations are absent, although he too wants to comprehend the symbolic forms of the past.[7] For Jane Harrison, myth belongs to the problem of the ritual; for Lévi-Strauss, myth shows how the human mind works.[8] This constant seesaw between critical and affirmative response to myth is repeated by the layman who chides someone's lies as "merely a myth" but goes on speaking positively about Mt. Olympus, the Virgin Birth, or Tannhäuser.

The discrepancies in the use of the term *myth* can be shown on such an issue as the Virgin Birth. To call it mythic is a grave insult to some, since it undercuts their literal reading of Scripture, while to others it is a perfectly valid approach.[9] It appears as if only the religious world proper is divided on the use of such a term; however recent statements have been made concerning the "myth of science and psychoanalysis," statements that have sent shock waves of anger and concern through these professions.[10] The label *myth* is considered a tribute by some and an indictment by others.

The linguistic philosopher demands that the terms be clarified, and once clarified the confusion will disappear. But the confusion has clearly not been dispelled. Not since Hesiod, Plato, Origen; not since Nietzsche, Heidegger, Campbell.[11] There are often quite subtle changes in the employment of the concept *myth,* even within the work of a single individual, such as Kirk.[12] I shall employ the term *myth* as designating first of all early Greek and Hebrew oral tradition about gods and heroes, about heaven and history. I am aware that this term changes throughout history, for as we begin to analyze the reactions to myth, we also begin to alter what that myth might have been in the first place. For me, this shift happens as I consider the transmutations from *myth* to *myth understood* in terms of Nietzsche, Leach, Bultmann, Kerenyi, and Turner. Plato's reactions to art and myth

also show rather surprising mutations from negative to at least reluctantly positive attitudes.[13] This evolution, as it took place in classical antiquity, is a superb test case for the structural dilemma of myth.

II

Originally myth existed in oral cultures.[14] Research by contemporary anthropologists takes place in tribes where the mythical material is appropriated by a process of direct investigation. We do not possess the oral stage of Greek and Hebrew myth anymore, of course, and have to approach the original material through later written documents. All of the myths related by Robert Graves, for instance, were originally transmitted orally.[15] The written recollections of these oral traditions are but the last stage of ancient religious history.

The Pentateuch has preserved for us texts in which we can see two different flood stories, with two different lengths of the flood (40 days and 365 days). These two flood stories were transmitted side by side, orally, in different tribes. There are two different stories of creation, two different revelations of God to Moses, one on Sinai and the other on Horeb. And besides the classical texts on the creation of man and of the world, Genesis has even preserved an old fragment about the angels begetting man (Gen. 6:1-4), a text that is historically and logically quite unconnected with Genesis 1 and 2, and which shows the richness and variety of oral religion.[16]

On the Greek side, we know of numerous mythical traditions, many of them originally local, unconnected with each other and only later patched together to create mythical, or rather post-mythical, consistency. Apollo is the god of Didyma and also the god of Delphi. Zeus is the god of Crete before he becomes the head of the Olympian Pantheon. Gods fight with the Titans.[17] The stories of Uranus, Chronos, Hera, and Artemis go back into prehistory, and in most cases we can no longer follow them through those layers, into pre-Doric and pre-Mycenean times.

When the Hebrews and the Greeks began to write down their myths, the process took place as Auerbach has shown us, in different literary forms.[18] In that transformation from oral to written unit, the myth received a permanent shape. When it was sung or recited by minstrels or storytellers outside the tent or in the center of town, the mythical

tale changed with the minstrels who sang it, with the changing customs, with the movements of tribes and the cultural framework in which the tale was told.[19] These changes in myth occurred organically; people hardly noticed the changes and accepted them from their new cultural and emotional situations. But as the myth was written down, man suddenly became aware of, or was made uncomfortable by, the discrepancies. When the mythical material lies before us, the problems are brutally revealed.

The process of transmitting oral myth into literature can be studied in the book of Genesis. It does not matter for this context whether the J source is of the eighth century or older, and whether the redaction took place before, during, or after the exile. Whoever it was who wrote down the story of the flood, for instance, had two stories to work with, two kinds of data as to how many animals went into the ark (one couple each, or one couple of impure or seven couples of the pure), how long the flood lasted, and how exactly they all got out. The redactor could not break with any of these traditions. Had he done so he would have saved nineteenth-century scholarship much headache, but he also would have prevented us from observing firsthand the dilemma of transmitting multiple mythical material onto a script. As the flood story now stands, it exists in a transitory state, suspended between spontaneous tradition (which it is not) and a written finished account (which it is not either). Instead Genesis 6—8 is an account half-way between pluralism and unity, between oral traditions and the transformation of such traditions into a consistent account.[20]

One cannot say that the oral traditions lying behind the tortuously written flood story of Genesis are *not* art. They contain characteristics which today are certainly attributed to art: reduction (the flood as a metaphor of life), the creation of symbolic models (the flooded earth and the ark, the drowned mankind and the saved Noah), ambiguity (destruction and salvation, wrath and promise). As in the story of Gilgamesh, the chaos of the human situation and of natural catastrophe is confronted with the tales of one man's survival.[21]

But now that the tale is written down, something has happened to it. It can be repeated, reread, analyzed as it stands. (The oral tale could never be reheard until the arrival of the tape recorder.) Suddenly the myth is no longer part of the continuous process of organic changes, and the Genesis account, like the Gilgamesh epic, will from now on be a component of history. It has carried to this day that transition from

plural to unified myth. In the oral tradition we continue the creative process; if the culture changes, we simply change the story with it. We cannot change the Genesis tale anymore, not as it stands, not as we read it.

It would be a mistake to claim that the vivacious tales of tribal storytellers were not art. It is rather that another degree of consciousness became possible after these stories were written down, both for the person creating and for the person hearing such tales, and that change modified the entire artistic process: as mythical material appears in written shape, men begin to become aware of its created nature, of its problematic, relative and playful character. When the anthropologist writes down his research on the Bantu tribe he undergoes a similar transition from hearing the mythical tradition to seeing it on a page. Perhaps the mythical crisis began in man's recording and preserving what had been a fluid and ever-changing body of images. For it was in such writing that man became aware, not only of different cultural periods, but of his own distance from that mythical material. He became aware of his historicity, a first step toward a new experience of art.

III

The movement toward art, a movement transforming mythical traditions, operates in the Homeric epic. At first glance, the world of Homer is fully mythical: gods fight with each other, man is at the mercy of the gods who are involved in all crucial decisions about the death of Hector or the return of Odysseus. We can learn a great deal about Greek mythology by reading Homer who seems to be a traditional believer in his mythical gods.

But we discover on closer analysis that Homer is not a traditional believer. For Homer, the mythical world of Hera and Poseidon has become the literary tool by which he expresses the glory and the misery of man. The mythical framework exists for the artist to play with.[22] The goddess Pallas Athena at the beginning of the *Odyssey* is quite clearly a literary figure serving to introduce the epic on the island of Ithaca. Ares and Aphrodite are symbols for the gigantic battle. Homer sets up one structural duality after another and his gods are the literary material with which he plays in setting up his stage: Greeks and barbarians, adventure and culture, with the gods as lively and rather

human stage figures for this magnificent and gruesome show. As Homer uses his gods, he reveals his distance from them, that literary distance which will become so enormously important for the history of Western culture.[23] It is the distance between the artist and his world, between man and his gods, a distance which implies a sense of humor, anger, or freedom vis-à-vis the gods who are ambivalent participants in the human strife.

Homer's world does not represent counter-myth in any sense of atheistic polemic. He played, not in the Puritan pejorative meaning of that word, but in that of Johan Huizinga.[24] The gods are at his disposal. Poseidon and Zeus fight like jealous mortals. Myth is no longer a sacred canopy of tribal life but a metaphor, a tradition which the artist uses to hew his epic: Achilles versus Hector, Achaeans versus Trojans, Ulysses and Penelope as symbols for adventurous man and his wife.

Hesiod used mythical traditions to create his poetic theogony. Sappho, still part of the same world, created lyrical poetry. What Homer does to myth in his epic, Sappho does with her shorter compositions.[25] The transmutations therefore can take a variety of forms, large or small, monumental or intimate. Otis speaks of "civilized poetry,"[26] the poetic origins of classical civilization, images transmuted into metric forms by the consciousness of artists. Such work bears the stamp of an individual, which is why it is so much easier to translate entire sequences of oral myth than one page of Homer. Artistic autonomy had arrived and from then on, religion and art, whatever their common origins, could never again be identical.

IV

As we return to the Hebrews, the problem becomes more serious: something happens to myth, to religion, to imagery which tears apart the tribe and breaks the homogeneity of religion for millennia. The break happened with the emergence of prophetic poetry.

Hebrew tradition, like that of countless other tribes of the past, had created its song—

> I will sing to the LORD, for he has risen up in triumph;
> the horse and his rider he has hurled into the sea (Exod. 15:2).

Thus, the song of Miriam celebrated tribal glory in concentrated, hymnic form. The song of Deborah was likewise an expression of tribal pride in the victory of the Hebrews over the conquered Canaanites.[27] But in the work of Amos, a new kind of communication enters Hebrew civilization. Amos created units, short, concise, poetic passages—

> On that day, says the LORD GOD,
> I will make the sun go down at noon
> and darken the earth in broad daylight (Amos 8:9).

These units have a form which is no longer the product of old tradition, but that of an individual creating his own lines. They are the work of *one* person, turning against his tribe—

> For you alone have I cared
> among all the nations of the world;
> therefore will I punish you
> for all your iniquities (Amos 3:2).

They have the mark of individual experiences, rather than a collective vision of long traditions, of mythical images about serpents and eagles, heroes and floods; they are *his own* vision—

> This was what the LORD GOD showed me: there was a basket of summer fruit, and he said, 'What are you looking at, Amos?' I answered, 'A basket of ripe summer fruit.' Then the LORD said to me, 'The time is ripe for my people Israel. Never again will I pass them by.' (Amos 8:1-2).

In these units, literary law is already in operation. Amos reduces his communication to extremely simple, powerful images: an altar that collapses, the sun that does not rise.

> Can horses gallop over rocks?
> Can the sea be ploughed with oxen? (Amos 6:12).

A poetic creativity is at work which creates individual images for personal expression. The literary form of this poetry arises from old

Semitic *parallelismus membrorum*: Amos will often use two images in juxtaposition, strengthening the first by the second—

> Come to Bethel—and rebel!
> Come to Gilgal—and rebel the more!
> Bring your sacrifices for the morning,
> your tithes within three days (Amos 4:4).

This early poetry of Hebrew civilization is passionately polemic—

> Resort to me, if you would live, not to Bethel;
> go not to Gilgal, nor pass on to Beersheba (Amos 5:5).

The polemic of this poetry arises out of an individual rage. It is no longer a tribal product; the tribal canopy, the mythical super-structure, is lost. Amos is violently attacking the rituals of his people. His poetry makes use of images of Sinai and Yahweh, of a God calling his people out of Egypt and bringing about a day of darkness.[28] But the culture has been broken at the center: this poetry is the opposite of that which presents a canopy—it destroys, or it tries to destroy, whatever security or political and religious unity Israel seemed to have.[29]

It is imperative to face this conflict between mythical-social unity and the prophetic poetic products in order to comprehend the beginnings of the later complicated relation between religion and art. The prophetic poetry, different from the Song of Miriam and the victorious battle cries of Deborah, is born of extraordinary personal agony. Amos is thrown into a violent battle with the religious establishment of his time in Bethel, and he is finally forced to leave that town. Hosea, whose poetry has a remarkable sensitivity and delicacy—

> When Israel was a boy, I loved him;
> I called my son out of Egypt (Hos. 11:1).

suffers a great deal. He marries a woman who is unfaithful, a pro-stitute, and whether or not that marriage was real or only a product of his troubled mind, Hosea's experience with this woman reflects his entire experience with his tribe—

> They are crazy now, they are mad.
> God himself will hack down their altars
> and wreck their sacred pillars (Hos. 10:2).

The prophet experiences for the first time that loneliness, conflict with his people, ostracism, individuality, which would so often become the experience of the artist, the revolutionary, the critic, and the philosopher in the future: "the prophet shall be made a fool" (Hos. 9:7).[30] The poetry of Hosea is born of that conflict between the individual and his society, in that distance between himself and his culture which was to become a trademark of art—Büchner, Graf, Goya, Frisch.[31]

The most powerful poet of ancient Hebrew civilization is Jeremiah, and in him that artistic agony was carried to the extreme. Jeremiah came to curse the day of his birth—

> Alas, alas, my mother, that you
> ever gave me birth!
> a man doomed to strife, with the
> whole world against me (Jer. 15:10).

The lyric poetry of Jeremiah is born of his vision about the destruction of Jerusalem, his contempt of cultic foolishness as he experienced it (Jer. 7), the suicidal political trends for which he was jailed and of which he was in the end vindicated. Jeremiah is the first really alienated poet, more even than Hosea: he cannot enter a house of the dead, he cannot celebrate with his people. He is the artist who shapes man's agony in moving images—

> Hast thou spurned Judah utterly?
> Dost thou loathe Zion?
> Why hast thou wounded us, and there is no remedy (Jer. 14:19).

Here is the experience of utter individual loneliness, but also of utter integrity: this poetry, in all its protest, in its anger and suffering, bears the mark of that man, of his suffering ("I have never kept company with any gang of roisterers, or made merry with them," 15:17), of his all-consuming moral passion ("Go up and down the streets of Jerusalem and see for yourselves; search her wide squares: can you

find any man who acts justly, who seeks the truth," 5:1) of his historical and critical vision ("calamity looms from the North," 6:1), and finally even of his personal courage and hope as he buys land outside the city which he knows is doomed. If Jeremiah is thoroughly alienated from his people, from the political and social as well as from the religious institutions of his city, he is also passionately involved, a violent critic of cultic religion (people will do anything and then come into the temple and say, "we are safe," Jer. 7:10). The poetry of Jeremiah cannot be separated from his individuality, his agony, his critical political perspective, his extreme alienation from the mainstream of his age and the monarchic leadership. In all his alienation, Jeremiah was not a crazy dreamer but a public individual who expressed in his poetry one man's protest against an entire culture, the amalgamation of Hebrew and Canaanite traditions in the Kingdom of Juda, and hence against powerful religious currents.[32]

The emergence of poetry in the prophetic tradition of ancient Israel and Juda does not stand in opposition to all religion as such; but it certainly contributed to the crisis of that religion, a crisis brought about by the prophetic insight that myth and cult may be antithetical to justice and love and hence do a great deal of harm to the people.[33]

V

The next development, the change from myth to drama, took place in classical Athens. Myth had always been related to ritual: the myth of Exodus was acted out in Passover, the myth of the divine doom in Yom Kippur, and the myth of Dionysus in the Dionysiac festivals. The ritual act is the physical presence, the communal incarnation, of the mythical tale.[34] In performing its rituals, the tribe makes its canopy concrete. This inherent tie between myth and ritual present in most religious tradition lies behind the Greek transformation of myth into classical drama.

In this drama mythical models continue to operate, and there seems at first no difference between hearing or reading the myth and seeing it in the version of the Athenian playwright. Antigone, Oedipus, Medea are age-old mythical images not invented by Sophocles or Euripides. The crucial transformation takes place when this mythical model is put on a stage.[35] Even in the most ancient rituals, a distinction existed between the people leading the ritual and the crowds watching or par-

ticipating. In the transformation from ritual to drama, the priests, who had been performing a pivotal function in the ritual, no longer played that role even though the "hiereys" still might be sitting in a conspicuous place in front, as the theater of Dionysius indicates.[36] It is no longer the priest's act but the writer's and the people's. It takes place on a specially-created stage rather than in a sacred grove, or near the altar to the east of the temple; out in the valley in a special place, in Pergamon or Epidaurus, rather than in Didyma's temple.

In that theater an audience has been created. Now there is really a difference between the actors and those who watch, a distance in fact between the stage and the people.[37] Across that distance, the people watch the reenactment of their myth. It is an extraordinary step in the evolution of art—that distance between man and the play he watches. It is like the distance between man and his past, except more concrete, more tangible: out there on that stage, the myth is reenacted, and it is our myth. Man looks at his own story. And everybody knows that story in advance the way every child now knows the Christmas story at the Christmas pageant. But the chorus does not. The protagonist does not. Hence, for the first time in history man experiences the irony of his fate, the tragic knowledge about his own life. For the audience knows what the men out there do not know: that Oedipus is doomed.

The step from the Dionysiac ritual to classical drama is one of the most important in the crisis of religion, precisely because of this issue of identification.[38] Now that a stage has been set up, and now that the priests have become merely actors among equals, the mythical event has come horribly close. The spectator is waking up to his terror.[39] When at the end Oedipus leaves with his eyes torn out, stumbling into the dark of the night of his beloved land, we walk out with him. Or we share with the chorus the dread of his downfall. In a strange law of human experience, now that a distance has been created, the event has come closer. Myth has been taken away from the safe realm of the temples, it is no longer religious imagery created to comfort us.[40] With the distance comes the awareness of how shockingly close the myth had always been to us. And there are no more priests to protect us from its truth.

Perhaps because of the threat which tragedy produced across the space between the scene and the spectators, perhaps also because that distance created a new freedom to face whatever man experienced in his life, a counter-development came about: Aristophanes began to

offer a witty alternative. *The Frogs, The Birds, The Achaians*: now a playwright laughs, not so much at the myth as at the people who try to cope with it. The comedy of man was put on a stage to alternate with the tragedy of man. The break with ritual was complete: *The Frogs* is no longer a cultic transmutation but a farce. Nevertheless, at times the laughter of Aristophanes gets uncomfortable. We discover suddenly that the same human distance stands behind the biting words of Aristophanes and the tragic verse of Euripides, a kind of primal rage against the havoc man has wrought while using images of gods.

The fact that Aristophanes is more conservative than Euripides, Aeschylus more religious than Sophocles, does not matter for our investigation. All of them are playwrights and have replaced the tribe as the author of myth. It is *their* work, no longer a group product. Man, individual man, creative man, has taken charge.[41] The shift from ritual to drama is the shift from myth to comprehended myth, from lived religion to replayed religion. In this shift we watch the birth of autonomous art.

VI

While the major parts of the huge Hebraic corpus from Genesis to Judges represent either mythical or quasi-mythical, i.e., legendary or historically questionable material, a historical interest emerges during or after Davidic times. There exists for instance a description of Absalom's attempt to appropriate David's kingdom, a superb account of political rebellion in an Israelite household. Absalom makes friends with the people, "stealing the affections of the Israelites" (2 Sam. 15:1ff.); David flees from his palace, leaving behind his women (15:13ff.); Shimei curses the king; the plan of Ahithophel, which might have felled David, is replaced by the plan of Hushai (17:1ff.); and finally Absalom dies on a tree (18:14–15). These chapters do not represent historical scholarship; they do not analyze the political forces behind the revolution or the tribal tensions of which Absalom might have been the tool. But the tale is no longer mythical: no God opens the waters across a sea, no miracle takes place, no rain storm or darkening of the skies occurs. Only the acceptance of the unfortunate battle plan of Hushai is attributed to God's intervention (17:14). The description of Absalom's revolt is a fascinating historical tale from Davidic times, with real human insights—the heart of David breaks over the death of his rebellious son.

The real heirs to the early historical trends were the Greeks.[42] And here a tradition emerged which has to our days remained the classical example of positivistic writing, as the reports of Xenophon or the superb account which Thucydides wrote about the Peloponnesian War. The war between Athens and Sparta is no longer a war between the gods. In fact, the gods have nothing to say in that account, except in passing when a temple is ruined or priests play their role. The war is human, not divine. In the corpus of Thucydides, we find the alternative to the Exodus tale: an epic that does not tell the way a god liberates his people but the way in which two cities destroy each other by war.[43]

Like all great historians since—de Tocqueville, Ranke, Mommsen—Thucydides displays his passion, his belief, his involvement. Thucydides is highly critical of the war he describes, and it is precisely such a critical stance that gives his superb account its moral and political greatness. Thucydides takes for granted the crisis of theological belief, he has gone through the breakdown of the Doric mythical structure, and in his work the spontaneity of the tribal ritual is surely gone. He does not operate with revelations, and instead of Pharaoh and Moses as two religious symbols, there are Athens and Sparta as historical and moral forces.

VII

Another process of transformation takes place in the Greek world, beginning in the seventh century and coming to a climax in the fourth, the transformation of the religious quest into a philosophical quest.[44] It is a development which deeply affected not only Greek civilization, but also and just as much the subsequent Jewish, Christian, and Roman cultures.

When the Ionic philosophers began to seek "reality," something that really existed, "being" in distinction to "phenomenon," they followed language patterns which mythical thinking had long ago established. After all, the myth was, in some form, an abstraction, a concentration of our observations and experiences. Poseidon was a symbol of the sea, of water, of the ocean. Ares was a symbol of war, Aphrodite of love. Symbolic language does not have its origin in ancient Greek philosophy, it is infinitely older. Hence, the ability to reduce our experiences to concrete images, to observe the world and

make deductions, and to bring some of these experiences and deductions into certain coherent relations, exists in the creation of mythical tales, whether they deal with gods or heroes. The story of the fall in Genesis 3 not only creates mythical images, it deals in these images with very real problems, and it "abstracts," i.e., symbolizes these problems in a tale: sexuality, knowledge, male and female, the loss of innocence. They are reduced to metaphors.

What is new in the Greek philosophers is not the reduction as such, but the kind of reduction. Poets had struggled with moral issues,⁴⁵ and at first even the philosophical reduction was poetic: Thales sees the primal material of life as *water,* and in his "reality" we can still see the transformation of Poseidon from natural symbol to philosophical symbol. Very soon, the models will no longer be poetic-visual: they will be *atoms,* or *forms,* or the principle of *motion* in Heraclitus. While Aeschylus shows the birth of concrete drama from mythical thought, the Ionic philosophers show the rise of abstract philosophy from mythical thought.

But the philosophers set out on a path that is no longer parallel to the mythical one. They search for consistency, for critical analysis of heterogeneous experiences and images. There is a consistency to the myth, but it is a poetic consistency, a logic of polarities. The story of Genesis 3 is all of one cast, and we *know* it is of one cast: male-female, the loss of innocence, sexuality, the desire to know and have power, all these things are related. The relation lies in weaving the tale. The philosophers do not simply want to hear a tale, no matter how well it is woven. In Socrates, a passion takes over which has held philosophers—and all of mankind—captive to our day: to examine life critically, rationally, without mercy or fear, for our life unexamined would not be worth living. Poetic allusion, ambiguity, mythical polarity do not help us in such examination. Socrates follows his path to the end and with great courage: he drinks the hemlock for having led the youth of Athens astray. Man has declared war on his mythic past.

Perhaps the most remarkable phenomenon of all in the context of myth and counter-myth is the person of Plato. Coming from the Socratic critique of thought, morals, and society, Plato embarks on a path of inquiry, investigating in his dialogues the geometric, moral, and cosmological patterns of life, the soul, the cosmos, the state. His inquiry is dedicated to truth, to finding out, and in his *Republic* he

postulates, in one well-known passage, his philosophy of ideas. And yet Plato always returns to myth! It is extraordinary to see the philosopher end a dialogue with the Judgment of the Dead, or refer to his parable of the cave, or to the cosmic descent of the soul. The mythical elements in Plato are not fully integrated into his philosophical thought:[46] precisely for this reason they are very important. They represent the counterpoint to his rational thought. The problem of progress was posed in antiquity[47] and Plato's myths are the strongest evidence that, in the evolution from myth to counter-myth, the primal mythical forms, the archetypes and symbols, the mythical way of thinking, can always recur in one form or another, not in their original form, not unexamined, but in a strangely transmuted, "transmythologized" shape.

What Plato achieves in recalling the Judgment of the Dead is nothing other than Amos' achievement in conjuring up the Day of Yahweh. In the attempt to deal with the present, either in philosophical inquiry or in prophetic proclamation, the mythical past returns as art, as individual metaphor. In Plato and Amos, the gods return as words, as compelling artistic imagery, here philosophical and there theological. The parallel between the two goes even farther. Plato did not like art, or at any rate, he did not like many of the artists. "Like all Puritans, Plato hated the theater," quipped Iris Murdoch in her passionate book.[48] Amos hated to be called a prophet, and he made quite clear that he did not want to belong to that group. And clearly, just as Plato is, as Sidney Oates called him, a "philosophical creative artist,"[49] so Amos is a prophetic artist of very high caliber. Plato established the connection between critical inquiry and art, a connection we still see in Whitehead, Pascal and Nietzsche; and Amos established the connection between prophetic anti-myth and art, and it returned in Paul of Tarsus, Martin Luther, and Søren Kierkegaard.

VIII

It is this process of transmythologization which the observer of ancient religion must follow up in order to complete his picture of the mythical crisis.[50] For not only did the ancient world produce a philosophical transformation of myth into critical thought and abstract pattern, but it also produced a transformation into theological thought, with theological abstract patterns.

The major evolutions lie at the end of the Old Testament period in

the Wisdom literature, but they belong to a description of the mythical crisis because they have become extraordinarily important for the evolution of religious thought in early Christianity, in Jewish thought, and later on in Catholicism and Protestantism. When in the Wisdom of Solomon *Wisdom* (Chokmah) becomes a hypostatic entity, when *Logos* (the word) similarly becomes a divine principle in Philo, the Greek philosophic tendency toward abstraction has entered the world of religion. It is one thing to speak about God in terms of Yahweh (a personal name), of Lord of Hosts (a title analogous to the ancient patterns of kingship), of Shepherd (a rural symbol); it is another to speak of him in terms of being, word, and wisdom. The famous translation of the Septuagint, the Greek version of Hebrew Scripture, of the text in Exodus 3 stands in the tradition of such abstraction: "I am who I am" says God to Moses, and the verb which the Septuagint uses (*hēnai*) is the same which Greek philosophy has used for centuries in its quest for reality.

The fundamental difference, however, between the philosophical and theological developments lies in the fact that theological patterns existed in a vacillation between mythical, semimythical and abstract counter-mythical models. The entire history of early Christian thought is permeated with this inner conflict, on practically every single page of every writer. The Christian thinkers operated with personal and abstract patterns at the same time, in a merciless tension between mythical and counter-mythical forces and many of their unresolved conflicts result from the unacknowledged presence of these two streams.[51] While in Plato the mythical tradition is recalled at certain crucial places, cautiously, as if in some special poetic moment, in the Judeo-Christian theologians the juxtaposition of mythical and counter-mythical elements is everywhere: *ruach* and *pneuma* and *nous,* resurrection of the body and immortality of the soul, a personal God and eternal truth.

In fact, even ancient philosophical tradition did not know exactly how to answer this baffling mixture of mythical and counter-mythical elements. The philosophical schools argued about the value and necessity of the presence of religious images, and while the Stoics allowed for such images, the Platonists of all people would not. If the theological traditions were thoroughly mixed up about mythical and nonmythical images, the philosophical schools were not free of similar confusions.

By this point, in following the evolution of ancient civilization, a

shift has occurred in the meaning of the word *myth*. It is now not only the oral tale of preliterary history, it has become the heir and memory of such tales, with theological implications. With the arrival of the Hellenistic age, myth is speech about gods and divine levels or reality, physical imagery about creation and salvation. The ancients struggled bitterly with this transformation as they debated for over a thousand years the anthropomorphism of the gods. Myth had become a tale about *the gods of the past*. In their bitter anti-gnostic polemic, early Christians used the term disparagingly; but of course they shared mythical and antimythical tendencies with their enemies, from the "prince of this world" in Paul to the descent and ascent of the Savior in orthodox churches. The task for ancient Christianity therefore was not, as they thought, to reject myth but to decide what kind of combination between mythical and abstract-antimythical patterns to accept. The combination of these elements we call theology.

The process of combination was not smooth. While the mythical material had become a font for poetic and religious imagination, in Homer, the Synoptic gospel, gnostic poetry, Prudentius, and Ambrose, the theological endeavor tried to establish order. For intellectual but also for political reasons, man demanded consistency from texts and traditions which had been built on laws other than those of logical order. And suddenly the conflict between myth and philosophy, between art and philosophy broke out, and that conflict led to the violent history of ancient Christianity. The Christians paid a grave price: they meant to clarify creed after creed, they excommunicated one heretic after another, and at the end they had lost one church after another, Monophysite, Coptic, Arian, Montanist. The tension between philosophy and myth, and hence between philosophy and art, produced the drama of the Christian church; it also seriously damaged it.

IX

The presence of mythical and emerging critical-mental processes produced on the Hebrew side one of the most remarkable documents of ancient religion, the Book of Job. In it we can actually witness the transformation of mythic thinking into art, as distinct from philosophy.[52]

The tale of Job is mythical of course and it could have been used by

Aeschylus or Euripides as the outline for a play. Within a heavenly court an accuser steps up to Yahweh and bargains away the happiness of Job. The tale recalls concerns of oral traditions: wealth and catastrophe, man and woman, sickness and justice. The prologue is in prose.

Then the poem begins. It is a long debate, with agonizing arguments concerning justice and fairness, suffering and trust, god and man. The unknown author writes a sort of dialogue, somewhat in the manner of Plato. But since he has not been trained by the dialectic method of Socrates, his dialogue is much less controlled by inductive reasoning. He rages more, philosophically he knows less, he suffers more— infinitely more!—than his elitist counterpart in Greece. He does not stand above the dialogue but is caught up in the agony and ambiguity of his topic.

At the climax stands that unforgettable encounter of Yahweh with Job, a text which has few parallels in religious literature altogether. Yahweh speaks and Job cannot answer. It is precisely in that speech that we find the clue to the author's dilemma. That speech does not answer Job. It silences him. Jung has a point when he suggests that this speech is not really necessary since Job trusts Yahweh anyhow.[53] He never doubts the existence of the deity. Furthermore, some startling facts must be recalled: a woman nowhere appears and Satan no longer appears. All we have is a violent God silencing a frightened male.

In this speech of Yahweh we do not really have "answers" to problems posed. Instead we have a process into which the author draws us, and at the climax of that process we begin to realize that the verbal level cannot be taken naïvely. Do we experience God encountering God himself, man's violence against man? Is it the final, grandiose, or pathetic speech of patriarchal society raging against its detractors? Is Job, perhaps without realizing it, drawing us into an awareness of failed omniscience, of "might that excuses nothing"? Is that climax a process within God himself, within the world itself, within man himself? Whatever our options and our responses, and they will vary with our experiences, with our religious and intellectual affiliations, and above all with the stages in our lives at which we encounter this monumental scene, it is quite probable that we do not experience it merely on the verbal level itself, and that Job has conjured up unexpected ghosts in his magnificent work.

This is the stuff of art to which myth finally was channelled. The book not only relates a story, it draws the reader onward. There are unspoken codes, projection, ambiguity; the climactic scene is a gigantic experience of power and powerlessness which we can encounter in whatever state of mind and of life we find ourselves in. The author of Job could simply have written a treatise on the problem of God. By drawing us into a process he opened the way for a theological, religious experience of art.

There is a strange ending to that poem. A happy ending. The strangeness is not eliminated had someone else written the beginning and end of Job, since in its present form we must deal with the book as a unit. The book leaves us with a riddle. As in the *deus ex machina* of Euripides, we know that life is not like this. In the hand of the artist, the unreality of myth has been transformed into the unreality of art.

X

A change of equal importance to that in drama, lyric and epic, took place in visual art. It was again a development which has produced some very serious problems for religion as well as for the study of religion.

Religions for centuries had created a space for worship, *cella, temenos,* cave, the house of the gods. Religious traditions found a major outlet in sculpture, in the religious statue which represented the magical presence of the gods, the physical reality of the mythical vision.[54] Religious traditions similarly made use of painting, of symbolic representation. These artistic expressions created a physical relation between the worshiper and the cult object.[55] A monumental break, however, occurred in ancient Greek times between just such religious art and a new kind of creativity in which man no longer praises or serves his religion. I am not talking about subject matter. For ages artists had served priests and kings; sometimes they had created religious images and sometimes bracelets. What changed was not the object, but the process itself which suddenly was no longer directed toward priests and princes but toward the artistic expression itself. The artists of the archaic and classical age, and throughout the Hellenistic period as well, still painted and sculpted Zeus and Poseidon and Aphrodite, Jupiter and Neptune and Venus. They also represented the human figure: the charioteer, the discus thrower, the

boxer. What they achieved in either case is not a theological symbol, nor a decoration for a palace to serve the magnificence of a pharaoh or of an Oriental king. It is a conscious creation of form. The artist draws us into an event: for example, the Pergamum soldier about to die. It is not only essential that Zeus and Poseidon have become men, and that Aphrodite possesses female sexuality; what is so crucial about the Poseidon and Aphrodite sculptures is their autonomous artistic existence.

The creation of art has become an activity in its own right. Man has become conscious of this activity: for the first time, an artist signs his name on a vase: Aristonothos. Vitruvius writes a book on architecture.[56] It is disquieting to notice that in this creation of visual art as an independent sphere of human expression, religious elements tended to play not a revolutionary, but a conservative role. Temples were built and restored until the fourth century A.D. when the Christians finally closed the chapter of pagan religion. But these temples, as Vitruvius clearly shows, were extremely inflexible in their construction. The guttae, the fluted columns, the metopes and triglyphs are reminiscent of wooden construction before the use of limestone and marble. Hellenistic artists for centuries copied old models. Roman art repeated ad infinitum the she-wolf and her twins. In the creation of art, the religious component frequently exists as a petrified element from the distant past. It is only in terms of new religious movements, in the creation of the house sanctuaries of the mysteries, of synagogues and Christian churches, and in the creation of symbolism for these new movements that the religious dynamic returned.[57]

Art has existed for tens of thousands of years, from the age of the Lascaux caves to the time of the cultural transformation in antiquity. Only fragmentary remains have been preserved but they tell us of diverse trends, on one hand naturalistic, at least since Neolithic times, on the other abstract and geometric from the Neolithic period onward. There has been both sacred and secular art, one in the service of cult and priesthood, the other in the service of prince and king. As the episode of Akhenaten shows there have even been revolutions into which art was drawn. Artists' classes, artistic traditions, artistic symbols existed everywhere. When the period under investigation came about, art had long been part of religion, and it had been part of the social order, and the two had coexisted, as far as we can tell, side by side.

What came into being in antiquity is a new artistic consciousness, a new function and meaning of artistic creativity: art became the cosmos of an individual, who in turn created this cosmos for his age; art became the expression of persons who, whether sustaining or challenging the social order, created a new order of their own, and such order was a mixture of traditional and personal images or forms. The new order was shaped by a new logic, by a new rhythm in which the customary (religious and secular) codes of communication were transformed into poetry, epic, visual art, or drama.

The creation of autonomous art was one of the most important contributions to the mythical crisis of society, ancient and modern. It became also one of the greatest problems to religion.

XI

One more transformation must be mentioned: the emergence of science in the ancient world. The developments predate the period under investigation considerably; important astronomical insights were made back in old Egyptian, Sumerian, and Babylonian times. In Greek and Hellenistic times, also, extraordinary discoveries were made.[58] Originally, there had been a strong tie between astronomy and astrology. Religious-mythical and scientific-cosmological trends were intertwined and continued to be in many individuals. Theogony and cosmology, cosmogony and cosmology were always side by side. The first Book of Genesis is a fascinating document of mythical vision, the creation of the world by the word of God; and of scientific insights such as the crucial importance of water and light, the cosmic creation as prior to the earthly one, and the evolutionary pattern ending with man. Genesis 1 shows how closely science and myth could be mixed in antiquity.

But this tie between science and myth was broken. Euclid and Archimedes developed principles and practiced their craft no longer on astrological, cosmogonic, or theological principles. Hippocrates wrote about medicine, even though he was a very long way from what was later to be called medical science. Gallus collected laws and preserved them for practice and study. Pausanias traveled and wrote books about his travels. Herodotus had most remarkable information which often baffled him: travelers tell of different kinds of humans south of the Sahara Desert, and navigators report such weird tales as

of the sun standing north at noon when you go far enough south into Africa. The scientific task of discovery, of measuring, of creating collections and laws and grammatical principles was on its way.

However, the ancient material on science and myth reveals that the two were not as radically severed as our contemporary scientific world would have us believe. From the Pythagoreans to Plato, philosophers were willing to deal even though cautiously with the mythical past and its relation to number and geometry. The counter-myth of science was not as much related to its prototype, the world of myth, as drama was related to its mythical origins and the conflict between superstition and science, between magic and intellectual understanding was a serious one. Yet as Paul Feyerabend has shown so superbly, in that step from myth to science a transmutation of certain mythical patterns occurred. Science itself had taken on aspects of belief, dogmatic assertions that belonged originally to the myth it meant to replace. The transformation from myth to counter-myth almost inevitably leads to the process of transmythologization, to the establishment of new patterns which, although they do not repeat the old models, inherit some of their pitfalls.

Chapter 6

Icon and Idea: Aquileia and Nicaea

we see

we see a good shepherd
we see a picture of a good shepherd
we see what used to be a good shepherd

> what do you think
> what do you see
> what do you say

we see a good shepherd and wonder
we don't see good shepherds any more
we know there must be shepherds around
we see bad shepherds
we don't even know bad shepherds any more
we don't know

> we walk around in circles
> we take a picture
> we breathe deeply
> we wonder about the heat today
> we respond by science

we see and we are supposed to say something
we see a good shepherd we just said
we see and we refuse to talk about him

absolutely
reluctantly
we see a shepherd's play
it leaves me cold
it's brilliant

we touch

we touch the good shepherd
we touch the crozier with our finger tips
we touch the sheep below our sandals
we touch the orphic dress
we touch the orphic flute and he plays it lovingly
we touch the indentations between the mosaic cubes

we are supposed to say something
we speak
we speak with our lips
we speak with our tongue
we don't know we speak
we know we speak
we speak and we look at someone
we speak and we look at the shepherd again

we put long ears on his face
we stretch out his arms
we take off his fancy clothes
we watch him run away

we hear

we hear because there are sounds in the air
between the shepherd and us
we hear and we cannot imagine what we just heard
we hear and we cannot follow our own sounds
we hear and we can hardly distinguish between sounds
we heard and it made sense
we hear and someone just spoke again

we don't know if shepherds speak any more
we know what they are supposed to say
we know what they used to say

we can prime them
we know what they used to look like
we know what we were supposed to answer

we hear and we must try that melody
we hear and we must buy that record immediately
we hear and we must turn off the stereo
we hear and we want to drive away
we hear and we turn off the light
we hear and the music turns into thought

yes we think

we think reluctantly
we think clearly and forcefully
we think it makes sense
we think and we must talk about it right away
we think and we want to write a book

 the shepherd is a king
 the shepherd is obsolete
 the shepherd is meaningful
 the shepherd is a savior
 the shepherd is a shepherd
 the shepherd is not a shepherd

we think and someone is answering the telephone
we think and it becomes clear he said
we think and it is late in the day
we think and the class is over

we feel the day come to a close
we feel we have done what there is to do
we feel the humidity descend on the pebbles
we feel the evening brush the land

 the shepherd looks smug
 the shepherd's going to have to stay alone
 there was snow on him all winter and the lazy
 archeologists haven't cleaned him properly

we feel the satisfaction in our brain
we feel the fatigue in our legs

I

In a confrontation between religion and art one of the most serious issues to be raised is the plurality of perceptions through which we experience the world. When visiting New York City, we can go to a Yankees game; we can listen to a lecture at Columbia University; we can hear the New York Philharmonic at Avery Fisher Hall; we can participate in a Pentecostal service in Harlem; we can see the Guggenheim Museum; we can dance in a disco; we can walk through Greenwich Village. All of these experiences are typical for New York and each opens up one avenue of access.

Each of these processes has its own dynamic and its own ambiguities. In relation to the field of religion, perhaps no other issue has been more explosive than that between two of these processes, namely the visual and the verbal. The separation between Catholicism and Protestantism has been reduced to a preference for the vision versus a preference for the word. The same conflict has reappeared in the contemporary secular world: the television age and the outlandish claims of Marshall McLuhan have driven the representatives of the word into a corner, and the sharp decline of verbal and written skills in society indicates the victor in the clash. While for some the gains made through the rapid expansion of visual communication are immense, for others the present decline of verbal acumen is seen as a tragic trend in our century.

The study of ancient Christianity is a specific field that has to deal with these two processes of perception. In the datum of texts we read and in the datum of art we see. In both we find access to the world of the ancient Christians, although we must recognize that we are barred from other processes, for instance from participating in authentic services, from hearing original music in Santa Sabina, or from talking to people who assembled in Classe. Verbal and visual evidence *are* available, yet scholarship in the two areas is extremely fragmented, considering that it deals with two sides of perception constantly intertwined in our daily life.

I want to address myself to this dichotomy by comparing two sets of historical data, namely the Creed of Nicaea and the mosaics on the floor of the Cathedral of Aquileia. The two data originate approximately from the same period, the time of the emergence of imperial Christianity.

a) The verbal datum is the Creed of Nicaea, one of the crucial decisions in regard to early Christian thought. In the year 325, the Council of Nicaea, for whatever reasons and as a result of whatever pressures, formulated its declaration about the relation of the Son to the Father, a creed that includes not only the sentences stating that the Son was begotten not created, that he was *homoousios* with the Father, but even an anathema against those who claimed that there was a [time] when he did not exist. For decades these sentences were intensely debated; they created controversy, discord, schism and at times even led to exile and murder. One may claim in retrospect that the christological problematic of Nicaea was never really solved but only placed on the shelf of historical formulations; nevertheless, the council drawing up this formula was regarded as "ecumenical," a term implying not only that a large, "worldwide" body of bishops had assembled at Nicaea, but that the council's declarations merited a hearing, if not as divine decrees, at least as inspired and authoritative sentences about Christian belief.

b) Only a few years before Nicaea, a church was erected in the city of Aquileia, at the northern tip of the Adriatic Sea, about 45 km. from Trieste.[1] Aquileia was an important Roman port, and the considerable size of the ancient church attests to the importance of the Christian community there. The original basilica was replaced within a few decades by another construction which has not survived.[2] Over the foundations of the ancient basilica a Romanesque church was erected, which still stands. Its campanile ruined part of the ancient floor.[3] In a long process of excavation, the floor mosaics of the original Constantinian basilica and of a twin building adjacent to it were uncovered below this medieval church. These mosaics represent some of the most fascinating data that have come down to us from the age of Constantine or shortly before.[4] There are two parts to the floor, and scholars disagree as to whether the two parts are from the same period[5] or whether the northern segment is a few decades older (hence Diocletian) than the southern segment which dates from the second decade of the fourth century.[6] Just as the Nicene Creed is a major document for early Christian thought, so these mosaics are a major body of artistic evidence for the transition from pre-Constantinian to Constantinian time. Like the canons of Elvira, the rule of Pachomius, or the liturgy of Serapion, these data reveal specific aspects of Christianity at the outset of the Constantinian period. I list the major components in

abbreviated form:

Nicaea	Aquileia
we believe in	nonobjective floor designs
God the Father	horse
Almighty	donkey
Maker of all things	white hare
visible and invisible	lobster
	lamb
in one Lord	partridge
Jesus Christ	rooster and turtle
Son of God	gazelle
only begotten	pine cones
homoousios with God	portraits
God of God	seasons
Light of Light	Good Shepherd
Very God of Very God	Victoria
begotten not made	the demon
by whom all things were made	inscription of Januarius
who came down to us	inscription of Theodorus
was incarnate	inscription of Cyriacus
was made man	Jonah cycle
suffered	Jonah in the boat
was raised to life the third day	Jonah thrown overboard and
ascended into heaven	swallowed up
will come to judge	Jonah spat out
	Jonah under the tree
and in the Holy Spirit	fishing putti
	birds

Anathema

against those who say
there was a [time] when he was
 not
before he was begotten he was
 not
he was made of nothing
the Son of God is a created being

II

As we set out on a comparative examination of these two data, it is imperative to consider first the methodological problems that must be faced in such a comparison. We compare verbal data, for which certain criteria of research have been established, with visual data, for which other criteria have been fixed. Hence, a comparison is only possible through a cross-disciplinary approach.

The material of Aquileia belongs to the domain of art historians, iconographers, and archeologists. When historians or theologians point to it, they tend to use it in an illustrative sense and very seldom as evidence of art. The material of Nicaea is the subject of study by church historians and theologians, and specialists in symbolism, liturgy, or ecclesiology. The material of Nicaea is verbal. Decisions were made by a verbal process; the Creed was accepted by acclamation of the bishops present; the text was promulgated, copied, analyzed, and contested by words, letters, speeches, on papyrus or parchment, orally and literally. The evidence of Aquileia is visual. It consists of mosaics, stones, color, form, symbolic representations. It was created by hands and it was meant to be seen.

As we analyze these two data together, we are forced to enter two separate and distinct research processes behind which lie two distinct aspects of human existence. We perceive and appropriate the evidence on Nicaea through words. We read the text of the Creed and compare it with written research. We ask questions, we make deductions, we create a scenario, we try to understand, analyze, reconstruct, believing certain words or traditions about that Creed and reinterpreting others.

As we deal with the mosaics on the floor of Aquileia's cathedral, a different process takes place. It is of great advantage if we can travel to the site (less than two hours from Venice), enter the medieval church, and confront the evidence firsthand: walk on it; observe the dimensions; see the colors, the material, the symbols; experience the impact of these mosaics on the person who enters that church; and compare the mosaics in relation to each other and to the building which is, at least in loco if not in exact height and space, the successor to the ancient basilica. The initial and primary step of the research process begins of necessity with a visual-physical impact.

Of course verbal processes enter into the matter as well. We read

about the mosaics in Bovini or Brusin. We study the art of the later Roman empire, early Christian art and history, the age of Constantine. Even as we observe the mosaics on first sight, we wonder what they signify. We read inscriptions between the pictures. Verbal processes become important and the analysis of these mosaics takes place in a constant alternation between the visual impression and the subsequent verbal deductions. However, at this moment the crucial difference occurs: the visual impression can never be fully transmitted into verbal images. Whatever we say will neither fully explain nor replace the authentic initial visual impact. We do not terminate the process of transmitting the visual impact into verbal categories. In fact, the visual impression dominates throughout everything we say or write about these mosaics. It *must* dominate if we really mean to deal *with* these mosaics and not simply with some theories *about* them.

The visual impact is not mystical, but takes place through clear processes of perception. We scan, we take in the whole, we physically experience color, proportion, material.[7] The picture has its impact, its ambiguities, its unity. It has surface and depth, borders and center, and all of this we take in, not with these words (which we only write in retrospect, as a secondary, verbal response) but in an initial, visual comprehension. We study mosaics, in visual terms, the way we study the Creed—in a disciplined process—but the laws of that process, the steps and responses, are not primarily verbal. Only as we scan, take in, feel and see, do the verbal responses, the questions, and descriptions emerge. The visual process is an authentic part of our experience and comprehension and not merely an appendix to the word.[8] Further, this visual experience is autonomous—we do not really need to speak about these mosaics at all, but could instead respond silently by photographing, drawing, painting or copying them.

The problem of the cross-disciplinary approach seems considerably less serious if the scholar uses the datum of art simply as illustration. In such a use, the visual is made subservient to the verbal: the mosaics become a case in point, an example, a proof. In such a case, we face what I call verbal fundamentalism, a gross distortion of the process of human communication, experience, and expression. Human beings interact not merely through language but through a combination of verbal and visual processes. The impact Jesus made on his disciples was not merely through his words but through his personality, and such impact therefore combined speech with vision and hearing. It is

misleading to reduce art to an "illustration" of one intellectually conceivable process.[9] The mosaics have a structure of their own, they exhibit their own codes, antitheses, and ambiguities. By their colors and forms, by their specific mixtures of concrete and symbolic communication, by their impact made in the choice of stones, the mosaics have their own sphere, their own place. They make an individual statement which we try to see in relation to other statements, to other expressions and structures of the same epoch. To reduce the mosaics to examples of social or theological concepts would mean to destroy their impact. It would be a destruction of art.

Enormous problems arise as we cross the borderline between verbal and visual scholarship. No matter how the comparison is carried out it cannot be done within one field, and that means within one methodological principle as taught by any one traditional discipline. We are no longer, or not yet, within methodologically safe borders for which academic ground rules have been established by decades of teaching and publications. How can we translate simultaneously verbal and visual experience into a unity which is not merely another tyranny of words? And if there were to be parallel "histories," one of Christian thought, one of Christian society and one of iconography, how can we coordinate them without falling quickly into some kind of christological or sociological docetism to which the data of the icon would simply have to be subordinated? And if there are several histories taking place, are we not merely returning to the traditional academic fragmentation which leaves the individual histories to the specific turfs for special examination?

The methodological difficulties which we face in combining verbal and visual, literary and artistic evidence is considerable, but it is no worse than the methodological impasse we actually face at many steps of the historical inquiry into, for instance, the very event of Nicaea itself. Shall we examine Nicaea in terms of theology, of the history of ideas, or of sociology? Is Nicaea the product of authentic intellectual struggles which are not reducible to political or social forces, or is Nicaea a result of Constantine's rise to power and the Christian leadership's competition with the military Roman elite?

The presence of the mosaics in addition to the abundant verbal documentation lends a historical datum to the hermeneutic dilemma. We cannot really "translate" the mosaics the way we translate the Creed. We do not, on the whole, recite the Nicene Creed in Greek,

either in class or in church, but we do confront art in its original colors and forms and materials, even if we cannot agree on its meaning. The presence of visual art sharpens rather than softens the tension without which no academic task is accomplished: to face the past is to become aware of its uniqueness, while trying to ascertain its meaning at the same time. For without the question of meaning, research ceases to be. After all, Jonah is represented in one of these mosaics. Who is Jonah? Why is he there?[10]

III

One place to start a comparison is to suggest analogous structural tensions within these two kinds of data. If the Creed and the mosaics contain similar but not identical antithetical, plural, or binary meanings, if they express ambiguities in the way they were created as well as in the way in which that original creation was received by contemporaries, then we have found patterns with which comparisons can take place. On the creedal side it is not hard to find such polarities, since they have existed throughout the ancient church and in fact gave rise to the controversy of Nicaea. The Creed proclaims one God — but immediately goes on speaking about three. The Creed mixes personal (Son, Father, Maker, Man) with abstract, impersonal (visible, essence, light) imagery.

The creedal tensions not only span adjectives and nouns but, much more seriously, verbs, i.e., the very action taking place in the recital of that statement. *Pisteuō* begins the Creed and with it, presumably the bishops and their churches which were repeating or reciting the declaration of faith. The Creed is hymnic and its asyndetic rhythm of affirmations can be traced back to the primitive church. But the Creed also explains "begotten not made." It clarifies, it separates truth from falsehood, and it strongly rejects a wrong kind of faith. The Creed therefore celebrates and defines at the same time.

The Creed consists of multiple metaphoric layers and it fulfilled, even for the Nicene elite which created it, several functions. It arose from liturgical customs but it was also meant to create social and intellectual definition. With creeds the churches held their communities together, with creeds the bishops perpetuated their power and anathematized their foes. But with creeds the churches also defined their mythic canopy, celebrated their faith. We read the passionate, brilliant, and polemical *Orations* of Athanasius against the

Arians and trace in them the celebrant, the politician, and the religious philosopher. These divisions and their implied problems are the cause of grave contradictions and impasses as observers, from Sardica to the University of Chicago, try to make sense out of christological debates. The Creed not only leads to various interpretative options in contemporary research, it consists, as examined in its original context and in regard to its earliest contemporary interpreters, of multiple layers, philosophical, political, personal, social, and poetic.

We may outline the structural dilemma of the Creed in the following pattern:

<div align="center">

we believe

we celebrate we fight

we define

</div>

Throughout the entire history of the early Church, from Antioch to Constantinople to Chalcedon, the patristic elite acted out its creeds in these polarities. The dilemma between belief and comprehension, between celebration and politics, between logic and art, between the rhythm of language and the definition of metaphors lay at the heart of the history of the early Church, and if the contemporary academic community dealing with religion is so deeply cleft between social science and theology, between sympathetic and critical scholarship, between "conservative" and "liberal" or radical trends in scholarship, it stands in a continuum to the men who assembled at Nicaea.

The data of Aquileia also have their polarities but on very different grounds. There are two rooms, one to the north and one to the south.[11] The northern room has no explicit Christian symbolism, the southern room does. The mosaics themselves contain one polarity after another:

a) There are nonobjective and objective mosaics. As in countless Roman floor mosaics and wall frescoes, we have a constant alternation between figurative and nonfigurative designs, and the latter consist of crosses, meander bands, abstract patterns as found everywhere in Hellenistic houses.[12]

b) The figurative mosaics are divided into floral and faunal images: pine cones, flowers, a basket with mushrooms; animals, donkey, ram, lobster, partridge, a basket with snails.[13]

c) The figurative mosaics depict at times simply animals: a horse, a

ram, a bird; at other times they depict scenes which suggest symbolic meanings: a rooster fights with a turtle, a young bull has a dagger in its flanks, the ram looks at a basket with twelve eggs, loaves of bread, or stones.[14]

d) Some representations are pastoral and hence would fit into a pastoral program of a Hellenistic house floor; others clearly do not fit into the well-known pastoral designs but are representations of a coastal culture: the lobster, the details of the Jonah cycle with the sea, the whale, the boat, the putti around the boat.[15]

e) While many mosaics reflect *nature,* others are clearly a reflection of religious or social history: Jonah, the Good Shepherd, the demon next to the baptismal font.[16]

f) While most scenes depict animal life, other depict human, social, and historical scenes: the seasons, the portraits, the Shepherd, Victoria, Jonah.

g) While most scenes depict *visual* images, there are a number of *inscriptions*: Theodorus, Januarius, Cyriacus.[17]

While most of these contrasts could be found in pagan cycles, in the floors of Ostia Antica, for instance, or in the mosaics of Timgad, we find some distinctive polar patterns as we examine them in regard to form, content, and social as well as intellectual purpose:

a) The mosaics vacillate between Christian and non-Christian content. It is not possible to determine in each case if the content is Christian or not. Some of the mosaics are Christian without doubt: the Jonah cycle, the ☧ sign, the inscriptions of Theodorus and Cyriacus. Some are purely pastoral or decorative: the basket with snails, the horse, the meander band. The northern mosaics have been explained by different art historians as Christian and as pagan.[18]

b) The mosaics vacillate between representing a design and telling a story. We cannot say in each individual case if there is or is not a symbolic meaning. Scholars have disagreed on the extent of symbolic meaning.[19] But it is beyond doubt that while some mosaics are purely decorative, others were created with a symbolic meaning: the Jonah cycle, as proven by the large parallel and preceding material on sarcophagi and in catacombs, is a Christian symbol.

c) The mosaics express models of nature and models of culture. They belong, technically, to later Hellenistic provincial tradition, they express natural scenes we are familiar with from Roman art. But they also express separate traditions, Hellenistic, Greco-Roman. Jonah,

the demon, the Good Shepherd, whatever their specific Jewish, Orphic, or Christian origin and actual meaning, are not expressive of the natural order but reflect historical roots, specific cultural origins.

d) The mosaics vacillate between telling a story and hiding some kind of religious, intellectual, or artistic message. They *tell* a story: Jonah is swallowed and spat out by the whale. The Good Shepherd holds a flute. The rooster fights with a turtle. But these stories are also a kind of code. The demon is found exactly by the baptismal font, and that juxtaposition is hardly coincidental. The Jonah cycle is in the center of the church. The Good Shepherd, as we know from so many ancient parallels, is not merely a shepherd but has a symbolic meaning from the Orphic myth to Psalm 23. The following schematization coordinates these trends:

<div align="center">

the mosaics are symbolic

the mosaics the mosaics
tell a story hide a story

the mosaics are decorative

</div>

Both the Creed and the mosaics contain antitheses which have to do with the multiple possiblities of word and vision. Just as an early Christian creedal statement could be heard in more ways than one, so an early Christian icon could be seen and understood in more ways than one. What they both have in common is their multisematic character, the fact that what an individual or a group created was not unequivocally clear to the receivers. The dual antitheses indicate that the early Church as a whole was intrigued by the problem of meaning, by pluralistic alternatives. Hence, it is not, as it so often seems to apologetic students of religion, that the contemporary scholar carries his heremeneutic conflict back into the texts of the ancient church. As the violent battles around the Creed of Nicaea and the iconoclastic controversy brewing around Constantine's predecessors and contemporaries show, the creedal and artistic history of antiquity itself is burdened by the tension between the datum and its receiver.

IV

The creedal and the iconic data at the beginning of Nicaea belong to two specific strata in ancient Christianity going back a long time. There are creedal formulas from the earliest periods, in 2 Corinthians

13:14, in 1 Corinthians 15, in Philippians 2 and 1 Timothy 3. There exists a long history leading from these hymnic passages in primitive Christianity over the *Epistola Apostolorum,* the creedal allusions in Irenaeus, the Romanum to the famous formulations of Antioch, Arius, and Nicaea.[20] Certain specific elements of the Nicene Creed are not found in previous formulae, like *"homoousios* with the Father" and the *anathemata.* It is important to realize also that the so-called Nicene Creed of Catholic tradition is not the Creed of Nicaea, and that patristic scholars are not of one mind as to whether the creedal stance at Constantinople is a reaffirmation or a reinterpretation of the Nicene statement. The Niceno-Constantinopolitan Creed is one controversial link of a long and complicated intellectual and social chain.

Similarly, the mosaics of Aquileia belong to two historical streams. On one side they belong to pagan pastoral painting, to mosaics and frescoes in which fauna and flora are used for walls and floors, sometimes symbolically and sometimes as direct naturalistic representation. On the other side, the mosaics belong to the history of Christian iconography. In the catacombs of Domitilla and Callixt Jonah appears on many occasions on sarcophagi and in a fascinating group of sculptures in the Cleveland Museum of Art.[21] Jonah was a widespread iconic model by the time the artist decorated the floor of Aquileia.[22] The Good Shepherd appeared widely in sculptures now in the Louvre and the Vatican, in Roman catacombs, and on sarcophagi.[23] The Christian as well as the pagan mosaics both belong to historical streams, although certain elements seem unique to Aquileia, as for instance the demonic figure next to the baptismal font. We have no reason to claim that even such a juxtaposition was necessarily unique since Aquileia is the only one of early Constantinian basilicas whose iconographic cycle survives to such an astonishing extent. The way the Jonah cycle is used certainly puts the mosaics into the widespread iconographic tradition of ancient Christianity; the Jewish prophet, who was swallowed and spat out by the whale, had long been a major symbol.

As we compare these two traditions and their specific representations in Aquileia, we can make certain deductions which are of importance to the overall description of ancient Christianity. These two data seem to represent extremely different cultural levels of that ancient church. The Creed seems, and has seemed to generations of theological observers, considerably more sophisticated than, for ex-

ample, mosaics. The creed contains a developed Christology, it has intellectual nuances bordering on philosophical sophistication: begotten, *homoousios,* Very God of Very God. The imagery and symbolic world of Aquileia seem in comparison so much more primitive, crude, undeveloped: a rooster fights with a turtle, a prophet is swallowed by a sea monster, a demon lurks beside a baptismal font. A description of the Nicene and Constantinian age would put considerably more weight on the Creed than on the mosaic floor.

It is precisely such presuppositions of academic judgments that must be examined. If we are looking at the ancient church through a creedal looking glass, the mosaics appear of course greatly inferior. If we make judgments from a framework in which bishops, or synods "knew" what faith was all about, and hence decided the crucial issues of such faith, then the creedal decision is infinitely more important than an iconic creation. The verbal priority of patristic scholarship comes to the fore as we pose such a comparitive question. In such a framework the creedal-verbal evolutions represent the major trend, the *bene esse,* of the Christian movement, while monuments like the Aquileia mosaics are relegated to peripheral importance, executed if not by rustics at least by provincial and much more insignificant figures who in their naïveté never matched the wisdom of the Nicene Fathers. It seems imperative that patristic scholarship at least become aware of its onesided hermeneutics, for the comparison does not hold up. Although the Nicene Creed is sophisticated in comparison to crude imagery such as that employed by Hermas, the Acts of John, or the Emperor Constantine, it lacks sophistication if compared to the *Enneads* of Plotinus, the convictions of Boethius, or the theses of Aetius. The mosaics seem naïve in comparison to the Ludovici throne, the battle of Alexander in the Naples museum, or the Aldebrandini marriage, but compared to other folk art of the Empire, from Pompeii to the floors of Piazza Armerina, they hold their own, especially the older segments in the northern aula. If the Jonah cycle seems crude and mythological, the liturgy of Serapion also reveals a church that assembles and worships with mythological images and cultic actions, closing the door to outsiders.[24]

What then is the difference between these two data? One could point toward the age of the traditions behind them. The verbal trends in the church were certainly older than the visual art. The anti-iconic stance in many segments of the ancient church did not allow art to be a major

(at least a major *acknowledged*) factor for a long time. The intellectual and social history of the ancient church can be told for almost three hundred years, until the Constantinian age, without iconic evidence. But the situation changes dramatically when we enter the Constantinian epoch. Basilicas are constructed and an artistic style begins to evolve in the Christian churches.[25] Iconic traditions come to the fore on ivories, on sarcophagi, on walls and floors. What in the period of Dura Europos can only be documented in certain select examples now becomes widespread. Elvira forbade paintings on walls, but painting did exist even though one part of the episcopal elite did not want it. The floor of Aquileia is certainly not very far removed in time from the Council of Elvira, no matter how we date the latter and no matter how we separate the two parts of the Aquileia floor. The prohibition of Canon 36 of Elvira is directed against art and reveals an iconic conflict in the midst of the episcopal elite. The prohibition of Elvira was not a peremptory one and hence must be seen in direct reference to monuments such as Aquileia: the prohibition was half-hearted not only because such art existed but because bishops very likely had ambivalent feelings about such traditional prohibition.[26]

If we see in the floor of Aquileia an authentic datum as to the character of the Constantinian church, such a judgment is justified by what we can deduce about the leadership of the church responsible for such work. Januarius states the amount of square feet donated to the church. He must have been one of the well-to-do men in the Christian community.[27] The church of Aquileia was an important site in the town.[28] We are dealing therefore not with some little sectarian sanctuary, but with a major building in an important seaport. The size of the church attests to such an assessment. These mosaics were the products of artists working in the mainstream of Greco-Roman iconography. Also, the church was built in connection with an important imperial building.[29]

The Creed of Nicaea is the product of the Christian elite assembling at the invitation of the emperor. And judging by the events after Nicaea, it was not the belief of many of the bishops present. The bishops were embroiled immediately upon their return home in bitter controversies about the meaning of what they signed, as happened once again after the close of Vatican II.[30] Only in retrospect, and only to future generations appropriating the Nicene Creed into the main-

stream of Christianity, did this Creed represent "the faith of the church."[31]

If the major distinction between Creed and mosaic is the difference between verbal and iconic strata in ancient Christianity, then the Creed and the icon represent two quite different aspects of Christian social and liturgical life in regard to celebration, self-definition, and the world outside. The Creed is a hymnic expression of faith, as were earlier creeds, e.g., in Philippians 2. At Nicaea, the Creed contained a polemic twist: "begotten not made." More than that, the Creed pronounced an anathema at the end. Praise led to a curse. And this curse was not directed against outsiders, Jews or pagans or even Gnostics. It was directed against fellow Christians who, as the history of the Nicene controversy indicates, constituted a majority, at least in the first decades after the Council. It was extremely hard for either party to claim the entire Christian past for support. The Creed was therefore a partisan expression of the church.[32]

We must conclude then that the Creed was *divisive*. It divided the church socially as well as theologically: entire segments of the tradition were henceforth excluded from an "authentic" definition of Christianity. The Creed also separated the past, and that means the Bible as well as the primitive Christian past, into right and wrong. I do not have to dwell on the well-known factors leading toward this divisiveness, the Christian victory under Constantine, and the new role of this religion in the empire, the powerful socio-political task of the episcopal elite, and the demand for external unity within this new imperial religion. It is sufficient to recall that the attempts to create authentic and orthodox belief failed in the long run: by attacking individuals and groups, the Christians forced one schismatic and heretical movement after another to break with the church, Apollinarians, Nestorians, Monophysites. The creed that was created to unify the churches in fact helped to divide them.[33]

In contrast to the Creed, the mosaics communicate a different code. Neither in style nor in content do we have a simple distinction either between different Christian groups or between Christians and pagans, Jews, or even Gnostics. In the northern aula, extremely little can be identified as "Christian" in substance. And yet the Cyriacus as well as the Januarius inscription put this floor in a Christian context, even if it had been designed originally as a pagan building.[34] The Jonah cycle is

Christian, representing, as shown by the presence of this motif on sar-
cophagi, a symbol for resurrection. But the Jonah model is originally
Jewish. There were Jews at Aquileia, [35] and although by the year 300
they might not have put the Jonah model on the floor of a synagogue
due to its widespread Christian usage, the Jonah symbol represented a
tie with Judaism while, for instance, the story of Jesus cleaning the
temple would not. Pieces of painting exist where specific New Testa-
ment models are employed, as in the *fractio panis,* the woman at the
well, the Magi in the catacombs of Priscilla and Callixt. On the
Aquileia floor, as in other pre-Constantinian art which has survived,
the specific Christian substance is lacking, there being no allusions to
the life, person, and death of Jesus Christ. The Good Shepherd and
the demon can be well explained in a Christian context;[36] but they do
not exist purely in a Christian context.[37] The four seasons of Aquileia
as well as all the pastoral figures could be found on any pagan floor.
The putti in the Jonah scene are reminiscent of pagan art.[38]

The mosaics are therefore considerably more *inclusive* than the
Creed. While the Creed establishes the exclusive dimension of the
Christian movement and mythology, the mosaics portray, if not the
opposite, at least a much more contextual dimension. They are cross-
cultural in form as well as in content,[39] revealing a much more
tolerant, open kind of Christianity for which the borders between
"right" and "wrong" are not as clearly drawn and in which the
definition of *Christian* and *pagan* was not easily made. While the
bishops of Nicaea wrangled about very specific definitions of faith,
their artist brethren mixed Christian and non-Christian models
without much concern.[40]

There are many periods in history where the artist simply by what he
did made a political and even at times a divisive statement, as is the
case of the abstract and surrealist painters of the Soviet Union today.
Was this, to some extent, the case in the Nicene church? It is quite
possible that Tertullian who disliked artists so vehemently,[41] and the
Fathers of Elvira who blasted images in churches, faced one trend in
Christianity that did not support the kind of ideological verbal
polemic carried on by the majority of bishops against pagans, Jews,
and Gnostics alike. It is therefore possible that a statement, a code,
lies in these mosaics, perhaps not conscious but in fact expressive of
conciliatory, inclusive, and tolerant trends within the church. In this
case, the inclusiveness of the mosaics was itself a kind of statement, a

pro-iconic affirmation distinct from the anti-iconic stance in much of Christianity. If this should be borne out by further documentation, one would conclude that not only was the creedal-verbal activity divisive but also the very duality of verbal and iconic expressions was divisive.

The notion that the artists of Aquileia were "naïve" is surely untenable. If the mosaics reveal unconscious forces within the Christian church, these forces would be much more closely related to archetypal ancient models and sensitivities, fears, and hopes than the verbal declarations assumed. Christianity was part of a cross-cultural movement which dealt with birth and rebirth (Jonah), and with savior mythology (the Shepherd). The mosaics express, more clearly than the Creed, the ties to and the fluid borderlines against non-Christian trends.⁴² The Creed itself is not as clear as it sounds on first reading; it too has pagan roots and parallels which become clear in academic investigation: the parallel to other ancient, above all Neoplatonic triads, the tensions between one and two Gods in Philo, between God and the demiurge in Middle Platonism, Hermetic literature, and Gnosticism. The mosaics in presenting diffuse borders with late ancient paganism are not at all as naïve as they seem at first sight, considering the social, intellectual, and religious developments in the empire, in the mystery cults, and in religious philosophy.

V

It is this last issue of the borderline that we must finally examine more deeply. Both the Creed and the mosaics in their form as well as imagery seem straightforward and yet turn out to be highly complex, bipolar, or at times even contradictory. The form of the Creed is hymnic, created to serve as poetry of praise; yet the Creed curses. The form of the mosaic is late Roman; yet it appears in a Christian church and at least part of the mosaic cycle is created as a Christian one, i.e., as a decorative and symbolic statement in a Christian church. The tension in the form becomes more serious in the content, in language and idea where any ambiguity necessarily leads to conflicts as is evidenced by the violent christological history of the church. Whenever the step is made from direct ("give me bread") to metaphoric ("I am the bread of life") communication, the floodgates are open to social and intellectual conflict because of what I call *mythic ambiguity* or *symbolic ambiguity*.

Certain language of the data is clearly unambiguous. Januarius donated 880 square feet of the northern aula, a direct economic and social statement. When Constantine exiled Arius and in turn Athanasius, his commands were clear. The dedicatory inscription by Theodorus uses metaphoric images (*Deo adjuvante deo omnipotente*) but is essentially straightforward: *fecisti et gloriose dedicas*.[43]

However, in creedal imagery as in iconography, codes are not always self-evident. On the creedal side, terms like *father, son* and *begotten* came from daily life but in the Creed did not mean father and son and begotten in the usual sense, as Athanasius pointed out over and over. A father and a son are two distinct persons with different identities, and the act of begetting is an act in time. These connotations in regard to the deity were anathematized at Nicaea.[44] But when the creedal language was examined by the bishops it turned out to be highly ambiguous.[45]

By mythic ambiguity I not only mean that language is used in different ways at different occasions (personal one time and impersonal at others) but that the very use of language in early Christianity could have at times both a mythic and a nonmythic meaning. It is this ambiguity that brought so much turmoil to the history of ancient Christianity. Philosophically, the Christians had to make up their minds whether they wanted monotheism or concrete Christology: mythically they did not. The hymnic unit of the creed, from 2 Corinthians 13:14 to the Nicene statement, could very well tolerate a triune God, just as there was a Capitoline trinity, three temples on the main square in Sbeitla expressing the triune deities of Rome. Who is to say this Capitoline trinity *should not* exist? It did. The mythopoetic structure of religion has its own logic. The difficulty only arose when deductive philosophical logic was applied to the mythopoetic creations of primitive Christianity. *Begotten not made* mixes mythic with analytic language. The problem of the Creed is not the juxtaposition of monotheistic and christological images, a duality that occurred during the entire early Church[46]; the problem is the confusion of two layers of linguistic expression: on one hand concretion, poetic reduction, and visuality of imagery; on the other hand abstraction, philosophic reduction, and meaning of imagery. Both come together in the Nicene Creed as the Fathers of the Church tried to examine its models of God and the Son of God.

The Creed was ambiguous not only because an image communi-

cated several codes simultaneously and sometimes in contradictory terms, but because of mythic and postmythic (i.e. analytic) use of language. The Nicene Fathers, like all patristic theologians, dealt with religious mythic imagery; but they also were simultaneously involved in a critical analysis of this imagery. Ancient Christianity is neither merely a "mythic" nor merely a "philosophical" movement. It is profoundly caught between the two streams.[47] While some common symbolic ambiguity is contained in all authentic religious tradition, mythic ambiguity of the latter type is historical: it arose from that monumental conflict which started in antiquity between religion as a form of art, history, and emotional life and religion as a phenomenon to be subordinated to the laws of consistency, critical thinking, and conceptual logic. The conflict between myth and counter-myth is the story of the ancient world.

On the visual side, quite a different ambiguity exists. The people who created the Aquileia mosaics were not yet caught in the Renaissance problematic of the artist who has become self-conscious in his work. The mosaics do not reveal any consciousness in regard to the conflict between religion and culture, between faith and logic. Jonah is nude. Only a few decades later will such nudity, under the impact of a Christian culture, no longer be tolerated for a savior figure, except for the baptism of the young Jesus. An artistic conflict was apparently not present for the people of Aquileia. If the northern aula had been done a generation earlier,[48] its imagery was taken over without qualms, and remained unchanged. These older mosaics could have been revised, destroyed, or covered up as was the case in many churches later on. If the northern aula's mosaics date from the same period as the southern ones, the lack of conflict between pagan and Christian imagery is stunning indeed. In either case, the revisionist process that led to Nicaea did not operate at Aquileia.

Yet a symbolic ambiguity does exist, as critical as that of Nicaea. Take the "Jonah imagery." It could be seen by any representative of the rabbinic tradition in non-Christian ways. It could also be seen, with the sea monster that exists in other non-Christian myths back to Gilgamesh, in a number of religious and humanistic fashions. The context and locus of the cycle make it clear that Jonah is a symbol of Christian resurrection. Nevertheless, at the end he lies as he does in many other such representations as Endymion.[49]

Or take the Good Shepherd. By the beginning of the fourth century

certain iconic codes had been established which indicate Christian meanings. Yet the codes are not entirely clear. There are Orphic traditions with a shepherd, there are shepherds where it is not so easy to distinguish pagan from Christian meaning.[50] Even though the Christians had begun to establish certain specific codes for their shepherds, an Orphic initiate had he wandered into the Aquileia church would not have found the shepherd with the flute and the sheep so alien to his world.[51]

Or take the Victoria, the figure with the wreath and the palm next to the altar. This Victoria could well be seen by some visitor as a pagan victory symbol. It certainly could be seen as a Christian victory symbol. The Victoria is ambiguous not only for the bishops who ordered it, but for the culture at large.[52] The ambiguity arises of course from contemporary insights into the ancient world but it certainly can be observed in the ancient documentation itself. We are not sure what the Victoria in fact represents. It is possible, as has been suggested, that the Victoria was an angel. But the pagan Victoria, ever since old Greek times, had been a kind of angelic figure, the *Nike*. If the Victoria of Aquileia is an angel, the parallel with pagan art is even more significant.

The problem of ambiguity appears in a different light as we turn to other mosaics, for instance, that baffling battle between the rooster and the turtle. We do not know for sure if the mosaic dates from a Christian, i.e., early Constantinian or from a pre-Constantinian (Diocletian) period. We do know that the mosaic has been incorporated into the Constantinian church of Theodorus. Scholars have suggested several possibilities. The mosaic could signify: (a) simply a battle between a rooster and a turtle in the tradition of animal battles well known throughout antiquity; (b) the battle between light and darkness either from the Christian or the pagan side, and with some evidence to support such suggestion; (c) the battle of orthodox versus heretic.[53] Since we deal with a period in which an extreme, even cryptic reduction of visual imagery takes place, the decision on these possible interpretations can hardly be made, even by quoting evidence for one or the other possibility, because it might just be that we could present evidence that the battle between the turtle versus the rooster was used later on as a symbol for the battle between light and darkness, although this was not its original significance.

The ambiguity of these mosaics is accentuated as we examine the

problem of meaning. What did the mosaics mean? That question can be posed on several levels: (a) What did they mean for the artists who executed them? (b) What did they mean for the people who ordered them, the leaders of Aquileia? (c) What could they mean for contemporaries who were exposed to or had grown up with similar imagery and who could read such imagery in perhaps wider or even quite different meaning? The battle between the turtle and the rooster might well have had one meaning for the artist and another for the congregation; and the meaning might not have been the same for the artists executing the scene as for the men ordering it. The inclusive character of these mosaics supported such multiple reactions.[54]

Chapter 7

Processes of Analogy

You have heard that it was
said, to the men of old . . .
But I say to you . . .
Matthew 5:21 (RSV)

As the medieval theologians knew long ago, one path to knowledge proceeds by way of analogy. Originally this analogy was applied to the study of God: we do not know God, so they taught, but we speak about him by means of analogies.[1] But analogy applies as much, if not more so, to the study of history. I speak to another person: I assume that we employ language, images, metaphors in some analogous fashion, otherwise communication would not be possible. We employ a common code but the details of that code differ, as we realize, and often painfully, in the thousand daily episodes in which people and nations misunderstand each other. Analogy means that we do not use language in exactly the same way; experiences do not coincide; there is something common and there is something alien to our language. Processes of analogy bridge what is divisive and identify what is common, and it would be unimaginable to deal with literature or social science, with war or love or law without a tacit assumption that such processes are possible. It certainly would be unimaginable to do any kind of historical study including those of art and religion without taking for granted the possibility of analogical investigation.

I

As we have pointed out in previous pages, we are dealing with two separate spheres of perception, visual and analytic, not only in art but

in life altogether. The problem lies not only in the presence of these two spheres which are the result of our biological characteristics, but in the fact that actually two steps of perception take place: we see the Jonah mosaic without even noticing that in the final scene he looks like Endymion, and we become aware of the fact that he looks like Endymion and inquire about it. We undergo a double process:

A	B
word and vision are two distinct spheres each of which can or must be experienced in its own right	as we want to talk about both (the visual and the verbal datum), we reduce the response processes necessarily to the verbal level

The processes take place side by side. We hear a creed and we see the apse mosaic in the church. Then we wonder about creed and mosaic. The second step does not necessarily have to take place. We can read a poem and walk around: we can see Agamemnon and the one thing we may not want to do at the end is to rush into words. The visual as well as the verbal datum can make an impression without forcing us immediately into speech, and response can consist of silence, motion, action, or it can be visual. We may hear the *Waldstein* Sonata and want to paint.

But of course we might ask questions. We tell someone about the mosaics we have seen. We have been shaped by our biological and social evolution toward an all-pervasive duality of verbal and visual experience. The task of cross-disciplinary work is by no means to deny the word its place in culture—it would be absurd even to pretend we could or wanted to return to preverbal existence! The task is rather to become more aware of the polar nature of human perception.

There are two tasks to be done, and they can be separated. We have two perceptions and we turn each perception into verbal response; we experience two perceptions and correlate the two by a verbal response. It is the second which is so difficult and necessary in the contemporary academic arena. We hear an organ concert at Amiens Cathedral or in Riverside Church in New York. We experience a Gothic space and a Baroque fugue, side by side. We take in the space and the fugue by two separate perceptions, and both take place in us at the same time. At the end we talk about the organ, the organist, the music. We might

mention the space of the church, although in this case the words will probably be centered on the music, the purpose of our attendance. However, another verbal reponse can be made, namely to correlate the impact of the music with the impact of the space. Because it is this correlation in which we did experience that concert, consciously or not. Nobody sat in that room without being physically aware of the space, even if he did not give it a single thought during the entire concert. The real integration of perceptions is unconscious, physical, holistic. As we move from that holistic experience to language, the fragmentation sets in: we separate the space from the sound in order to talk about the sound. The cross-disciplinary task consists of responding consciously to both of these perceptions by establishing models for correlation.

Other categories besides verbal and visual play a role in the domain of perception. Every historian and social scientist recognizes the importance of man's physical activity. One example is the liturgical experience of man. The drama of the community was a major event in the lives of the people who were involved in the Aquileia mosaics and in the creeds that were recited in such churches. The ritual involved physical actions. People washed their hands, knelt, raised their arms, ate bread, and drank wine. They sang, heard, saw, rose. They existed in a space. The early Christian ritual changed radically from the meals of the primitive community to the grandiose services in Hagia Sophia and to the simple prayer times of St. Benedict's monastic community, but in all of these stages, a similar process was at work. A community expressed itself with body language, with sound and sight and word, with gestus and thought and, as is exemplified by the burning of incense, even smell.

We can extricate from these events, and have done so constantly, elements of moral or social issues, liturgical development, history of art, ideology. But that ritual, like drama and recited poetry, is the cross-disciplinary test case par excellence. Here is a union of thought and action, idea and participation. The scholar who has absolutely no feel for the gestus, for dramatic action, will have great difficulties in comprehending the impact of the ancient Christian church. Hence the kind of physical action practiced in ritual and drama is a process in its own right. Just as we can only comprehend the visual datum by employing the processes of our eyes, we can only understand the ritual by a sense of physical symbolic action.

What holds true for symbolic action, holds true for music. The Christians sang in their services; the New Testament speaks about hymns and contains hymns. As the centuries developed, there developed impressive musical traditions. Music cannot be replaced by language. But we do not have direct access to ancient music anymore. What we can do is hear music from later periods, a so-called Ambrosian chant for instance, and extrapolate back to the ancient period. We embark on a process of analogy by which we return, say, from a concert of Ambrosian music in a medieval church, to a reenactment of an ancient ritual. Such a process of analogy is our only means of access in an attempt to reexperience a sphere of the past which is accessible neither through words nor vision. I shall return to the task of analogy later on in this book.

The incorporation of liturgy and music into the problem of perception brings up another level of experience. Music, like drama and liturgy, is connected with silence. We wait, we begin, we end, we pause. We enter the building and wait for the ritual to start (the "magical moment," as a director used to call the instant before the curtain goes up, or just before the first actor makes his first move and says his first words). Anyone practicing music or studying drama knows of the crucial importance of silence, the ability to wait. The mastery of silence, the strength to suspend, no matter how minutely, the measure, the word, the action, is an essential aspect of art. "If you want to have rhythm you must be able to wait," Bruno Walter said once at a rehearsal. Silence, that extraordinarily powerful component of all art, is not a thing in itself, it only exists in contrast to speech or action or sound.

Silence is not the only radically nonverbal and nonvisual experience. Through the entire ancient world there took place what I call the experience of *askesis*, ascetic control. It was at work in prayer, in fasting, in meditation, in numerous ascetic practices from secular Greek moderation to religious taboos. In askesis, we do things with the body, and to the body. Whether what we do is harmful or beneficial has been widely debated, and we face, as in so many other historical judgments, scholarly disagreement. We are dealing with a category that is only accessible by some kind of physical analogue. One who has never experienced any kind of self-control of his body, no matter in what secular or sacred context, will hardly be able to imagine what the ascetic trends in the ancient church represented and why they were so compelling and far-reaching in Christian

expansion. It is one thing to have the classical balance toward food and wine, and another to starve your body in the desert eating leaves.

Finally, *Ekstasis* represents another autonomous, nonverbal path. Ecstatic processes are known from many religious traditions and were present in the same church which gave us Aquileia and Nicaea: glossolalia in the Book of Acts, Paul's charismatic vision, the Montanist enthusiasts, and the death of martyrs. Ecstasy is an experience beyond the boundaries of language, vision and sound, a physical *tour de force* in which the individual's control over his body is lessened and strong unconscious forces of personality and society rise to the surface. It took many forms, the classical Greek maenad in the cult of Dionysus, the Hebrew *nabi* who danced and sang in the prophetic band, the Arab dervish and the follower of St. Bernard of Clairvaux. Modern psychology tends to reduce ecstasy to manageable categories of abnormal psychology, and even in classical antiquity people were scandalized and terrified about such practices, from the Bacchae of Euripides to the vituperative polemic of Epiphanius against Montanus. And, of course, ecstasy can be highly problematic—Ignatius of Antioch wished for his death—and it has done infinite harm to society and individuals. Ecstasy has also, from the birth of the Christian movement to countless other periods of religious creativity, produced forceful religious *aggiornamento*.

Ecstasy is an experience which we can only appropriate or transmute into language with great difficulties. It is often repulsive or threatening to people who are unfamiliar with it. The person entering an ecstatic trance does so by means of or with the help of words; Agave speaks as she is drawn into the Dionysiac madness in which she murders her son. But the ecstatic subordinates speech to his experience. How can we find an entry into this realm of behavior and experience, a realm in which man pushes to the very limits of acceptable behavior and frequently crosses those limits? We are again in need of analogies. From highly charged experiences which are accessible to the average person in music, religion, art, and emotional life we can draw certain analogies of experience. Few professors have ever received the stigmata, and there is no direct access to the ecstatic, but through an indirect, analogical path we may enter that strange territory.

II

Processes of analogy arise from our desire to close the gap between word and vision, between right brain and left brain activities. The pro-

cesses try to bridge what seems close at times but turns out quite distinct at other times.[2] Whether we are talking about theoria and praxis, concept and illusion, diachronic and synchronic understanding,[3] time and time again we run into the fact which I established at the outset of this book, that both "religion" and "art" are precarious concepts.

Both fields have been challenged time and time again: art is dangerous,[4] religion is evil; art is immoral or amoral, religion is exploitative or neurotic; art shelters people from life,[5] so does religion; art keeps us from the truth, religion prevents individuals from meeting one another. The analogies apply to the opposite sides, the salvific propositions of the two fields. On one side we hear the religious claims: if you had religion you would solve the problem of your life; on the other side, the claim of art: if you had art you would solve your life's dilemma. Generations of intellectuals quite openly admitted such analogy by attributing to art the place of religion as in Goethe's famous saying: the person who has art and science *eo ipso* has religion.

The difficulties in coming to agreement about art in any comprehensive way, i.e., in terms of artists, art historians, estheticians, believers, and even unartistic observers are matched by the difficulties in agreeing about the nature and definition of religion in terms of scholars, believers, politicians, unbelievers. The problems are not identical. Although these controversies are frequently connected on both sides with the issues of ethics, the religious dilemma more than the artistic one is connected with content, reason, and society. Finally, we find minimal and maximal definitions on both sides and either a select or a comprehensive realm of culture is attributed to the two.

In specific analysis, these analogies are exceedingly complicated. In trying to establish a formula to serve as a guideline for study, we achieve at best only approximations:

$$art^{theoria} : art^{praxis} \cong religion^{theoria} : religion^{praxis}$$

$$art^{min} : art^{max} \cong religion^{min} : religion^{max}$$

$$art^{pos} : art^{neg} \cong religion^{pos} : religion^{neg}$$

or quite simply:

art	:	anti-art	\cong	religion	:	anti-religion
myth	:	counter-myth	\cong	vision	:	word
art	:	life/society	\cong	religion	:	life/society

Such are the introductory guidelines. In the concrete, the task includes a host of consecutive steps which must be followed in order to juxtapose the two fields successfully. For instance, religion and art certainly belong together in any examination of the Reformation and the Renaissance. The processes to be followed are extremely intricate and involve many areas of research: individuals such as Erasmus, Luther, Michelangelo, and Bucer; Renaissance Platonism, poetry, painting, and religious revival; Florence, Basel and Augsburg; Italian Medici circles, Saxon Germany and the England of Henry VIII. The etchings of Urs Graf, the work of Leonardo da Vinci, the Huguenot Psalter, the writings of Calvin are all part of that interaction, and demand differentiated processes of analysis.[6] There is no simple book to be written or class to be taught on art and the Reformation, Coulton's famous work notwithstanding. Precisely because the analogies include subject as well as object, different forms of art (visual, verbal, music, dance) as well as positive and negative attitudes toward religion and art (the critic, the admirer, the doubter, the believer), a study on religion and art in the Renaissance and Reformation must take us through many avenues and corners of that cross-disciplinary labyrinth.

As I have pointed out, the problems can be traced at least three thousand years back in our cultural heritage. Plato struggled with myth and he struggled with the artists. The Hebrews prohibited iconic representations and their prophets slandered the mythical fertility symbols of their people. If the dilemma of religion, both academically and in the culture at large, is no longer as closely tied to the fate of art as it once was, we still construct analogous experiences between the two.[7] When I participated in the life of a Protestant seminary, some faculty members and students would fight what seemed at that time a theological revolution in the same breath and no less bitterly than trends in modern art; and the Vatican polemic against cubist French art at Assy was closely connected with its conservative polemic against modernist trends in French Catholicism.[8]

The polarities operative behind such analogies are not reserved of course to the fields of art and religion; they appear in the realms of ideological custom, patterns of human relationship, political systems, and simple human cultural habits.[9] What is present in these two fields more than elsewhere is the degree of symbolic behavior, a combination of freedom, play and imagination, all of which are capable of causing conflicting response. Tensions are easily aroused and a major cause is man's fear of the new. New art, new religion, no matter how traditional when seen from a distance, often become a major threat to the human psyche and hence to society. The orthodox is threatened by a liberal worship service, the atheist rebels against a Pentecostal meeting; the religious revulsion is paralleled by the emotional polemic that can be heard when a radical new play opens off-Broadway or a wild new artist presents his work in Soho. The dilemma between reality and illusion, built so deeply into human history, becomes explosive when art or religion break accepted patterns, because such a break makes us painfully aware of the volatility of social and intellectual order.[10] That volatility is as much at work in antireligious as in proreligious individuals, and the intolerance is about evenly divided between the two.

The philosopher recognizes this dilemma, of course, and deals with it on a rational basis. In art and religion we do not merely deal with it, we act it out. The analogies between art and religion lie in the fact that what exists academically from a distance is here incorporated into the creative act itself. The Quaker service was not merely a protest or a philosophical alternative against the liturgical tradition of the West: in the silence of this service the protest is socially and physically incorporated, "somatized." People do not talk about silence, they *are* silent. In Léger's figures, we do not merely make a statement about industrialized society, we are absorbed into it by means of color, form, symbolism, and space itself. The analogies between religious and artistic processes lie in their concretization.

Analogies are present everywhere. The Ghent altar is a document of fifteenth-century Renaissance history; and it is a document to be analyzed precisely in its authentic function and integral structure.[11] Luther's doctrine about justification by faith is a theological vision that has its place in an evolutionary perspective of Christian thought; it can also be seen as an expression of Renaissance man. Both therefore reveal the contemporary academic problem, the methodological

pluralism of our century and its far-reaching sociological and conceptual uncertainty. It is not easy, not even for man-come-of-age after the Holocaust and the death of God, to accept or create an open cross-disciplinary atmosphere.

Neither the datum of art nor the datum of religion tell us how to deal with them. The artist may say to the critic: you do not comprehend the first thing about my art! And at times he is right. He is also often quite wrong, for theoreticians and critics have influenced artists from Renaissance Italy to the Left Bank.[12] The worshipper asks the critic, How can you possibly know what goes on in our world? The fact is, the scholar might totally miss what goes on there. On the other hand, he might have perceptive insights.

The analogies go one step further. We deal with fields which are not merely highly volatile examples of the polarity between creativity and reflection. These two manifestations of human civilization may have their very existence condemned at any moment.

III

One important type of analogy in the description and analysis of both art and religion is found in the processes of historical understanding.

Historical study takes place in a constant dialogue between past and present. We start from our contemporary vantage point, from our body and mind, from our rules of speech and thought, from emotional and cultural experiences gained through our own lives.[13] If we did not assume that man in the past had used language analogous to ours, if there were not some kind of correlation, no matter how remote, between ourselves and the object of study, no statement about the past would be possible. Historical analysis is reenactment; the process of analogy makes this reenactment possible. We can reenact a scene of the past because we feel not only estrangement but kinship with the evidence under investigation.

However, we also experience the opposite influence. We experience our own world through words, images, ideas, and events that are not our own but come to us from the past. Our images of the world have largely been given to us in home and school, by books and media and human interaction. The past gives us models for thinking, points of reference, visual symbols. The past gives us the tools for survival, and

by such past we do not mean merely the short historical period of six thousand years.

We come to the past from our experience and at the same time we cope with that experience through the tools of the past. This double momentum is not only at work in historical study, it is at work in the historical process itself. Luther looked at the New Testament through models that reflected his own life experience, monastic discipline, the teaching at Wittenberg, the breakthrough in the tower experience, the battle with his enemies about indulgences. From his own personal life he judged, to the end of his days, the entire past. But Luther's models also were the product of that past, Ockhamist thought, *via moderna*, Gabriel Biel, the Saxon peasantry and Saxon rebellion, Humanist currents. Luther saw the entire New Testament and primitive Christianity in terms of analogy with his own life. He translated Jesus and the apostles by means of his own experience, which itself took place in a sharp interchange between his own life and the forces that created him. Just as every individual exists in a polarity between his autonomy and his own past, so the historical vision he creates exists in an interchange of what he sees and what he finds.

The same problem exists in art as well as in the description of art, and it helps one to become conscious of the dual historical currents in order to understand the frequently angry exchanges on art. Paris of the eighteen-seventies was deeply shocked at the impressionists. They were seen as fools, and possibly dangerous fools, a reaction that is quite normal in regard to new religious thoughts or experiences, as the case of Luther indicates. But in retrospect we see the roles Turner, Manet, Courbet, and Corot played in bringing about that "revolution." A double aspect of continuity and break, of linear creativity and revolution appears, and we can frequently view the historical process from both angles. Just as the study of history takes place in a double movement (we come from the past and we come to the past) so the historical process itself can be analyzed from two aspects (history continues and history is broken).

Kinship and estrangement: these two primal forces in the creation and evaluation of the artistic and religious past are indeed not merely the property of academic people, but come from profound human experiences. Constantly, whether we know it or not, we return to images of our youth, of our adolescence, of our forefathers and teachers. We travel and we compare what we see with what we left behind; we meet

someone and we compare the person with someone else; we hear a new idea and we immediately correlate it with what we knew before. And yet a strange counter-pull exists: we return to our hometown and we no longer belong there. We are invited to lecture at our Alma Mater and we marvel at the distance we have traveled since we left it. We belong and yet we no longer belong.

We partake of history and we break with it. There are many ways to explain such currents as a means of growing up, as a path to our autonomy, as experiences of individuation and socialization. We know our parents and we do not; we come from our childhood world and we are no longer there. Whatever the theories, the experiences are widespread.

These short indications of the difficult problem of historical analogy and evolutionary dynamic throw some light on the dilemma expressed at the outset of this book. To operate with analogies is to accept volatile avenues of inquiry. The religious scholar of an American liberal arts college will undergo a different process of historical study on a Muslim text than a religious Muslim scholar. Their vantage points, the cultural and biographical forces which have shaped them, differ. For a long time the Western critical scholar simply called the other bigoted or uninformed, which is certainly an effective way to end the debate. With the arrival of Marxist, psychoanalytic and, recently, structuralist studies, it has become unacceptable to label any uncomfortable vantage point bigotry, although such accusations have been pronounced by many scholars hostile to the tendencies in social science. I certainly do not want to invite religious bigotry back into academic study, but I do mean to point out that in the processes of analogy with which we approach history, the variances must be taken extremely seriously.

If in such processes of analogy we start from separate vantage points we recognize frequently that these vantage points are not "discussable." We cannot simply sit around a table and agree on methodological ground rules. Indeed we want to sit around the table, but whether we reach an actual methodological agreement is another matter. What if religion and art really are obsolete? What if the academic enterprise is an obsolete enterprise? On the sides of both art and the academic study of religion, the starting points may span a serious existential battle for survival.

This is not the place to analyze in depth the causes for the variety of

vantage points on which we have touched. One thing however is useful for our analysis of both art and religion: artistic imagery reveals currents more clearly than rational categories can.[14] To incorporate religion and art into the methodological debate can mean to introduce elements that are transcending those of ideological and scientific presuppositions.

IV

These processes of analogy at work in the interactions between art and religion can be explored through an examination of the ancient Christian basilica. I have earlier presented the difference between verbal and visual domains in research. Now I intend to show what kind of processes are at work as we try to comprehend the Constantinian church. The art historian examines the basilica with methodologies of architecture and visual art; the religious historian examines the basilica in terms of social function, theological symbolism, and liturgical event. These tasks are part of exceedingly complicated processes through which we pass as we try to understand the ancient church.

Let me begin with a diachronic question: what went on in the establishment of the basilica as opposed to the temple which had been for a millennium and more the cultic center of classical religion from Zion to Delphi, from Didyma to Jupiter's temple on the Capitoline hill?

Classical temples, produced by Greeks and Romans over a thousand years, stand everywhere around the Mediterranean Sea, from Evora in Portugal to Baalbeck in Syria, from Corinth in Greece to Dougga in Tunisia. These temples, rectangular and circular, produced rich stylistic developments, from simple columnless sanctuaries to the classical hexastyle temples of Paestum and the rotunda of Fiesole. Architectural laws, numbers, and proportions, entasis and architrave, metope and triglyphs have been analyzed even by the ancients,[15] and we admire the shortening of the perspective, the curvature of the stereobate and the entasis of the columns. Pagan antiquity continued to erect such sanctuaries throughout the early Christian era, and as late as A.D. 361 pagan temples were repaired in the city of Rome.

The Christians produced a sanctuary that was distinct from the temple: the basilica.[16] Only a few traces have come down to us from pre-Constantinian times, but from the fourth to the sixth centuries a good number of impressive major basilicas as well as of parish churches has survived in Rome, Ravenna, Salonica, Istanbul. The origins of these

basilicas are contested, and one can argue whether one should call all early Christian churches summarily "basilicas."[17] The overall trend is clear: the Christians did not build temples. They developed a sanctuary that was, like the pagan temple, at times rectangular, at other times circular, a sanctuary that was distinctly different from the famous temples in Dougga, Bassae, or Selinunte.

The steps can be historically traced. Christians offered, or thought they offered, an alternative religion to the pagans. They were not about to duplicate their sanctuaries. One reason was cultic: the Christians celebrated their Eucharist in a building, and architectural pattern obeys this program. Another was political: some of the major prototypes of the Christian sanctuary are found in political buildings, the basilica of Septimius Severus in Leptis Magna and the basilica of the young Constantine in Trier. We can explain the shift by political and ideological analogies. While the Christians did not hesitate in other instances to take over important religious symbols of paganism (Helios, Kyrios, Soter), in the choice of their sanctuary they did not take over the cultic pagan space. They took over and developed a political and sectarian space which in turn had been related to the cult of imperial worship. The reasons for the shift can be deduced from texts, from the historical evolution of Christianity and its conflict with Roman culture.

We can also approach the problem synchronically and then another set of analogies begins to operate. I choose one example from each structure, the Doric temple at Segesta and the Basilica of Santa Maria Maggiore in the center of Rome.

We drive to Segesta, located on a remote hill drenched in Mediterranean sunlight. Before us appears that Doric temple, apparently unfinished for reasons we shall never know, a hexastyle sanctuary made from bluish stone which blends into the rugged contours of Western Sicily. From the valley we approach the temple, walk around it, and immediately feel its profound "paganism," its organic relation to the slopes on which it stands; it rises from the rocks as Venus rose from the sea. We become aware of an esthetic harmony between stone and form. We enter. No *cella* has remained and everything is open toward the outside, enhancing the unity between temple and land. The sun floods in and the wind blows through the spaces between the powerful fifth-century B.C. columns. The locusts are singing everywhere.

One day in class, a graduate student smiled as I used just such an ex-

ample: what on earth do locusts and wind have to do with the academic study of religion? A great deal, indeed. As I juxtapose the Christian basilica to Segesta, I find no locusts in Santa Maria Maggiore. It is quite a different experience that awaits us there.[18] We are in the middle of Rome, we enter through the Renaissance narthex, the ancient atrium has long since disappeared, we step into an enormous hall, the room is dark and we must adjust our eyes. It is cool in here, no locusts indeed, and the wind is shut out by the massive walls. All we hear perhaps is the noise from automobile horns. We are in an urban world, yet in an ancient Christian basilica, and though the decorations, the transepts, and the gigantic baldachin are Renaissance, the dimensions of that church, the spatial atmosphere, and the mosaics take us back into the fifth century A.D., almost a thousand years after the building of the temple at Segesta. The experience at Segesta takes place in an open world. We are part of the Sicilian land, we feel the rocks from which the temple is hewn, we walk easily in and out of the sanctuary. We touch with our palms the rough and weather-worn columns. I cannot imagine visiting an ancient temple without feeling the marble or limestone with my palms, perhaps fifty million years old and at times enlivened with petrified shells. Through the intercolumnations between the fifth-century B.C. columns I can watch the hills roundabout. The fact that the *cella* is nonexistent here enhances the openness of the temple. The gods may enter this naos anytime and leave on the other side.

In the basilica, a fundamentally different experience awaits us: we enter a space that is shut off from the outside. In ancient times, catechumens had to leave before the Eucharist, and in some prestigious Roman basilicas a guard may still chase modern women away who try to enter the space with bare arms or offensive garb. For in here the outer world seems banned and has been replaced by a new, symbolic cosmos. Shoes resound in the hollow space and we hear the echo of voices. The external cultic space has been replaced by an inner, an enclosed cultic space. Columns have come in, a fundamental shift of architectural symbolism. The event has come in, the cult, the social gathering. In the pagan temple, there stood an idol in that *cella*, in the center of the temple: now everything has become *cella*, the people, the columns, the symbols, the prayers, the feast.[19]

As we repeat these two processes, first approaching a temple in its symmetry, location, and external impact, then entering a Christian

sanctuary where we must adjust our eyes before we can begin to see, we duplicate something like the shift that took place in the psyche of ancient man as he replaced the temple as the locus of his communal ritual by the synagogue or the basilica. The antique process is paralleled by a modern one: when we enter the basilica, we go through different psychological and artistic steps than when we walk around a temple. The person sitting on the plinth of a Doric stereobate today does not experience the same relation to his environment as one sitting on a bench or on the floor of a basilica.[20]

There are reasons for this shift. Cultures do not exchange their major symbols without the motivation of urgent necessity. The replacement of the temple by the basilica is such a primal symbolic change. When the Persions had ruined the temples on the Akropolis, the Athenians gathered to build new ones. They became more glorious than the former, symbols for the mythical past, for tribe, city and land, reflecting that rich mythical canopy (Pallas Athena, the Caryatids, Nike) from which the classical world had been shaped. But the temples did not suffice in the long run. Instead of the temple in Zion, synagogues rose all over the ancient world. Already the Athenians walked in huge numbers to the mysteries of Persephone. With the age of the mysteries, house sanctuaries spread everywhere.

One could recall that there had been enclosed shrines since prehistoric times, from the caves of Crete down to the Roman Lararia. The architectural change might be called a return to earlier cultic symbols, as in the Mithraic *spelaeum*. But if it was a return, it was a highly artificial one: the Mithraic cave is often "constructed" in the middle of a Roman city. The mythologies of Cybele and Isis are ancient, but the sanctuaries lie in contemporary Greco-Roman cities. In every change, there is a confluence of progression and return. What is new in the Christian basilica, as in the sanctuary of the mysteries, is its urban characteristic; a sect which claims "old" truth offers a new sociomythical identity.[21]

But now only do we come to the problem of analogy in the interaction between art and research. We experience the temple today as a momentous unity, a work of art out of one cast, a total architectural statement. When the Athenians rebuilt the Akropolis, after the Persian wars, the old-time Hellenistic religion had long begun to crack. During all the time in which the classical Greek temples were being built, from the age of Pericles to the age of Hadrian the religious crisis

of antiquity was on its way. Plato was writing and so were Democritus, Aristotle, and Xenocrates. The clash between myth and philosophy, between gods and man was already being fought. Socrates died for his "unbelief."

The temple is not an expression of the "reality" of the ancient world. It is an artistic vision, a glorious symbol for polis and society, a play with forms, a technological achievement, a brilliant display of mythical imagery and humanity's genius. But it is not an accurate rendering of the religious reality of Athens or Rome, of ancient man's society. It reveals one side of the ancient religious attitude, a conservative, ideal one. If we did not have Parmenides, Socrates, and Aristophanes we might not know how partially the temple displayed the religious world.

The academic purist tends to smile at the modern tourist who hopes to experience some kind of contact with classical antiquity in a sports car. The tension between the classical temple and social and intellectual reality was already present when the Athenians rebuilt the Parthenon, and much more so when Caesar, half a millennium later, built a temple in his Forum to Venus Genetrix. Pausanias was a tourist.[22] If someone wants "pure religion," he should not go to a classical temple.[23] The problems between religion and art were already present when these temples were built. Therefore not only in the secularized Museum of Modern Art in New York and in cubistic twentieth-century architecture, but already in classical antiquity art drew people into its tension with society.

Similarly, as we enter Santa Maria Maggiore we find ourselves in a tension between art and life. Here man built a wall around himself and constructed a cosmos of his own. It is a cosmos of redemption and new life, in gold and purple and white, and in that cosmos man was to find security, beauty, and power. But as we know quite well from the texts, man did not find these things in here: it is in these basilicas that ugly statements were made and vile sermons preached against heretics and Jews.[24] The tension between the statement made by these architects and the society to which this architecture belongs is as severe in the basilica as it was in the temple.

Moreover, the basilica consists of a rather far-reaching ambiguity. Here is a new space, with mythical symbolism (Jerusalem and Bethlehem, the gospel symbols, lambs and crowns and purple gowns). The symbolism is arcane, the baptized only are partakers of the

mysteries. But the basilicas are enormous; the feeling of the inner space is countered by a feeling of public power. The basilica consists of a sharp tension between its arcane and its public thrust, revealing a church that lived in a world of its own and that crammed this world down everybody's throat. The basilica is private and political at once, and we feel that duality strongest in the Roman examples, which are the most spatial ones. Such ambiguity in the basilica was surely not a conscious act by the architects or bishops but an unconscious expression of the problematic of the church.[25]

An unequivocal process of analogy does not exist. Temple or basilica can be comprehended by several methodological tools. We can see them in terms of artistic, architectural, symbolic, or iconographic rules; we can see them sociologically, in terms of social history of art, i.e. in relation to pagan and Christian history; and we can see them in terms of a psycho-historical approach, as expressions of man's predicament in the first millennium B.C. and in the first few hundred years A.D. Cross-disciplinary work must juxtapose and confront such different methods, which when left alone often represent polar avenues of research.[26]

We discover within such multiplicity a double relation between art and life. The temples and basilicas reflect social reality, but they also lie about it; they sometimes present an accurate emotional reality and they sometimes deceive us. Art like religion is a mixture between representation and deception: neither the temple nor the basilica "reflects" ancient man accurately. We find out what man was as we juxtapose temple and basilica with what we know from other data, namely from texts. As we confront temple and basilica with such data, we are led to write more than one story. The symbolism can be read in several ways as I have pointed out before. Archenemies like Arians and Catholics could use the same baptismal iconography. A Roman basilica is what the leadership wanted the believer to experience, what it forced the believer to worship in. A pagan could walk through a basilica and experience a different building than did the Christian architect.[27]

Let me give an example for two distinct experiences in the ancient basilica, experiences which we can in part repeat today as scholars or visitors. The ancient Christian entered the church in a straightforward sequence: through the atrium, into the narthex, toward the front of the church, i.e., toward the altar, *schola cantorum, presbyterium,*

apse. He looked East (in the reverse Roman churches he looked West) toward the apse with its iconic display. From the presbytery, the bishop would step down toward him with the presbyters, and as a layman he would receive the heavenly food. But the ancient cleric experienced that church quite differently: he entered the sanctuary from the sacristy, or from the *diakonikon,* he stepped on the *exedra,* looked back, looked down, did not see the apse mosaic but the mass of believers from above, would speak to them or sit in front of them, and finally step down toward them. A building exists for man to dwell in, to walk and feel and sit and speak and hear in. These inside buildings existed for two quite distinct experiences, one for the clergy and one for the laity, and the millions who worshiped in them in the final centuries of the Roman Empire underwent two distinct physical and social processes. They "saw" two different churches from different perspectives:

looking up	looking down
facing apse windows	facing the congregation
walking toward the few	stepping down toward the many
hearing	speaking
receiving	offering

Behind these two different perspectives stands the entire clerical, social, and liturgical polarity of the ancient church.

Many years ago Collingwood proposed "reenactment" as a major process in historical research. My entire approach is, of course, based on Collingwood's suggestion, with one crucial difference. Reenactment is not merely a rational mental process; it is also a physical, visual, and experiential process. As we deal with data of art, we deal with vision and we are drawn into a response. Vision and response are as much part of the disciplined academic enterprise as are deduction and verification. The scholars of the Western world have, if only in theory, expressed a preference for intellect and reason as the locus of consensus and objectivity rather than experience, emotion or vision, even though this seemingly rational basis has led to little agreement. To operate with reenactment is to acknowledge a broader research process than merely one of intellectual deduction: we reenact with our body and with our emotions as well as with our logical mind.

Such reenactment is not, of course, a replacement of reason, and I

am not about to substitute a dogmatism of intuition for the dogmatism of reason. Reenactment, like acting on a stage, is a mixture of gestus and mind, of bodily and intellectual and emotional activity. In order to inquire into temple and basilica I walk and feel and enjoy; I also think and deduce and question. Enjoyment and critique are equally valid atitudes toward the object of research. The subjective danger lies less in the often expressed fear that "anything goes," a fear that is greatly exaggerated. The danger lies in the fact that we start from distinct points and hence, from the very beginning, wander different avenues. If we ask a conservative Greek Orthodox theologian, a psychoanalyst, a structuralist art historian, and a specialist in iconography to speak about these basilicas, their processes of comprehension, their reenactments will vary greatly. To accept reenactment is to incorporate subjectivism, even the lack of ultimate consensus, as much as the rigor of intellectual investigation and the task of documenting theories as precisely as possible.

V

The process of analogy also starts from the present as we confront the basilica. We live in a modern town, we were born into a twentieth-century home, we have received our learning from a contemporary school. The starting point of the historical inquiry into the churches of ancient Christianity is the world around us. The analysis of the contemporary components in the process of analogy has important bearings not only for the study of ancient churches but for that of the entire relationship between religion and art.

There has developed since the 1920s and 1930s something like a modern style of church architecture.[28] The style has ramifications in individual architects and traditions. It is thoroughly challenged by large groups of religious as well as by nonreligious people, but it can be identified by definite marks: starting from such constructions as Perrier's church in Paris and the *Johanneskirche* in Basel, it incorporates into its basic structure contemporary building material, glass, steel, concrete; it exhibits cubistic tendencies, the return to basics, geometrical reduction, empty spaces, the break of traditional symmetry; it manifests technological and scientific trends akin to twentieth-century science and technology. Because of its unfamiliar shape it shocked the burgher by its daring innovations, and not many

of these new churches were received without incredulity and even ridicule. The construction of the contemporary churches was a revolution. The architect of the reconstructed Cathedral of Coventry recalled once that he had received numerous letters in regard to his building, some of which were rude and others which were very rude.

One of the aspects of this contemporary style consists of the breakup of familiar architectural traditions.[29] For a century and a half, Europe and in its wake America had built copies, Romanesque, Byzantine, Gothic, Renaissance, Colonial, Georgian, Baroque. From Ronchamp and Worms and Birsfelden to Elmgrove Village outside Milwaukee where William P. Wenzler built one of the most fascinating churches of the century, sanctuaries went up that no longer looked like their predecessors.[30]

Nor was it possible any more to recognize from a distance to which religious traditions such a church belonged. To be sure some parts of Europe had developed a code by which a cross marked a church as being Roman Catholic and the rooster on the bell tower made it Reformed-Protestant. But that distinction was simplistic and frequently misleading: Catholic medieval churches could have roosters. Ronchamp is Roman Catholic. So is the Cathedral of St. Mary in San Francisco. Elmgrove is Episcopal. Saint Peter's at Lexington Avenue in New York is Lutheran. The contemporary style goes through the entire spectrum from free church to synagogue. Frank Lloyd Wright built a Unitarian church, a synagogue, and a Greek Orthodox church.

The use of glass, concrete, and steel often gives to these churches a factual, technological, or scientific appearance.[31] They seem at times cold. They are fascinating in their cubistic or surrealistic shapes. The coldness is countered by dazzling effects of colored glass and contemporary painting. Audincourt and Assy display modern art. Léger, Chagall, Lipschitz, and Germaine Richier have donated their works for modern churches. Louise Nevelson designed a chapel in New York. There is a Rothko chapel in Texas and a Chagall chapel in Jerusalem.

However, there is no consensus about this style in the religious traditions at large. Many churches built especially in North America and in the so-called Third World are not of this contemporary style. The free church tradition with its conservative constituency continued to build what looked familiar from the past. A millionaire gave money for a chapel at Northwestern University on the condition that it be Gothic. It still astonishes me, not that such a condition was made, but

that no one among the trustees of the university was astute enough to stand up for artistic integrity against the bequest. Churches at large finally did accept a compromise between traditional and certain cautiously incorporated contemporary forms. It is that compromise which to many people represents "modern" church architecture. In this compromise, Christian groups tended to incorporate iconically conservative elements and traditional paintings, copies of the Last Supper or of an ancient Christian mosaic that would adorn sanctuaries or entrance halls. American Protestantism produced its own icon, Werner Salman's *Jesus,* a mixture between traditional European symbolism and early pop art: an innocent man's face with blond locks radically different from the faces coming to us across the rooms of a modern art museum. On the whole, contemporary art as well as the kind of contemporary buildings symbolized by such names as Wright, Corbusier, Gisler, or van der Rohe were only reluctantly accepted by the mainstream of modern believers.

So far the picture in outline. What kind of analogies can we draw from this situation? Or rather, to what kind of analogies are we led, given our participation in this contemporary evolution? It is immediately clear that the historical evaluation will differ depending on where we start. I expressed my dismay to some of my colleagues about Northwestern's mealy-mouthed acceptance of a Gothic sanctuary and some of them saw no reason to get upset about this case. The conservatism in art was not a major concern for theology. If it had been a matter of conservatism about race or social ethics, the tenor would immediately have changed and they would have been enraged about, say, accepting a contemptuous stance versus Blacks or Jews. The person who gets angry at traditional racist views on Blacks but who could not care less about modern views on form will look at ancient Christian churches differently from the one for whom contemporary art is as important an issue as contemporary race relations. A great many of the conflicts between psychological and artistic positions in regard to history, society, and personality go back to such fundamental disagreements about values and culture. I continue my case obviously from a position in which the attitude toward form is an indicator for human and cultural values, and not an irrelevant esthetic hobbyhorse, but I realize that this position is countered by Marxist as well as by traditional ethical and rational anti-esthetics.

The analogy leads to concrete historical observations. By the fifth

century A.D. there was such a thing as a Christian art.[32] There are buildings, structural elements in these buildings, iconic codes which established a Christian tradition. The mausoleum of Galla Placidia, Santa Maria Maggiore, Santa Prassede, or Sant'Ambrogio belong to and express an important artistic trend of a major religion. Our age is no longer sure what such a religious code could be or even if it should or could exist.[33] The pluralism in academia, to which I pointed before, is repeated, in fact emphasized by an extreme polarity among religious traditions in regard to art. The documentation on art is therefore an excellent indicator of the lack of intellectual and cultural consensus frequently ignored by the academic mind. However, as we go back two centuries before Classe, we find quite a different world. We stand in Santa Costanza and debate whether the symbolism is Christian or not. The scholars do not really know. We are not sure about the cross in the Herculaneum, nor about the poem about the Phoenix. If the Phoenix in the Christian museum of Aquileia had not been found near the church, it would be hard to determine whether it was Christian or not, despite its halo. If we try to find analogies of artistic experiences, we have to go to the beginnings of patristic art and not to its apex, i.e., to the third and fourth and not to the fifth and sixth centuries.

This observation bears on how we comprehend both our own and the ancient church. We live, so to speak, in a new Hellenistic universe, in an amalgamation of heterogeneous trends. It consists of radical confrontations between old and new, of often bizarre encounters between East and West, magic and science. Different cultures set themselves apart from the "barbarians," i.e., the rest of the world. The links in this neo-Hellenistic universe are no longer Greek and Roman and the imperial systems of highways, mail and maps but are modern communications of English, Russian, Arabic, and Chinese. What distinguishes the new from the old Hellenistic universe is the dangerous process of racial amalgamation against which the old tribal momentum rebels, and the degree of interchange both through travel and the media. If we try to comprehend the evolution of the ancient church, we must realize that the Pax Romana, the imperial experiment of a large world, made Christianity possible, but that it was overthrown in turn for the sake of a considerably narrower, particularistic, and autocratic tradition, namely that of the Christian church.

It is from that distinction that one can identify two desires among the historians of Christianity as they deal with art: one is a longing for

the kind of unified Christian culture which the early Byzantine data manifest in such glory (the apse of Classe is one of the most superb documents of the ancient church in its unity of theological, architectural and iconic statements);[34] the other is a rebellion against the artistic trends in the ancient church because, especially in the early period, they do not support the linear picture established by ecclesiology and Christology. Constantinian art confuses us because of its iconic uncertainty; Justinian art dazzles us in its totality. We live in a culture that is much more akin to the first, but we come out of a culture which lived in the dream of the second.

Another aspect of analogy must be mentioned which relates to the enterprise of scientific understanding. The culture from which we enter the analogy consists itself of an amalgamation of two thousand years. The analogy is built into our very starting point: we walk through London, Munich, or Rome and before us lies an impressive historical corpus which contains the roots to our present culture. Basilicas, churches, monuments, Renaissance houses, Baroque, classicistic facades, city halls from the fifteenth to the nineteenth century. We come out of a present which is itself a visual documentation of the confluence of past and present. This fact is not a matter of course: Orwell's nightmare state would destroy the past consistently in order to construct its narcissistic totalitarian present, and there have been plenty of iconoclastic voices which would want to destroy precisely these layers, the richness of cultural amalgamation. The artistic breadth of contemporary man, our cross-cultural perspective, is not acknowledged by all; but if we no longer had it, our confrontation with the past would be quite different and we would be so much the poorer for it.

The awareness about and presence of analogies in the study of art and religion makes us sometimes recognize unexpected elements of continuity and discontinuity between the two fields, and most of all between individuals within the two fields. It is not the case that a conservative church by necessity produces conservative art. The Unitarian churches of America, contrary to what one might expect from their historical rhetoric, have created a surprisingly large number of Colonial copies, while churches with a considerably more conservative structure and theology have been a leading force in contemporary church architecture.[35] Even within specific traditions there are significant variations between congregations and individuals vis-à-vis art.

The Eastern Orthodox tradition asked Frank Lloyd Wright to build a church in Milwaukee, the Episcopalians built Wenzler's church in Elmgrove, the Lutherans had the same architect build a church in Glendale, Wisconsin. While modern architecture swept the European religious scene from the forties on, the American scene became visibly split between congregations copying the past and congregations building contemporary sanctuaries.

These analogies throw light on the ancient material. The temple was not simply, as it may appear to the romantic traveler, an expression of a creative society. In terms of artistic achievement, of architectural genius, it was; in terms of religious evolution, it was an astonishingly conservative symbol. It perpetuated in marble earlier structural elements, columns, guttae, metopes. In terms of the emergence of classical civilization the temple was an expression for the conservative aspect of religion. The basilica, as the Christian counterpoint, was a symbol for a new, highly political religion. The acceptance of the basilica over the temple by the early Christian Church was not a conscious but an intuitive socio-political and artistic act, yet the basilica in turn became the static symbol for this new religion. Its forms were perpetuated for centuries. As in so many other manifestations, the Janus-character of religion became obvious in Christianity, the presence of preserving and creating forces within one and the same movement. Neither in the contemporary nor in the ancient Christian world do we have a full correlation between religious and artistic creativity, and it is imperative that we free ourselves from the simplistic notion that the creativity of a religious group necessarily expresses itself in art, or that a religious group is not creative in art when it is creative in social or intellectual models. Because religious traditions are so profoundly caught between the prospect of change and the panic about change, their relation to art vacillates between creativity and a rejection of creativity.

In order to explain these vacillations, we can point to the tension between the average worshiper and the avant-garde leadership of the culture, a tension that has achieved dangerous degrees in a democratic society where a community decides on a sanctuary and on art and not the leadership. Nevertheless, strong counter-indications show that the artistic dilemma in religion is much more complicated. Churches with strong clerical decision-making processes like the Roman Catholic church have found it easier to create some contemporary

churches than say Methodists, yet the very same Catholic church has fought contemporary art vituperatively in some dioceses. Pastors in both Catholic and Methodist churches are divided on art. Never perhaps in history has the rift between traditional mainstream and avant-garde religion been as severe as today, and one arena in which that rift is battled out is in the realm of art.[36] The church of Ronchamp looks like an absurd alien construct to the person unfamiliar with modern art. The extent of the rift can be easily measured when we compare popular Christian art such as is sold in religious bookstores with imagery by Germaine Richier or Salvador Dali.

And yet the split is only one more variation of that conflict that goes back to the origins of Judaeo-Christianity: between religion as a conserving force and religion as an expression and tool for social and intellectual change. Religion is a support for the political establishment, and religion is the locus for revolution. We have known that duality for a long time, in ancient Judaism as the conflict between prophet and priest, in Rome as a violent confrontation between the Senate and the Bacchanalia. The tension cannot be solved, at least not in terms of a social order, of an ideology or even a ritual, because it represents the religious dynamic of mankind par excellence: man wants security (and he finds this security in the religious patterns of the past) and man wants change (and he finds hope in social and mythical constructs); and both security and hope are built into religious symbolism. No wonder analogies criss-cross one another.[37]

VI

Without processes of analogy we would not possibly inquire into the world outside, let alone into the past. We assume that what we experience has some validity for what other people experience, and that analogies exist between what we experience today and what people experienced in the past; that certain associations of language, despite all cultural transformations, have remained constant; and that we can argue from the present back to the past. Analogy is not identity: not all people feel the same way, or use language the same way, and to expect homogeneity would be utter foolishness. The processes of analogy are approximations, they create proportional relations between my cosmos and that of another culture or individual. All historical study, in religion as well as in art, is based on such an assumption.[38]

Such analogy is made possible because of a double relation we experience toward our own past. Man possesses *memoria,* as Augustine knew so long ago,[39] that enigmatic ability to recall. It is one of the great mysteries of human existence altogether. We return to the places of our youth. We know the houses, the schools, the playground, the church. We walk through the streets: all looks familiar to us, as in a very clear dream. But as we walk that dream, a second impression is present: I do not belong here any more. I have gone somewhere else, and whole layers of experience connected with these places, have been erased or suppressed. The processes of analogy work with both familiarity and distance. We imagine a way back in order to recover what is lost, and we know that spontaneity and immediacy are gone.[40]

That dual relationship to the past is tied in with the mythic creativity of which we spoke before. The revolutions of 1776 or 1917 become models of recall. But in the process of *memoria* we are mixing facts with illusion. We recall and deceive ourselves, but we also recall and fortify the present. Analogies, like myths, are a mélange of fact and dream, and as such extremely potent. After all, the *memoriae* of the Buddha and Jesus, of Exodus and the Prophet, created world religions.

A powerful emotional component is present in the censorship of evidence. Familiarity and alienation, continuity and discontinuity work together, and our brain tries to eliminate what it cannot tolerate. Behind the often frustrating lacunae of historical documentation lies man's genius in suppressing what would make him ill, or insane, if he had to carry his past in all its horror.

These emotional aspects of our past return in the cultural attitudes toward fringe religion. The horror of censored experiences is let loose on the heretical foe or on the feared intruder. Our culture treats the Krishna movement or the Moon church with the same venom which it used to unleash on Irish Catholics, Anabaptists, or Jews. The fear of the strange is a pervasive force in the censoring processes of our memoria.

Similar mechanisms operate vis-à-vis art. Fascination and repulsion surface constantly, especially in confrontations with new works of art. Courbet was not only rejected by the salon, he was ridiculed. We have shown before how the iconoclastic eruption is often the result of fear, and how art, often a tool for social or cultural change, can be violently rejected by whatever establishment is in charge. In the history of art,

in all the many controversies over new styles, over the human body, over permissible topics and intolerable demands, fear is projected in the process of analogy onto the object, the painting, the novel, even the new music.

However, in an encounter with art, visual art no less than music or poetry, it seems to us that analogies might not be always necessary. We might be able to face art directly; space, harmony, balance, texture, light, and color might not need a previous experience, a contemporary starting point. One could easily admit that to write a history of Haydn or Rembrandt analogical processes would have to come into play since we examine biography, social conflicts, creative processes. But we do not need to know the sociology and religion of Ghana in order to appreciate a wooden sculpture from one of its tribes.[41] Even "content," that major stumbling block in philosophy and history, should come to us directly: a face remains a face, a figure can exist outside any context. We study faces from cultures about which we know absolutely nothing. Even minimal content in art performs some kind of communication.

And yet art history is as much dependent on analogical processes as every other field. Directness is mostly not possible. We must pause before that Ghana sculpture, and in that pause something goes on in us as we begin to appropriate and translate that strange cubistic figure into our world. The step from the datum to our mind presupposes some kind of proportional transmission. Gombrich's *Art and Illusion* makes that case superbly.[42] To the persons trained by the academy, the canvases of Pissarro looked wrong. The people of Paris walked out when they heard for the first time *Le Sacre du printemps*. Art becomes appropriated only when some kind of exposure is possible, and that means when the receiver creates or is given some kind of a bridge between his world and that of the strange work. We all know that the gap can hardly be closed fully.

What can an interaction between art and religion contribute to the problem of analogy that has been with us since antiquity and that often has led to so much discord among scholars? I believe that perhaps the major contribution of our cross-disciplinary venture lies just here. More than half a century ago, Rudolf Bultmann proposed that we admit to a double task within the historical enterprise. He suggested that we first study an historical datum as evidence in its own right. We examine words, context, and roots critically; we consult lex-

icon, commentary, and we sever authentic from dubious evidence, the primary from the secondary sources, and so on. In a second step we ask what these data mean. When we hear metaphors like salvation, kingdom, resurrection, or fall we want to find out what they meant to the people hearing them from our own experiences. We can only ask that question by some kind of analogy: today, resurrection might mean hope in the future, affirmation of life etc.[43] By such proportional analogy we might comprehend why a religion appealed to the ancient world. Bultmann thereby tried to separate the positivistic task, the inquiry into *what happened,* by severing it from a second, equally important question: *what is its meaning?*

There are numerous problems to this approach, not the least being the fact that "meaning" for Bultmann was so much tied up with one set of existential imagery. Furthermore, one can point out quickly that the two cannot be neatly separated. When we inquire, for instance, into the famous saying of Jesus, "Upon this rock I shall build my church," even the historical inquiry is laden with our stance toward episcopal authority or papacy. I would like to suggest, however, that as we transpose the model of Bultmann to the level of religion and art, it receives some unexpected support, except that prior to the distinction between positivistic search and translation into meaning a preliminary level of confrontation must be considered.

There exists in art as well as in religion a pre-academic, prescientific, and hence pre-analogical stage of encounter. It has been present in the field of religion all the time: in the story of St. Francis, the conversion of St. Augustine, and in Luther's stance before the diet of Worms. These stories made an impact on people—despite the fact, or precisely because of the fact that they are bordering on the mythic—to the point of creating entire new movements. All we need to do is study the role of the poor in Jesus' life, through Western society, and we comprehend the extent of this immediate impact.

Similarly an immediate impact of art is quite possible. The specialist tends to smile at the romantic role David played in Florence or the Göttin of Raphael for the city of Dresden;[44] a confrontation on a preacademic level especially in terms of larger social forces has happened in the past. To be sure, the impact can be misleading in regard to that society, it can be innocent, phony, the Victorian infatuation with Thorwaldsen. Nevertheless, the prescientific confrontation with art breaks the hermeneutic impasse nonchalantly: the persons who wept

when the Sistine Madonna returned to the Zwinger of Dresden needed no explanation, no theory of art, no religious imprimatur.

A second step follows the positivistic inquiry into the evidence. The analysis of material, color, space, light, in terms of ritual and drama, context and roots. Something basic is at stake in this process: now the datum of art, as the datum of religion, is no longer my own projection. I am at least potentially and partially delivered from perpetuating Narcissus ad nauseam. A world of form is outside of me, to be confronted beyond the boundaries of belief and experience, outside my own familiarity. In art as in some religious texts I face an *alienum,* a world before which I can still wonder without appropriating it immediately, a realm that contains the unexpected, the numinous, threat and joy.

There is a third step: I want to appropriate what I see consciously into my world and with my language. I *must* talk about art. I must draw, sing, dance, or take pictures. But I must respond. I become conscious of what I see or hear. I wake up.[45]

The three stages are intertwined, of course, and do not need to be separated artificially. Yet the separation drives home a crucial point. Bernard Tschumi exclaimed that I cannot simultaneously experience and think about experience. Well, perhaps not simultaneously, but I certainly alternate quickly and frequently between experience and response, between impact and reaction. That alternation is at the root of human consciousness and social interaction. The hermeneutic process begins the moment I tell someone about a work of art I have seen in a show, and the moment I leave the theater and make the first gesture. We experience and we think about experience, and that duality makes us human. And even silence, the inability to respond with words, can be one such form of response, by the body, by the breathing, by what goes on in our brain while nothing comes out of our lips.

I would like to suggest a frame in which these steps can be actually tried out and I take as an example the 1978 Rothko retrospective at the Guggenheim. Frank Lloyd Wright has created a rather ideal space in which the hermeneutic experiment can be carried out. When I begin on that sixth floor I enter a process. I walk down and it is as if I go through a dramatic sequence, a reenactment of a set of data. I walk "through" the data.[46]

Now I can walk through that exhibit without any agenda. I let

Rothko make his impact on me. After all this is how art works on us abundantly: we pass by the Oldenburg clothes pin or the Lipschitz bronze in Philadelphia. This kind of spontaneity and immediacy is hard to achieve. But in such a process I am given the chance of being, once more, open, *tabula rasa* in front of the Rothko panels. I have found it extraordinarily helpful to send students through such a show and tell them, "Please do not talk." Experience whatever you wish, whatever you can. No grade. No need to show off to anyone. Get absorbed by whatever processes you are capable of this afternoon. The chance of immediacy, the attempt to overcome narcissism no matter for how short a time and in how limited a degree, is worth that try.[47]

I take that elevator back and start a second time—Frank Lloyd Wright's building, so often slandered, has given us a superb chance to experiment with such repetitive processes. I start all over. I look at the painting with the tools of Roskill, Arnheim, or Clive Bell. I examine material. Light. Technique. The dual colors. The triple colors. The disappearance of the figure. The tension of the horizontals, two, three, four strata. The predecessors that come to mind, the followers. The emergence of the mature Rothko in a short time after 1946. The impact of this art on the American scene.

We test the data. What color is primary? What rhythm can we detect, what general development? We test the structural order, the color schemes as a whole, the purity of the color, the nuances in the differentiations between higher and lower panels. We learn to see with sober eyes, we learn to differentiate. How are the colors mixed? What is the impact of the mixture? What does Rothko achieve, where does he finally come out before his death? What does the evolution indicate?

I take the elevator up a third time and ask some questions of Rothko. I realize some art historians will prohibit me from doing so but I shall not listen to them, for I came to America like Rothko, over the Atlantic, and I have brought to America my past the way he brought his Russian past, and hence my past and my present cannot be effaced before these canvases.[48] I brought with me Camus and Nietzsche, the Holocaust and Karl Barth and Paul Tillich, Paul Klee and Federico Fellini. I respond with my history. I let my mind wander and I see stunning parallels. I know the famous church of Zillis quite well, whose panels date from the second quarter of the twelfth century.[49] In Zillis the life of Jesus panels are painted against a horizontal

background, the four-story universe of Romanesque art, always in the identical colors of green, red, blue, and yellow which are superimposed on each other. For Rothko the same horizontal stripes exist but they change their colors and the figures disappear. The foundation has become the whole, and the persons die out. Can modern art no longer face the human partner? A mystic or an existential process, the elimination of a "Thou" or the recovery of the "I"?

I have simplified and perhaps artificially controlled matters. Generally we do not go through a museum or through a church in such a fashion, although I have practiced such interaction between the object and us with such discipline and with valuable results.[50] Not everybody experiences the same way, and some people do not even have the patience for such processes, some want to quit after the second time since meaning is threatening to them, while others cannot exist without immediately asking for meaning.

We can also add other processes and one of them is exceedingly important for our investigations. We can *reverse* the sequence (it takes some cunning because the guides at the Guggenheim will push us toward the elevator!) and recall the entire process, go backwards, *walk up,* roll up Rothko's work from the last to the first. Karl Löwith taught us to teach history in this fashion, and I have always practiced it both in history and in art.[51] I experience creativity in reverse, I become conscious of the processes of time, running against it. As we reexperience in the Uffici a six-hundred-year process in reverse we become especially conscious of the evolutionary process in turning back, in going to roots and to more roots until we finally stop at the medieval madonnas of Tuscany.

And here we come to the clue: these processes of visual perception and personal response, physical and intellectual at the same time, tend to break the hermeneutic circle with which academia has been cursed for so long, not by any new "insight" as if we would be able to write an especially brilliant thesis after these processes or by an epistemological theory that would "solve" art history or religion once and for all. The value of these processes lies in having found analogies between "art and mind" to use Wollheim's phrase; I learn, I forget myself, I become objective, I become silent, I free myself, I let the object be—and I recall myself, I impose myself on that object, I dare to ask and think. Whatever the verbal theories that come out of these processes, Panofsky, Wölfflin, Gombrich, or Weitz, the hermeneutic

spell has been broken because I have incorporated the stages of reaction and experience in myself. I have encountered and at the same time experienced the pluralism, perhaps the relativism of that encounter. In a strange reenactment of a drama, the whole has become considerably more than merely the sum of its parts.

To be sure, as we walk down that ramp we may meet the dogmatists who try to prevent that pluralism and that process. They will make demands as to what we should and should not do: Rothko must be seen their way. The priests are wearing new chasubles, of psychiatry, of art history, of confessional religion; they are liberal or Marxist, structuralist or mystic. As we find out quickly it is easy for any of us to put on that gown. The conflict between religion and art, between dogma and spontaneity, can break out at any moment and anyone can become victim or oppressor.

The example of the Guggenheim retrospective with its multiple process and the possibility of multiple interpretations leads me to one more observation in the issue of analogy. As we participate in academic life, we tend to take research solutions, whether in art or in religion, in static fashion. We quote one another, as I do in this book, and imply that what a person said in 1960 he still would say in 1979, as if no growth had taken place in eighteen years. Strange assumption. In Mozart or Beethoven, in Giacometti or Picasso, to use extreme examples, we would never expect such rigor mortis. We hear an early piano concerto by Mozart and Symphony no. 40 and we accept it as a matter of fact that the two come from two periods. The confrontation between religion and art raises serious questions about our inflexible attitude toward the written work. Art is change, and the reaction to art is subjected to that flux.[52] I have publications in the libraries that do not correspond at all to my present insights, yet people quote me, and I quote people likewise: do I reckon ever with change?

The incorporation of art into the study of religion challenges our assumptions of the static character of evidence and model, and introduces, not merely in someone else's work but in our own an awareness for organic patterns of growth, for sequences of play, for blind alleys and adventures in form and idea. It is to this challenge that I must address myself in a final chapter.

Chapter 8

Art and the Study of Religion

Je ne cherche pas, je trouve.
Pablo Picasso

In a few final observations, I wish to explore what the presence of art can contribute to the study of religion.

Art and religion, as I have shown, stand in a peculiar relation to each other. Both are terms familiar to most people; they are referred to in daily life as well as in academia. Yet both are contested: there are people who regard them as unnecessary or dangerous or who even deny their right to exist. When it comes to definitions it becomes exceedingly difficult to find agreements, in academic circles as well as in the culture at large. Anti-religion and anti-art have been a cultural ferment, along with religion and art, for at least two and a half thousand years.[1] As we have stated before, religion and art, so closely tied to each other, are in conflict, not only with each other but even more so with themselves.

New religious phenomena are still being born, either as religious movements proper (Rastaferians, the Church of Scientology, the Unification Church) or as trends which are, despite prevalent anti-religious polemic, surreptitiously transmythologized forms of earlier religious notions or practices (science, psychoanalysis, Marxism). There are constantly coming into being new forms of art, from Dadaism to Pop, from television to earth sculpture, from improvisation theater to dance therapy.[2] We can argue endlessly whether or not such new forms are "really" transformations of art and religion.

167

Both are equally plunged into the research dilemma with which I began this book, the hermeneutic, synchronic, and critical. The structural polarities can be shown one after another applying equally to the study of Christian art and to the study of the Christian church. Both phenomena can be studied in their respective departments and they can also be studied in philosophy, psychology, anthropology, or urban studies. The relation between religion and art is a test case for the cross-disciplinary task.

I

Academia is caught by clearly identifiable polarities which can affect the very role of the academic in public life: research and responsibility, analysis and reenactment, freedom and involvement, event and thought, description and interpretation.[3] The presence of art in the evidence of religion and religious study confronts us concretely with the multiplicity of data and the multiplicity of methods.[4] The ambiguity in vision, sound, and language, for academic study a serious problem to be solved, is often the goal of art.

In our attempt to deal with religion, we can identify groups of evidence.

First we can examine visual data:

a) Data exist which are straightforward, archeological, cultural. Stone quarries of Syracuse where the captured Athenians were left to starve. The Via Appia with its travertine replaced many times, leading in a straight line through Latium. A lead pipe found in the soil of Ephesus. A trench of World War I.[5]

b) Data exist where religious components are present and must be accepted as authentic expressions of a community. The Orphic Underground Sanctuary in Rome. The Baker's Tomb in Domitilla. The mausoleum of Galla Placidia. A Mennonite church of eighteenth-century Pennsylvania.[6]

c) Data exist which show the transmutation from myth to "myth understood," from a tribal religious experience to images reproduced by art. *Laokoon*. Leonardo's *Annunciation*. *The Pegasus* by Lipschitz at Columbia University's Law School.[7]

d) Data exist where such religious, mythical components are absent on the surface. They might or might not be present "below" or "behind" the surface. The figurines of Lascaux. Mondrian. Henry Moore.[8]

Second, there are similarly verbal data in which we can identify analogous differentiations:

a) There exist purely prosaic data without any of the definitions we employ for art. The list of cities distributed by the Hebrew tribes after the conquest of Canaan (Judg. 15ff.). The palace archives of Ebla. A membership list of a Presbyterian church.

b) There exist data in which the statement is mythic-religious, whatever the social, historical, or psychological ramifications and explanations. The story of the golden calf. The oracle of Delphi. The Lord's Prayer.[9]

d) There exist data in which the ancient mythical elements have been used in transformations, either in theology (Origen, Luther, Schleiermacher), philosophy (Plato, Duns Scotus), or art (Euripides, Milton, Arrabal).

e) There exists verbal evidence where on the surface such connotations are surely not intended and where archetypal notions might or might not be present. Thucydides, Mommsen, Peter Handke.[10]

Third, there also exist data for which language and vision are subservient to other processes:

a) In the ritual dance or in the secular dance we deal with motion.[11]

b) In liturgy we deal with a ritual process that combines motion, music, and word.[12]

c) In the song we deal with music and language.

d) In pure music neither dance, song, nor motion matter. We can hear a concerto grosso without necessary responses by speech, vision, or motion.

The intertwinement of data is taken for granted and not only in the study of religion. We do not study merely motion, idea, or language. Religion deals with ritual, hence with a combination of motion and speech. Religion deals with prayer, hence with gestus as well as oration: the ancient Christians knelt or stood, *orantes* with outstretched hands, and that gesture is as crucial as the words employed.[13] The myth is replayed in the cult: the combinations of vision and word and action, action and music, belong to the core of religious research.[14]

In the sphere of art, one specific religious datum is experienced in a multiplicity of responses. We enter Cosma e Damiano in Rome, an early Christian sanctuary. We begin a process that is physical, visual, emotional, and intellectual. The art historian teaches us iconographic detail, material, structure. The social historian teaches us the cultural

function of this architecture. The theologian teaches us symbolic and communal connections. These methods are not only valid but necessary. But as we enter that church, something else is taking place: the building draws us into its space. We walk and we see and we feel and we think. We can walk or sit alone and the space is extraordinarily silent;[15] suddenly, people come and the space is filled with sound. In some strange way all kinds of academic methods merge, interlaced with each other. To go through that church turns out to be, although seldom consciously, a cross-disciplinary experience. Art draws us into crossing research delineations: space can be experienced as a pure work of art; space contains iconic meaning; space reflects fourth-century Rome.

Did people in antiquity or of later times know of such multiplicity? The texts do not say. To be aware of multiple function and layers of reality is a modern insight. The average person in fourth-century Rome did not distinguish between art and sanctuary, between symbol and social reality. Even today there is always a gap between intuitive perception and conscious perception.[16] Christian preachers and philosophers have dealt with the New Testament without dealing consciously with the artistic power of its language and yet they were drawn by that power. The early Christian who entered that church *did* feel color, space, material; he entered as a citizen of a fourth-century community; he heard language spoken from that apse and may have marveled at the gigantic figure of Christ during the service.[17] The multiple experience was present. Art broadens the scope of study by opening up and acknowledging these divergent avenues of perception.

We could approach the cross-disciplinary matter differently. The people who worshiped in this church were bishops, priests, laymen. Some belonged to the Christian-Roman elite; many, or most, could not read. An esthetic experience took place in that room together with a social experience: in here the clergy exerted its power over the laity; in here the community celebrated; people came to find relief; intellectual ideas were expounded.[18] The locus was one room with its iconography, its light and color, its distinction between apse and nave. Different people played different roles and together they enacted a scene of communal Christian life. Perception differs from one person to the next and is influenced by the social roles we are playing.[19]

We comprehend from these examples why the presence of art in the

study of religion supports the multiplicity of data but equally so the ambiguity of meaning.[20] Since religious research deals with ritual (or with any of the subsequent transmutations of ritual) and myth (or with any of the mythical transmutations into theology and philosophy), with society and thought, it invites crossing methods. This crossing demands interpretative appropriation the way art demands response.[21] Ancient art has influenced modern history in a variety of ways (Erasmus, Petrarch, the Capitol in Washington), ancient religion has induced many kinds of responses (Plotinus, Plato, Lucian, Philo in antiquity, Luther, Loisy, Winkelmann, Frazer in more recent times). In academic study, this material has produced responses which are so far apart from each other precisely because cross-disciplinary encounter invites multiplicity (Eliade, Bloch, Lévi-Strauss, Bultmann). The introduction of art into the cross-disciplinary task makes the pluralism of methods, the modern analogy to the pluralism of the gods in antiquity, comprehensible, even organic.[22]

For instance, we read Amos as Hebrew theology, as apocalyptic preaching; we can also read him as ancient Hebraic social protest; we see in his writings the breakdown of tribal society with the extraordinary personal toll that resulted from such crisis; and we read Amos as poetry. Art is more than the sum of its parts. The Book of Amos is not social gospel, it is not theology, nor is it *l'art pour l'art*. As we deal with this book in a cross-disciplinary fashion we are constantly led back and forth from language to society, from emotion to content, from belief to doubt, and from meaning to form. Collective and individual factors, subjective and objective at the same time, intersect constantly. Our categories do not suffice, not because there is something wrong with our categories but because the insufficiency of categories is one of the results of the bipolar, or perhaps multipolar aspects of life itself.[23]

We see *Antigone*. At the end we are stunned and want to talk. But it is precisely during this talking that I become aware of the insufficiency of my responses. We must order our experience and for that order we need language. Yet it is exactly that language which is insufficient! The locus classicus in which to examine this profound tension between theory and art is *Oedipus Rex*. We can hardly separate this play any more from the reduction Freud has given to it, and yet compared to the play, the Freudian theory does not suffice. *Oedipus Rex* is not equivalent to a lecture in Psychology 1. Why not?

Go and see the play, and take Psychology 1, and you shall know the difference! The drama does not explain, it draws us into its cosmos, a visual-verbal-experiential space. It does not teach but makes us shudder, it draws us in and at the same time lets us experience from outside.[24] To build models is a necessary activity of our intellectual nature, but the models at the same time violate precisely that which they try to comprehend. "In general," Stzygowski once remarked, is the enemy of art. Freud and Sophocles are at opposite poles of our life's spectrum; one explains order by a model, the other creates an order by shaping a space of his own. If the theory saves me from the chaos, art saves me from the theory.

The incorporation of art into the academic study of religion reinforces rather than eliminates the tension between theoria and praxis. As I have shown at the outset, religious study constantly vacillates between observation and participation. We study Islam and participate in an Islamic prayer session, but we study that phenomenon of prayer by observing it from the outside. For the believer it is blasphemy to stand apart, for the student it would be a failure not to stand apart. While academic tendencies have strongly favored distance after painful epochs of apologetic abuse, the Marxist polemic has brutally reminded us of the strong links between theoretical and practical relations in regard to the object of study.[25] The tension is no easy matter. None of us like the preaching professor who uses his academic pulpit to slander his enemies, Catholic or Muslim or liberals or faithful. And yet in art presence and distance come together. Emotion and control, passion and reason; in fact, passionate acceptance and critical rejection are possible as they are hardly possible in the academic arena.[26]

I give an example for another aspect of this duality between participation and distance. Outside Munich lies the concentration camp of Dachau. What we see in this place is only partially primary historical evidence. We do not confront bodies lying around in decay but photographs of such bodies, recollections, blown-up newspaper clippings, official documents. The camp has been transformed into a museum, with a chapel, inscriptions and modern sculptures. The visitor is given a sequential tour of the camp's history: pictures tell the tragedy visually, but the beauty of these pictures in perhaps their most horrendous aspect, the counterpoint to the pictures' content of shoes and hair and gallows. Susan Sontag claimed that in such photography lies

the problem of art because these pictures make horror possible. And indeed in the display of Dachau we recognize the character of art. Of course we experience "distance,"[27] because we could not tolerate the stench of decaying bodies. We have not been there, and no one should chide us for not having been in Dachau when talking about it. The sequence makes accessible the nightmare, beginning with nineteenth-century anti-Semitism. It is not the event itself, which would have killed most of us or driven many of us into madness.[28] Many Germans have never set foot in the camp, for fear of what they might experience. Susan Sontag is wrong: while the photos, the display of that "museum of horror," make that horror available, they also make it accessible to all. Like Medea. Like Oedipus. Like Job. The alternative would not be to participate fully in the nightmare (which is a romantic illusion) but to forget or to become insane.[29]

We can hardly go through that museum without asking all kinds of questions. And without getting angry. Here is a form of art that demands response, even interpretations. Other forms of art do not. The next day I stand before a Mondrian in the Pinakothek, and I do not have the same need to interpret; I stand before an Egon Schiele, and I do. In dealing with art we might be freed from that academic intolerance which either prohibits us from interpreting what we see or hear, or chides us for not interpreting.[30] The choice and freedom of response belongs to the hermeneutic interplay between art and observer.

II

One of the central questions put to modern man is the relation between religion and anti-religion. The brilliant critics of the eighteenth century thought they had solved it, religion was finally explained, the miracle was clarified, the gods made sense. The replacement of religion by art and science seemed assured and man could finally embark on a saner journey. Alas, we did not. The religious dilemma, the hell of psychological and social contradictions, the need for initiation, magic, and eschatology returned as strongly as it had before. Instead of Mary, the Revolution placed in the Cathedral of Strasbourg the goddess of Nature, Diana Rediviva. As Foucault showed so poignantly, the sickness that came with our post-Renaissance health was at least as grave as that before.[31] Instead of solving the dilemma of religion, the eighteenth century reinforced that ambivalence between

man's need to break with his mythical past and his desire to re-create transformations of precisely such archetypal images. What has been with us since the days of Homer and Micah lies at the springboard of contemporary culture, from Eugene O'Neill to Peter Shaffer's *Equus*. After all, there hangs a picture of Lenin where there used to hang a Pantocrator of the church.

The incorporation of art into the study of religion gives these two trends their authentic places. Some artists have been part of religious communities, others have been outside any religious group. Iconographically art has been religious and it also has at times been void of religious connotations. Stravinsky composed *Petrouchka* and his Mass, Dürer painted the Virgin and German merchants. The distinctions in content say nothing about art as such, and the term "Christian art" is an exceedingly precarious term outside the matter of content. Art belongs to the realm of religion and to a realm outside religion and it has been so for millennia. Most of us accept that duality: people of religious convictions hear *Petrouchka,* atheists hear a Schubert Mass. The presence of art transcends religious, and also nonreligious domains as a matter of course.

Art is present in religious epochs, in classical Hinduism of Sri Lanka and Cambodia, in medieval Catholicism and German Protestantism, with often specific emphasis on verbal, hymnic, or visual forms.[32] But art is also present in periods when religion is beginning to crack, in Renaissance Italy, in Athenian Greece, in modern French Catholicism. Art is operative in the creation of religion, and art is operative in the crisis of religion.

In art, the affirmation of myth and the anger against myth can both be equally tolerated. We go through a museum, Chicago, the Louvre, the Metropolitan: we walk through an eight-hundred-year space of myth and anti-myth, an experience of religious vision and man's turning away from that vision.[33] The student of art who refuses to deal with this ideological "baggage" misses a great deal of his own world, for in that evolution of form, perspective, space, and color is contained the dramatic evolution of man, theological, magical, absurd, and polysemous. The evolution is not linear: religious connotations come and go. Man in this evolution does not evolve in linear fashion either: autonomy comes and goes, the body, the face, the three dimensions. The museum offers us a fascinating walk through our human space, through past and present and possibility, through fear and form

and experiment; it takes us through an ongoing religious crisis, from the medieval cosmos to Renaissance freedom, from the classical cosmos to its nineteenth-century breakup, a history of creation and liberation in form and color and brush stroke as well as in iconic communication. Both sides have been part of our past, some have raged against, others have passionately believed in, and others again have ignored that religious tradition which came into being long before writing was invented. The vacillation between belief and unbelief, between creating gods and breaking with the gods is built into our history.

In art, we learn to accept religious and postreligious currents as expressions of the human predicament: the tale of Genesis, Milton's *Paradise Lost, The Fall* by Camus. The tension can be formally analyzed at the very roots of Western culture, in Homer and Hebrew poetry.[34] For the latter, the religious crisis is a desperate matter, for the former it is simply taken for granted and transformed into epic. Not only do different literary rules apply in the study of both; an analysis of the prophetic poetry demands a theological sophistication which Homer does not. That primary experience of Western man to continue his mythical past and to break with it, lies at the very root of our literary heritage.[35] The poverty of twentieth-century culture is rooted among other things in the fact that it all too quickly surrenders either theological passion or secularity, the two expositions to our cultural drama.

This evolution from myth to counter-myth, to postmyth, and so often back to transmuted mythical metaphors gives us a considerable freedom from the kind of provincialism in which a theologian discovers a new God or experiences the collapse of his mythical cosmos as an apocalyptic event of the twentieth century. For many a reader of Homer in antiquity, Zeus was a purely symbolic figure; for many a worshiper at the gigantic Zeus temple at Athens, this person of Zeus was a living reality, an Olympian Father to whom he pleaded for help. What do the two have in common? Name? Historical roots? Poetic imagery? Transformations of primal mythical meaning? Analogies?

Both sides participate in the transformation of art and religion. Zeus was originally a god of Crete before being transported to Mount Olympus. Mythical models are transformed into larger or narrower patterns, cult into epic, myth into theology, creed into historical perspective, divine law into secular law, secular law into canon law.

Suddenly there is a return to roots, in the age of Augustus, in the Renaissance. Sartre writes *The Flies,* employing Greek imagery. In research, Malinowski speaks about magic; Lévi-Strauss sees primitive culture as authentic and autonomous. The documentation of art, verbal as well as visual, is a spectacular display of these opposites. Art accepts the tension much more freely than specific academic positions ever can.

The incorporation of art into the study of religion is therefore not a hobby.[36] In the university art is seen either with a romantic halo, or it is relegated to the specialist in English or Art History. Art has a down-to-earth, concrete role to play in the academic jungle.[37] It is a play that disturbs the linear, dogmatic, and ethical presuppositions in research,[38] and it makes possible a multiple analysis of the relation between man and his world. We must consider both of these further.

As scholars in religion we stand in a long tradition of cross-disciplinary enterprises, long before such a concept became fashionable. The work of Thomas, Tillich, or Schleiermacher was cross-disciplinary: it dealt with philosophy, history, theology, even with art and psychology. Most scholars must reject these specific combinations today, because a great deal of delicate detail work has been done in these fields, and no single man can master any more what St. Thomas thought to accomplish in his monumental task.[39] Nevertheless, the vision existed, and if there is one justification for a department of religion in a contemporary university it lies precisely in such a synthetic perspective. The synthetic path cannot be tracked by one man any more, nor does it usually end in an all-encompassing magnum opus.[40] It is a task of urgent interaction and confrontation in which we become aware of the academic *coincidentia oppositorum*; the coincidence of opposite avenues of comprehension is not a schizoid postulate of people who cannot face life but a major cultural contribution to the analysis of this life, as much enigmatic as promising. The presence of art supports a pluralistic approach to research.[41]

I use a classroom example to demonstrate the place of art. The purpose of teaching is to comprehend and communicate a certain aspect of religion, Hinduism, Jesus of Nazareth, the sacraments, the problem of death. We present material, we appropriate that material critically, we think through the problems raised by it and involve the audience in that thinking process. Finally we hope that the entire process of studying and learning has certain effects on us, intellectual, ethical, social, or personal, although we cannot predict or manipulate

such effect by harping on any cheap or direct "relevance." I teach a course entitled *The Christology of the Ancient Church*. A large amount of material is available with long-established avenues of research. Questions have been debated for a long time, monotheism, gnosticism, incarnation, the person of Christ. The critical verbal research on this patristic material is the basis for what is about to happen.

As I incorporate art into the course on ancient Christology, the path of study becomes immediately difficult. An anarchic threat rises in cross-disciplinary research, and it becomes especially dangerous as we incorporate poetry and visual art into theological avenues of comprehension.[42]

The students study André Grabar's work on early Christian art. We show slides with christological connotations: Christ as shepherd and as pantocrator, as Apollo and Dionysus, as Orpheus and teacher. We introduce the data of liturgy, not merely as texts but as reenacted drama. We play out parts of that drama, a physical counterpoint to comprehending intellectual metaphors. In christological texts we *read,* in iconic imagery we *see,* in liturgical drama we *act*: we mix not only the object of research but the very means of comprehension.[43]

And slowly the christological package with the well-formulated problems falls apart. Visual images, mythical and philosophical models, political and dramatic processes are intertwined in the evolution of the ancient church. Was it Orpheus or Christ these people saw? Does it matter what they saw? But why would they split the church if their Christ had in fact a protean face that belonged as much to them as to their heretical or pagan foes?[44] As we juxtapose intellectual and visual, philosophical and dramatic avenues of comprehension, the notion of a christological development is rapidly replaced by a labyrinth of historical forces, models, levels, and experiences, often resistant to exact definition: the Son of man of Mark, the teacher of Santa Pudenziana, the Orpheus of the catacombs, the Logos of Origen, the God of Nicaea, the cross of Classe.[45]

The cross-disciplinary momentum has begun. Not only do we begin to mix the research categories of philosophy, history, and theology with those of art history, mythology and drama, we qualify the visual image by intellectual insights and vice-versa. We introduce visual, mythological, poetic, or cultural ambiguity into theological concepts. An extremely difficult and long task lies ahead. What makes this task so frustrating: the cross-disciplinary approach does not create super

models, such as scholars often impatiently demand (and hence doom themselves to disappointment and cynicism when no such super model is found). It may lead to astonishing points of contact between data and between scholars where we did not expect it. But often the opposite is the case, and the juxtaposition of art and thought, vision and dogma ends in turmoil.[46]

If the interaction between visual and verbal, historical and social-scientific, artistic and analytic approaches does not lead to a super model, it leads us back to the ancient Christian and his society. Christology is a pattern *a posteriori*, superimposed on images that once were living codes of interaction and expression in the minds of people, in language, sculpture, mosaic, ritual. There is no reason to assume that the actual juxtaposition of images and forms of political and psychological functions was any less confusing and any more unified in antiquity than in contemporary culture. Reduction in the *Odyssey* is a stage of research, and an important one; it must be seen next to that other stage in which reduction is replaced by a web of organisms, of living patterns which cross each other like the woven threads of an abstract design. We take the student through two steps, giving him thereby a feel for the interaction and the necessity of positivistic and interpretative labor, without being constantly afraid of the duality between theory and experience, whether academic, theological, or ethical.

Art supports multilayered evolution and interaction because one of the basic components of art is its ability to contain ambiguity.[47] Take as an example Athanasius, the famous advocate for the Nicene program. We can analyze Athanasius and point out the philosophical bind in the homoousian cause, as Aetius did so brilliantly. But we must also see Athanasius' Christology as part of his political momentum. In a modern play, I am never sure of the level on which we hear or see. The same holds true for Athanasius: we are never fully sure on which level to read him. We can reduce him, of course, to simply a political being. We can reduce the entire struggle for the Nicene creed and the Athanasian position to a megalomaniac's drive for power. We can also extract a Christology and create a trinitarian theory. The analogue to the play allows us to take seriously the polysemous reality: Athanasius fights for the divinity of the savior and plays that savior himself in the most arrogant way against emperors and heretics. He writes a book with great emphasis on humility, on the ascetic Anthony, and we don't quite believe him. The elements of

art, i.e. of play, ambiguity, distance, and involvement, tie the Christology of Athanasius closer to his life than the reducing categories of sociology, psychology, or cultural anthropology, or the positivistic categories of history; for the elements of art permit diachronic and synchronic sequences to exist simultaneously, something which all these disciplines cannot, and should not, permit. Art contributes to a holistic experience of life.[48] For only art can permit this life to be seen simultaneously in its sense and non-sense; only in analogy to art can we laugh at the holy saint and take him seriously nevertheless, as Bernard Shaw does in his *St. Joan.* Only in analogy to art can we analyze the man in precise linguistic, philosophical, and sociological rigor and yet "play" with him by juxtaposing his piety with his brilliance, his lies with his convictions.[49]

It may sound shocking to speak about laughing at Athanasius, or rather with Athanasius. In our confrontation with such a serious matter as Athanasius and patristic Christology, the scholar has become terrified of subjectivism. He has built his career on an intellectual control over life, and in academic gatherings emotion is usually suspended until after the session. We understand the reasons for the fear: Athanasius has been quoted for so long in that line of saints, a model for repression, an orthodox venom by which the Nicenes had set out to destroy the Arians and in the wake of which crusades against heretics were easily justified.[50] Academic objectivity is the counterpoint to the apologetic emotionality in which the religious advocate used his heroes to spread his bigotry.

The introduction of artistic analogies frees another kind of passion in that classroom presentation. We have the freedom to weep in front of patristic Christology for all the evil it has helped to bring upon Western civilization down to the anti-Semitic formulae it submitted to the Third Reich. We should have the right to enjoy the esthetic and intellectual nuances in the shaping of christological imagery. And we might, indeed, laugh at the councils which were as farcical as our faculty meetings and congressional investigations. The passion in analogy to art is no longer one in which "we" are the orthodox and "they" the heretics (and that "we" can be a historian, high-church Anglican, or atheistic philosopher); instead it is one that gives us a new kind of academic irony, not one born out of contempt for people and errors but that terrifying distance which Aeschylus created when he made us watch the drama out there which, in fact, is our own.[51]

The admission of categories analogous to those in contemporary art

puts another face on the research dilemma with which I began this book. The polarity between sympathy and distance is a major issue to any academic enterprise; the intertwinement of intellectual and emotional responses is taken for granted in art. No one has to apologize for being terror-stricken at the fate of Medea. The difficulty in making that analogy lies in the fact that to be able to combine passion with objectivity implies some kind of distance. At the very moment of full religious involvement we cannot understand, we should not understand: the Montanist woman in Phrygia could never have understood what their fascinating movement was about since any attempt to understand would have destroyed their very charismatic freedom. The academy shares with the artist the distance between life and work. The person praying in the temple of Bassae is not necessarily an artist.

The mixture between analysis and response creates, to be sure, serious academic problems.[52] Cross-disciplinary work is difficult to evaluate. In specific disciplines we have solid criteria from which to judge poetry, painting, and music. No one can master several fields as thoroughly as each specialist in each field. Within narrow limits judgments can be made so much more comfortably than with cross-disciplinary material. What gets lost in the enterprise is academic control, one of the forces that glue the universities together. Hence the academic terror of subjectivity.

And yet the problem is not really any different from all prior academic reaction to innovation. The most important contributions in social science, Marxist sociology, and Freudian psychiatry were for decades barred from the academic forum. Some of the most important contributions to our understanding of religion came from outside the academic paths proper: Reinhold Niebuhr, Karl Barth, Robert Graves. Carl Gustav Jung was actually barred in Basel from becoming a professor by no other than the professor of psychology, and after a few lectures which we heard with great fascination he had to give up his teaching, once more a heretic anathematized by the orthodox establishment. The academic does to his foes what Athanasius did to his.

III

My introduction into the interactions between art and the study of religion leads me to important qualifications. From Amos to Dylan

Thomas and from Aeschylus to Arrabal art is not life but a statement about life. Art has a law, a logic and a rhythm of its own.[53] Whether we interpret art (Neuman) or reject the validity of interpretation (Susan Sontag), we can see or read or hear art on its own terms, in a process demanded by its medium, language, stage, song, sculpture. Art is not Aristotelian in its evolvement, although we can and constantly do speak about and write in Aristotelian categories, catharsis, mimesis, form. Whatever our definitions, art is not life but a creative process or product in relation to and in distinction from life, illusion, reduction, expression, illustration, play. It is a code but the code plays with our everyday language exposure; it distorts reality; it leads us to truer understanding; it deceives us or it makes our life bearable. Whatever our definitions of art, we cannot identify it with life, otherwise we could simply talk about life.[54]

The distinction is important for the religious analysis. Back to Jeremiah where the artistic process is well on its way: these hyperbolic, angry, devastating poetic units did not represent the daily life of ancient Jerusalem. I am not even sure they represent the entirety of Jeremiah's own life. His art was an alien voice to his people, perhaps at times even to himself. They were afraid of his art which was *verbum alienum,* word from somewhere else, ambiguous, disturbing, with lyrical longing, and the passionate terror of an alienated individual: woe to my mother that you have borne me!

Similarly, the famous *Laokoon* in the Vatican is not life itself but a statement about it, a moment captured from life, a scene, a mythical reenactment, a display of a body and its battle with nature.[55] Both Jeremiah's verse and Laokoon's agony are examples of man trying to master chaos in his own space by a verbal or visual order which is distinct from the thousands of snakes on the crusty hills of Attica or from the everyday palace intrigues of Zedekiah.[56]

Nor is art science, although it demands the same rigorous discipline.[57] The logic of artistic communication tends to diverge from scientific rules, the verification of an artistic statement is not like verification in science. Very few works of art have ever been accepted by academic departments as doctoral dissertations. We realize that Leopold von Ranke writes a superb German style and that there is a poetic quality to the work of Thomas Altizer or Richard Rubenstein. There is a fascinating poetic quality to Plato and Whitehead, yet in terms of contemporary science with its demands of model building,

critical analysis, experimentation, and verification, art is neither on the side of exact science nor of social sciences nor even of humanities.

Nor is art theology. It is no longer religion as defined by theology. To be sure, in the transmutation of religion into postreligious substitutes, art at times has a corner in the market. Art can function the way churches have functioned in giving man comfort and a satisfying emotional experience. But the opposite may be the case. The artist has become autonomous. He has the right to believe in God if he so feels, and he has the right to discard his gods if he must; whether he belongs to a religious community or not, whether he returns to the fold like Eliot or lives in defiance of his church like Léger is irrelevant to his artistry. Art can be used by theologians for their apologetic purpose as Aulén has done with Lagerqwist[58]; but as we compare the writer with the apologist we realize that an abyss separates the logic of art from the logic of scientific study of religion.

What then can we say at the end, having seen the analogy and closeness between religion and art and their separation from each other? It turns out to be a precarious relation after all, especially when it comes to the study of religion, the topic before us. What can be done, concretely, if art is so necessary to the study of religion and yet so antithetical at the same time? Many years ago, in one of the Wednesday afternoon seminars at Basel, I had a sharp exchange with Karl Barth on the issue of art, an exchange which became decisive for my entire theological career. As he used to do in cases that interested him existentially, Barth responded vehemently to a statement of mine about art and pressed me further and further toward the question: does art have an autonomous function in man's salvation? Does art change us in any way, is it a viable alternative to reason and religion? For Karl Barth, the answer was a passionate, an absolute, and emphatic: NO! For faith art was unnecessary.[59]

But the simple fact is: in Karl Barth's life art was extremely necessary. He would not begin his work unless he had played a record from his spectacular Mozart collection, and one of the glorious moments of his career was his speech at the two-hundred-year Mozart jubilee in the Casino.[60] And with that observation I get to the heart of the debate. Scientific study of religion offers us two options in respect to art. The first is practiced widely and I began this book with it: we wear two masks, and while with one we catechize the truth, we live with the other a second life. Perhaps Barth could not have created as he did,

he, the brilliant professor of systematic theology, without Mozart's music which he was not willing or capable of integrating into his system.[61] Perhaps he had to lie about Mozart in order to do his theology. The majority of students or professors live such an option, and I certainly have done it often in my life: art is not appropriated into the framework of our academic existence. We hear music, we see plays, and we go to museums, a whole unexamined life is around us the way most people on this planet live their unexamined life without ever coming to terms with science or religion.

I do not claim that this option is not a viable one. We cannot integrate all aspects of our lives, and it might be better to leave the relation between religion and art unsolved than to solve it by some miserable esthetic theory or by cheap art, killing whatever spontaneity is still left in a bureaucratic universe. Look at what we have done at times to religion, and look at what art history and literary criticism have done at times to art and literature. One of the options for the academic is unexamined life, innocent, pre-Socratic in its hidden exchange of masks, and with art permitted to exist like a nude Canova on the hidden shelf of some Victorian professor. Perhaps art can be the secular parallel to that sacred schizophrenia in which a critical professor goes to a conservative church on Sunday, tolerating that double life as long as he is not called on the carpet to explain it.

There is however a second option, precarious, rather dangerous to the enterprise, but nevertheless lurking behind several trends in modern times, religious and otherwise. This option is to allow art to challenge and ultimately transform the scientific endeavor. It would not turn science into art: if such exchange happened we would simply have art instead of science. But it would indicate far-reaching changes in our task, for it is quite possible that the scientific epoch in which we do our work will come to an end one of these days, and that the processes operating in the artist might support alternatives to the traditional academic journey.

The history especially of Western religion of the past thousand years has taken place in a large-scale conflict, at times violent and at other times internalized and peaceful, between science and religion. It is a conflict that has formed and transformed our culture and we should be proud of it. Laurentius Valla showed us that the Constantinian Donation was a falsification: the claim for medieval papal policy was a fraud. In the brilliant minds of St. Thomas and Duns Scotus, *scientia*

held together faith and knowledge; in the equally brilliant mind of Ockham it did not. The critical feat of Valla stands for the rigor of a millennium: from Erasmus to Freud, science tore at religion. In fear of religious henchmen, Ockham fled Avignon by night, or else he might not have survived the year. Giordano Bruno, the philosopher, was burnt. David Friedrich Strauss lost his job. A glorious battle was waged, that eighteenth-century triumphal war against the religious bigots, the closed-minded priests and professors and pious tyrants on the thrones of Europe. Science lifted the veil from miracles and tore at the ominous power of the clergy. Peter was not the first pope; Moses did not write the Torah. The battle and the insights are still with us.

It is possible that the scientific endeavor faces a challenge similar to the religious endeavor which went before. New avenues toward knowledge begin to qualify science the way science has so radically qualified the insights of religion. Signs are going up everywhere. Take the cross-disciplinary issue presented in this book. Just as the mythical cosmos fell because it could not withstand, even in antiquity, the pluralistic and syncretistic forces due to commerce, travel, and urbanization, so the present scientific cosmos might not be able to sustain methodological pluralism, that radical challenge to academia from within.[62]

The academic cosmos has not found ways to combine Marxism with liberalism, psychoanalysis with experimental psychology, logic with existentialism, historical analysis with hermeneutic interpretation. In our university a well-known professor of English vetoed the publication of a book on poetry by a psychologist, not even allowing it to be brought up to the university board because, as he put it, a psychologist had no business writing about poetry. I suspect that the proverbial arrogance of the academic mind results in part from the attempt to preserve academic objectivity, and from the helplessness of achieving it in the face of precisely that methodological bind of which I spoke. There are important tests, rules of literature, verification, logical clarification, there is English grammar and logical thought. But there is no God who comes down to tell us who has a right to write or not to write a book on poetry. Science is play, a play with different laws and consistencies (Foucault, Trilling, Lietzmann, Martin Buber, Leach, Gershom Sholem). In order to deal fearlessly with methodological pluralism, the academia will have to take much more seriously the concept of play, whether in terms of Feyerabend, Van de Leeuw, Wittgenstein, or Merleau-Ponty.

Science is not art and it cannot surrender to art its primal task of describing life, finding models for explanation, breaking up unexamined life in order to understand. But the religious academic world might learn certain insights from the field of art.[63] For instance, the field of religion is terribly thrown by the problem of methodology. The problem of methodology seems the most serious issue of all, not only because there are so many methods around on which we do not agree, but because we cannot really teach a methodology to do serious and satisfying work. We must begin to teach the students critical analysis, model building, textual precision, historical verification; i.e. to give the students the necessary academic tools. We must teach these tools like we teach how to use the tools of the chisel, the brush, or the poetic rhythm, to set the student on his way. But once he has begun a certain craft he will quickly continue on his own.

I have put the dadaistic sentence by Picasso over this chapter because it pinpoints the academic bind brilliantly: the process of finding is an autonomous event.[64] What we believe to be a method is actually not a method but the result of a person's autonomous, disciplined confrontation with the world. Only the small mind has a method, a dogmatic little follower who translates every person into one more test case for Papa Sigmund or for Erik Erikson. Nietzsche, Geertz, Wittgenstein: whatever method we attribute to them is always that of the disciples, of the first person writing about the master. Lévi-Strauss' "method" is one of the most baffling things one may try to untangle from his fascinating books, beyond the structuralist outline which we teach in an hour.

Bultmann's demythologizing program we can teach in an hour; beyond that program, Bultmann is a complex individual, shaped by literary criticism, Heidegger, and the hermeneutic debate, by preaching and positivism and the problem of meaning. I have watched Paul van Buren over our twenty-five-year friendship. His academic life has been one constant acting out of polar insights. There are recurring questions in his theological (and antitheological) odyssey. But there is no method, at most there is a composition of avenues: philosophical, historical, theological, personal. And so often, the avenues are at odds.

Other signs I have seen going up for alternatives to the traditional academic task.[65] The meditation technique is emerging as an avenue of investigation. First impressions about it were not very positive, for it was hard to take seriously the alienated sons of affluent Western

culture returning from India daydreaming and in flowing skirts. But as this emphasis is moving away from an initial romanticism about an unreal East, from gurus on beds of nails (or in Cadillacs), certain fascinating options are suddenly opening up, at work not only in the East but in the West, from Meister Eckhardt to Jakob Boehme, indicating that there are indeed other paths to comprehension than those of traditional deduction.[66] Psychoanalysis combined meditative, physical, intuitive reenactment with a logical, rigorously rational discipline. Medicine is experimenting with hypnosis, and scholars in primitive religion are taking seriously the magic and the healing of tribal society.[67] Russian and other scholars are working with parapsychological processes. None of these trends is art of course: what they have in common is a discipline of mind and body that differs from traditional deductive processes of investigation, a discipline at times strangely reminiscent of the role of ascetic control in the creation of art.[68] Perhaps it is a *scientia negativa* which they have in common, alternative avenues to meaning and comprehension long present as counterparts to science from the Cabbala to the Hasidim, and from acupuncture in Taoism to Pythagorean circles in antiquity.[69]

IV

We cannot return to the mythical past. Billy Graham's Madison Avenue crusade, despite its claims, does not return to it, it only makes use of it, as does the symbolic film playing with the past, *Sundays and Cybele.* If we listen quietly to the rhetoric of revival preachers, we discover in it the same anger which operated in the mythical hell of Job. Here then lie the ties between art and the student of religion: they both share the knowledge that innocence cannot be recaptured, perhaps because it never existed except in our memory. The gods were always dying. A generation brought up in an innocent present experienced the mythical loss as something horrendous, unheard of when, in fact, that experience was ancient and led to art as well as to science and theology. Loss of innocence, demise of tribal security, experience of alienation and individuation are built into the history of our civilization as a personal and mythical terror: "My God, my God, why did you forsake me?"

And yet we cannot go on without precisely that mythical past. The religious transformations, no matter how much some may hate

them, return and return, in Gestalt groups, in the Marxist revival preacher, in the film drama or novel: Lorca, Fellini, Bergman, Eliot. We may get angry at the transformation, at the medical doctor who reenacts the bloody priestly show all over (white gown, secret language, the initiation, and ritual of his training, his social status and merciless economic exploitation of the populace, and the healing that goes on despite and with his priestly charade). The more I watch such transformations that go on, often only thinly disguised, it seems to me that the crucial question is to choose between valid, healthy, and exploiting repressive remythologizations of archaic images and patterns. The demythologizing of myth that was at work in the ancient world (Plato, Philo, Paul, and Origen) goes on and on and often leads to remythologization. No sphere of life has been creating new images as has the world of art, although advertisement, political rhetoric, and scientific discoveries have contributed valuable material in turn.

The presence of art in religious study reinforces and makes us acutely aware of that dual trend in history: a return to any mythical, i.e. authentically tribal religious past, is as much an illusion as it had been when practiced by Augustus who wanted to revive the good old Roman religion at the time of the birth of Jesus;[70] and that at the same time life without mythical metaphors, without an epic-poetic cosmos of both images and icons is an impoverished life. We do not need to force any imagistic option down anyone's throat. In fact we can grant that some people will have nothing to do with the past, with myth, with icon. Most such violent opponents are the first to create iconic models all over, without even being aware. It is healthy for art as well as for religious study to exist in such suspense.

It is good, perhaps, to exist in such suspense to the extent that we are not even sure if "art" and "religion" are meaningful concepts. It is good for a scientist to face the chance that his task may come to an end. Such suspense was operating at the origins of Western art: Euripides used myth and yet was distant from it; Jeremiah spoke about his God, yet he was disturbed about him. What art and religion have in common is that proximity between creation and destruction. We live between death and life, between images discarded and images created. The academic proponent of religion has lived perhaps the most foolish of all illusions: as if at that lectern, in that book of ours, we have transcended our historicity and speak from above, as if we do not play, like any artist or any scientist, Shiva pure and simple.

Nobody told the king of Jerusalem whether the voice of the crazy man from Anathot was authentic or not. After two and a half thousand years, we still hear that voice. The play worked after all. And thus, the artist may say to the student of religion: it is not necessary to write your books with a hidden agenda, pretending to write for eternity when you write for the upper classes of Marburg, of Oxford, or for the middle classes of Illinois. That's all right. You are involved, as everyone else on this planet, in that play of forces which has brought us, painfully and at times gloriously, to where we are at present. And you have solved as little as anybody else the interplay of passion and reason, the justice of Zeus and the freedom of Christ.

Selected Bibliography

RUDOLF ARNHEIM *Art and Visual Perception: A Psychology of the Creative Eye,* 2nd edn. (Berkeley: University of California Press, 1974).

HANS-ECKEHARD BAHR *Poiesis: theologische Untersuchung der Kunst* (Munich: Siebenstern, 1965).

ROLAND BARTHES *Image-Music-Text,* tr. Stephen Heath (New York: Hill and Wang, 1977).

DAVID W. BOLAM and JAMES L. HENDERSON *Art and Belief* (New York: Schocken, 1970).

PIERRE DU BOURGUET *Art paléochrétien* (Amsterdam/Lausanne, 1970; Paris: Cercle d'art, 1971); *Early Christian Art,* tr. Thomas Burton (New York: Reynal, 1971).

JOHN BOWKER *The Religious Imagination and the Sense of God* (London: Oxford University Press, 1978).

SAMUEL G.F. BRANDON *Man and God in Art and Ritual; A Study of Iconography, Architecture and Ritual Action as Primary Evidence of Religious Belief and Practice* (New York: Scribner's, 1975).

HORST BREDEKAMP *Kunst als Medium sozialer Konflikte Bilderkämpfe von der Spätantike bis zur Hussitenrevolution* (Frankfurt am Main: Suhrkamp, 1975).

TITUS BURCKHARDT *Sacred Art in East and West,* tr. Lord Northbourne (London: Perennial, 1967).

EDGAR DACQUÉ *Das Verlorene Paradies: zur Seelengeschichte des Menschen,* 4th edn. (Munich: R. Oldenbourg, 1953).

CHRISTOPHER DAWSON *Religion and the Rise of Western Culture* (Garden City: Doubleday, Image Books, 1958; New York: AMS Press, 1978).

JANE DILLENBERGER *Style and Content in Christian Art: From the Catacombs to the Chapel Designed by Matisse at Vence, France* (Nashville: Abingdon, 1965).

JOHN W. DIXON, JR. *Nature and Grace in Art* (Chapel Hill: University of North Carolina Press, 1964).

ANTON EHRENZWEIG *The Hidden Order of Art: A Study in the Psychology of Artistic Imagination* (Berkeley: University of California Press, 1967).

WALTER ELLIGER *Die Stellung der alten Christen zu den Bildern in den ersten vier Jahrhunderten,* vol. 2: *Zur Entstehung und frühen Entwicklung der altchristlichen Bildkunst* (Leipzig: Dieterich, 1934).

FINLEY EVERSOLE, ED. *Christian Faith and the Contemporary Arts* (Nashville: Abingdon, 1962).

PETER T. FORSYTH *Christ on Parnassus: Lectures on Art, Ethic and Theology* (London: Independence Press, 1959).

THEODOR H. GASTER *Thespis: Ritual, Myth and Drama in the Ancient Near East* (New York: Harper and Row, 1961).

ERNST H.J. GOMBRICH *Art and Illusion: A Study in the Psychology of Pictorial Representation* (Princeton: Princeton University Press, 1969).

EDWIN M. GOOD *Irony in the Old Testament* (Philadelphia: Westminster, 1965).

ERWIN R. GOODENOUGH *Jewish Symbols in the Greco-Roman Period,* 13 vols. (Princeton: Princeton University Press, 1953 ff.).

MICHAEL GOUGH *The Origins of Christian Art* (New York: Praeger, 1974).

ANDRÉ GRABAR *Christian Iconography: A Study of Its Origins* (Princeton: Princeton University Press, 1968).

C.I. GULIAN *Mythus und Kultur: Zur Entwicklungsgeschichte des Denkens* (Vienna: Europa Verlag, 1971).

JOSEPH GUTMANN *The Image and the Word* (Missoula: Scholars Press, 1977).

PETER HAMMOND *Liturgy and Architecture* (New York: Columbia University Press, 1962).

DAVID B. HARNED *Theology and the Arts* (Philadelphia: Westminster, 1966).

ARNOLD HAUSER *The Social History of Art,* tr. Stanley Godman in collaboration with the author, 2 vols. (New York: Knopf, 1951).

ROGER HAZELTON *A Theological Approach to Art* (Nashville: Abingdon, 1967).

STANLEY ROMAINE HOPPER *Interpretation: The Poetry of Meaning* (New York: Harcourt, Brace and World, 1967).

JOHAN HUIZINGA *Homo Ludens: A Study in the Play Element of Culture* (Boston: Beacon, 1955).

HOWARD HUNTER, ED. *Humanities, Religion and the Arts Tomorrow* (New York: Holt, Rinehart and Winston, 1972).

PAUL KLEE *Das bildnerische Denken: Schriften zur Form- und Gestaltungslehre* (Basel: B. Schwabe, 1956).

HUGO KOCH *Die altchristliche Bilderfrage nach den literarischen Quellen* (Göttingen: Vandenhoeck & Ruprecht, 1917).

RICHARD KRAUTHEIMER *Early Christian and Byzantine Architecture* (New York: Penguin, 1979).

ERNST KÜHNEL *Islamic Art and Architecture* (Ithaca: Cornell University Press, 1966).

GERARDUS VAN DER LEEUW *Sacred and Profane Beauty: The Holy in Art,* tr. David E. Green (New York: Holt, Rinehart and Winston, 1963).

HANS PETER L'ORANGE *Art Forms and Civic Life in the Late Roman Empire,* tr. Dr. and Mrs. Knut Berg (Princeton: Princeton University Press, 1965).

WILLIAM F. LYNCH *Christ and Apollo: The Dimensions of the Literary Imagination* (New York: Sheed and Ward, 1960).

GEDDES MACGREGOR *Aesthetic Experience in Religion* (London: Macmillan, 1947).

JOHN MACMURRAY *Religion, Art and Science: A Study of the Reflective Activities in Man* (Liverpool: Liverpool University Press, 1961).

F. DAVID MARTIN *Art and the Religious Experience: The "Language" of the Sacred* (Lewisburg: Bucknell University Press, 1972).

ALBERT C. MOORE *Iconography of Religions: An Introduction* (Philadelphia: Fortress, 1977).

CHARLES R. MOREY *Christian Art* (New York: Norton, 1958).

PETER MUNZ *When the Golden Bough Breaks: Structuralism and Typology* (London: Routledge and Kegan Paul, 1973).

WHITNEY OATES *Plato's View of Art* (New York: Scribner's, 1972).

ERWIN PANOFSKY *Idea: A Concept in Art Theory,* tr. Joseph J.S. Peake (Columbia: University of South Carolina Press, 1968; New York: Harper and Row, 1974).

D.W. PRALL *Aesthetic Judgment* (New York: Crowell, 1929).

ALAN S.C. ROSS, ED. *Arts versus Science: A Collection of Essays* (London: Methuen, 1967).

WILLIAM S. RUBIN *Modern Sacred Art and the Church of Assy* (New York: Columbia University Press, 1961).

KARL SCHEFOLD *Römische Kunst als religiöses Phänomen* (Hamburg: Rowohlt, 1964).

ALESSANDRO DELLA SETA *Religion and Art: A Study in the Evolution of Sculpture, Painting and Architecture,* tr. Marion C. Harrison (London: T.F. Unwin, 1914).

OTTO VON SIMPSON *The Sacred Fortress: Byzantine Art and Statecraft in Ravenna* (Chicago: University of Chicago Press, 1948).

EMERSON H. SWIFT *Roman Sources of Christian Art* (Westport, CT: Greenwood, 1970).

WOLFGANG F. VOLBACH *Early Christian Art,* tr. Christopher Ligota (New York: Abrams, 1962).

CONRAD WADDINGTON *Behind Appearance: A Study of the Relations Between Painting and the Natural Sciences in This Century* (Cambridge, MA.: MIT Press, 1970).

PAUL WEISS *Religion and Art* (Milwaukee: Marquette University Press, 1963).

RICHARD WOLLHEIM *On Art and the Mind* (London: Lane, 1973).

NOTES

Chapter 1

1. Albert C. Moore, *Iconography of Religions* (Philadelphia: Fortress Press, 1975): S.G.F. Brandon, *Man and God in Art and Ritual* (New York: Scribner's, 1975).

2. Boethius, *De Consolatione Philosophiae* (London, 1927).

3. Christoph Wetzel, *Die theologische Bedeutung der Musik im Leben und Denken Martin Luthers* (Münster, 1954).

4. Alessandro della Seta, *Religion and Art: A Study in the Evolution of Sculpture, Painting and Architecture* (London, 1914); F.D. Martin, *Art and the Religious Experience* (Lewisburg: Bucknell University Press, 1972).

5. F.H. Spiegelberg, *Die Profanisierung des japanischen Geistes als religionsgeschichtliches Phänomen* (Leipzig, 1929). Spiegelberg's analysis of Japanese secularization, as shown in the UKIYO-YE woodcuts, was made long before the secular development of postwar Japan.

6. Plato, *Rep.* X 602, *Soph.* 233ff. For modern times, cf. Rose Frances Egan, *The Genesis of the Theory 'art for art's sake' in Germany* (Northhampton, Mass.: Smith College, 1921).

7. For instance, there is extremely little traditional religious content in an analysis of painting such as Edward Lucie-Smith, *Late Modern* (New York: Praeger, 1976).

8. For instance in highly religious, liturgical context, cf. Justus G. Lawler, *The Christian Image: Studies in Religious Art and Poetry* (Pittsburgh: Duquesne University Press, 1966).

9. André Grabar, *Early Christian Art* (New York: Odyssey Press, 1969). I shall not operate with the terms "religious art" or "Christian art" in this book. As Grabar's work indicates, there is a valid concept of a "Christian art" in historical perspective, i.e., of the art which emerged in the 4th and consecutive centuries within the scope of the ancient Christian church and which represented a Christian iconography par excellence for a thousand years and beyond, even to the present day. I shall show in chapter six, how the term is quite problematic at the point of emergence; it has become problematic again

today, from the perspective of both art and Christianity. Similarly, there is a great deal of art in religion, as this book will show, art related to and originating in religion. The concept "religious art," however, is too loaded with historical and theoretical contradictions to be useful today. It also confuses the relation between art and religion as I shall present it in the following chapters.

10. Giovanni Battista Tiepolo (1696–1770): *The Triumph of Religion,* The Louvre, Paris.

11. In Christianity, the Protestant, verbal emphasis in Hans-Eckehard Bahr, *Poiesis; theologische Untersuchung der Kunst* (Munich, 1965) and the Catholic, visual one in Romano Guardini, *Die Sinne und die religiöse Erkenntnis* (Würzburg, 1950).

12. See the new work by Peter Knauer, *Der Glaube kommt vom Hören* (Darmstadt, 1978).

13. Ernst Kühnel, *Islamic Art and Architecture* (Ithaca: Cornell University Press, 1966); and Talbot Rice, *Islamic Art* (New York: Praeger, 1965).

14. See William S. Rubin, *Modern Sacred Art and the Church of Assy* (New York: Columbia University Press, 1961).

15. A broad introduction to the many aspects of the interaction between religion and art is found in Finley Eversole, ed., *Christian Faith and the Contemporary Arts* (Nashville: Abingdon Press, 1962). There exists a subdiscipline of religion and literature; see Nathan Scott, *Modern Literature and the Religious Frontier* (New York: Harper, 1958); Roland Frye, *Perspective on Man, Literature and the Christian Tradition* (Philadelphia: Westminister Press, 1961); Howard Hunter, ed., *Humanities, Religion and the Arts Tomorrow* (New York: Holt, Rinehart and Winston, 1972).

16. D.W. Prall, *Aesthetic Judgment* (New York: Crowell, 1929).

17. John Bowker, *The Religious Imagination and the Sense of God* (London, 1978).

18. Robert Bellah, *Beyond Belief* (New York: Harper and Row, 1970).

19. Avant-garde, or anti-art has two enemies: established art and low-grade art. Kenneth Coutts-Smith, *The Dream of Icarus* (London, 1970), rages against both. Modern avant-garde often goes against both, popular art and the art of the intelligentsia. See Renato Poggioli, *The Theory of the Avant-Garde* (New York: Harper and Row, Icon Editions, 1968), pp. 123ff.

20. Joseph Campbell, *The Masks of God* (New York: Viking, 1964); Erwin Goodenough, *Jewish Symbols in the Greco-Roman Period* (Princeton: Princeton University Press, 1953ff).

21. John Dewey, *Art as Experience* (New York: Capricorn, 1934), versus Max Bense, *Aesthetik und Engagement* (Berlin, 1970).

22. A brilliant case for a combination of art history with esthetics was made by Erwin Panofsky, "Über das Verhältnis der Kunstgeschichte zur Kunstwissenschaft," in *Aufsätze zu Grundfragen der Kunstwissenschaft,* ed. Hariolf Oberer and Egon Verheyen (Berlin, 1974), pp. 49ff.

23. William Lynch, *Christ and Apollo* (New York: Sheed and Ward, 1960); Amos N. Wilder, *Theopoetic* (Philadelphia: Fortress, 1956). Donald J. Bruggink & Carl H. Droppers, *Christ and Architecture* (Grand Rapids: Eerdmans, 1965).

24. David Harned, *Theology and the Arts* (Philadelphia: Westminster, 1966); George C. Coulton, *Art and the Reformation* (Hamden, CT: Shoe String Press, 1969); see also John W. Dixon, *Nature and Grace in Art* (Chapel Hill: University of North Carolina Press, 1964); Roger Hazelton, *A Theological Approach to Art* (Nashville: Abingdon, 1967); Peter T. Forsyth, *Christ on Parnassus* (London, 1959); Paul Weiss, *Religion and Art* (Milwaukee: Marquette University Press, 1963).

25. Robert Stoll, *Ronchamp* (Einsiedeln, 1958).

26. Léon Wencelius, *Calvin et Rembrandt* (Paris, 1937).

27. Erich Neumann, *The Great Mother* (New York: Pantheon, 1955).

28. Joseph Masheck, *Marcel Duchamp in Perspective* (Englewood Cliffs: Prentice-Hall, 1974).

29. Whitney Oates, *Plato's View of Art* (New York: Scribner's, 1972); Rupert Lodge, *Plato's Theory of Art* (London, 1953); Joachim Dalfen, *Polis und Poiesis* (Munich, 1974); and Constantine Cavarnos, *Plato's Theory of Fine Arts* (Athens, 1973); the latter highly apologetic.

30. Radhakamal Mukerjee, *The Social Function of Art* (Westport, CT: Greenwood Press, 1954).

31. John Macmurray, *Religion, Art and Science* (Liverpool, 1961) and Martin Johnson, *Art and Scientific Thought* (New York: AMS Press, 1970). Also Georg Kraft, *Der Urmensch als Schöpfer* (Tübingen, 1948).

Chapter 2

1. An extreme cultural definition of religion in John Murray Cuddihy, *No Offense: Civil Religion and Protestant Taste* (New York: Seabury Press, 1978). Cf. Martin E. Marty, *A Nation of Believers* (Chicago: University of Chicago Press, 1976), and above all, Robert Bellah, "American Civil Religion," *Daedalus,* 1967.

2. Thomas Aquinas, *De Vera et Falsa Religione.*

3. Van Austin Harvey, *The Historian and the Believer* (New York: Macmillan, 1966).

4. Rudolf Thiel, *Luther* (Philadelphia: Fortress Press, 1955).

5. Erik Erikson, *Young Man Luther* (New York: Norton, 1958).

6. John S. Dunne, *The Way of All the Earth* (New York: Macmillan, 1972).

7. Franklin H. Littell, *Wild Tongues* (New York: Macmillan, 1969).

8. Julius Wellhausen, *Israelitische und jüdische Geschichte* (Berlin, 1895); Walther Eichrodt, *Theology of the Old Testament* (Philadelphia: Westminster, 1961-7).

9. Alfred Loisy, *The Birth of the Christian Religion* (London, 1948). Martin Werner, *The Foundations of Christian Dogma* (New York: A. and C. Black, 1957). Franz Overbeck, *Studien zur Geschichte der Alten Kirche* (Darmstadt, 1965 [orig. 1875]).

10. A book like Sigmund Freud's *Moses and Monotheism* (New York: Vintage, 1939) is still seen by many apologists as an attack against Judaism or against religion altogether.

11. John Cardinal Newman, *The Arians of the Fourth Century* (London, 1888).

12. Claude Lévi-Strauss, *The Savage Mind* (Chicago: The University of Chicago Press, 1966), pp. 245ff.

13. Vilmos Vajta, ed., *The Gospel as History* (Philadelphia: Fortress, 1975).

14. Hans Lietzmann, *A History of the Early Church* (Cleveland: World Publishing Company, 1949); Adolf von Harnack, *Geschichte der altchristlichen Literatur* (Leipzig, 1958).

15. Rudolf K. Bultmann, *History and Eschatology* (Edinburgh: Edinburgh University Press, 1957).

16. Hans Gadamer, *Philosophical Hermeneutics* (Los Angeles: University of California Press, 1976); John C. Maraldo, *Der hermeneutische Zirkel* (Freiburg, 1972).

17. Karl Kautsky, *Foundations of Christianity* (New York: Russell and Russell, 1953); Ernst Bloch, *Atheism in Christianity* (New York: Herder and Herder, 1972); Richard Rubenstein, *My Brother Paul* (New York: Harper and Row, 1972).

18. I. Howard Marshall, *New Testament Interpretations* (Grand Rapids: Eerdmans, 1977). Scholars talk about "hermeneutics" when they have not really understood the hermeneutic impasse. See Gerd Schunatz, *Das hermeneutische Problem des Todes* (Tübingen, 1967).

19. Zevedei Barbei, *Problems of Historical Psychology* (New York: Grove Press, 1960) and Maurice Mandelbaum, *The Problem of Historical Knowledge* (New York: Harper and Row, 1967).

20. Theodor W. Adorno, *Negative Dialektik* (Frankfurt, 1966), p. 391.

21. Jürgen Habermas, *Knowledge and Human Interest* (Boston: Beacon, 1968).

22. Hans Jonas, *Gnosis und spätantiker Geist* (Göttingen, 1954), which is a much better presentation of Jonas' hermeneutic genius than his English *The Gnostic Religion*.

23. R.G. Collingwood, *The Idea of History* (Oxford, 1967).

24. Otto Von Simson, *The Gothic Cathedral, Origins of Gothic Architecture and the Medieval Concept of Order* (Princeton: Princeton University Press, 1973).

25. Thomas Merton, *The Seven Story Mountain* (New York: Doubleday, Image Books, 1970).

26. Marshal Spector, *The Concept of Reduction in Physical Science* (Philadelphia: Temple University Press, 1978).

27. Gregory Dix, *The Shape of the Liturgy* (London, 1970).

28. Jean Piaget, *Structuralism* (New York: Harper Torchbooks, 1970).

29. Thomas Luckmann, *The Sociology of Language* (Indianapolis: Bobbs-Merrill, 1975).

30. Richard T. De George and Fernande M. De George, eds., *Structuralists: From Marx to Lévi-Strauss* (New York: Doubleday, Anchor Books, 1972).

31. Robert Polzin, *Biblical Structuralism* (Philadelphia: Fortress, 1977).

32. Karl Barth, *Kirchliche Dogmatik,* Vol. I, 1 (Zollikon-Zürich, 1944), pp. 227f.

33. Ernst Troeltsch, *The Social Teaching of the Christian Churches,* 2 vols. (Chicago: University of Chicago Press, 1931).

34. The conflict can be studied in any issue of *Christianity and Crisis* on one hand, and *Christianity Today* on the other.

35. Kenneth Burke, *Attitudes Toward History* (Boston: Beacon, 1961) on rejection and acceptance of history.

36. Hans Trümpy, *Kontinuität und Diskontinuität in den Geisteswissenschaften* (Darmstadt, 1973).

37. Larry Shiner, *The Secularization of History* (Nashville: Abingdon, 1966).

38. See for instance the recent publication by Weston LaBarre, *The Ghost Dance* (New York: Dell, 1979), a book extremely critical of religion. It could have been written in 760 B.C.E. by Amos of Tekoa against the Dances of Bethel.

39. John Stuart Mill, *Nature and Utility of Religion* (Indianapolis: Bobbs-Merrill, The Library of Liberal Arts, 1958) does not ask this question with the same sting as does LaBarre in the previous note but his pamphlet is of course an answer to precisely such a critical inquiry.

Chapter 3

1. *Concepts of Modern Art,* Tony Richardson and Nikos Stangos, eds. (New York: Harper and Row, 1974). Clive Bell, *Art* (New York: Putnam, 1959); an introduction to the esthetic aspects of the problem in Albert Hofstadter, *Truth and Art* (New York: Columbia University Press, 1965). Basic for the problem

of visual comprehension is Ernst H.J. Gombrich, *Art and Illusion: A Study in the Psychology of Pictorial Representation* (London, 1972).

2. Paul Klee, *Über die moderne Kunst* (Bern, 1924); Naoum Gabo, *Of Divers Arts* (Princeton: Princeton University Press, 1962); Jean Arp, *Arp on Arp* (New York: Viking, 1972).

3. Camille Bourmiquel, *Les créateurs et le Sacré (textes et témoignages de Delacroix à nos jours)* (Paris: 1956).

4. "An analysis of Cézanne's methods cannot be divorced from an exposition of his theories," wrote Theodore Ryff, in *Cézanne, The Late Work* (New York: The Museum of Modern Art, 1977), p. 44.

5. Examples in Harold Spencer, *Readings in Art History* (New York: Scribner's, 1969) on Michelangelo, pp. 67ff., or Delacroix, pp. 253ff.

6. Georgia O'Keeffe, *Georgia O'Keeffe* (New York: Viking, 1977): "I write this because such odd things have been done about me with words. I have often been told what to paint. I am often amazed at the spoken and written word telling me what I have painted. I make this effort because no one else can know how my paintings happen."

7. "Critical inquiries are not settled by consulting the oracle," stated W.K. Wimsatt, Jr., and Monroe C. Beardsley, in "The Intentional Fallacy." William K. Wimsatt, *The Verbal Icon* (Lexington: University of Kentucky Press, 1967) reprinted in Joseph Margolis, *Philosophy Looks at the Arts* (Philadelphia: Temple University Press, 1978), p. 305.

8. Theodor W. Adorno, *Aesthetische Theorie* (Frankfurt, 1970), p. 281.

9. Radically new investigations in art are *Studies in the New Experimental Aesthetics,* D.E. Berlyne, ed. (New York: Halsted Press, 1974); and Anthony Hill, *Data: Directions in Art, Theory and Aesthetics* (Greenwich, CT: New York Graphic Society, 1968).

10. A good example is to be found in the poems, pamphlets, essays, and meditations in the book by Arp, mentioned above.

11. Anton Ehrenzweig, *The Hidden Order of Art* (Berkeley: University of California Press, 1967).

12. Allie M. Frazier, "The Problem of Psychic Distance in Religious Art," *Journal of Aesthetics and Art Criticism* XXXI (1973), 389ff.

13. The distinction between the Kantian esthetic categories and the modern notions of individuation (Rosario d' Asunto, *Estetica dell' identità* [Urbino, 1967]), and feeling (Suzanne K. Langer, *Feeling and Form: A Theory of Art* [New York: Scribner's, 1953]).

14. The psychoanalytic approach produced fascinating studies, today frequently belittled by art historians, such as Otto Rank, *Art and Artist* (New York: Agathon Press, 1932, 1968).

15. An excellent article on this issue, pertaining to the distinction between an artistic datum ("art") and an archeological datum ("icon") by Robert Redfield, "Art and Icon," repr. in Charlotte M. Otten, *Anthropology and Art: Readings in Cross-Cultural Aesthetics* (Garden City: The Natural History Press, 1971), pp. 39ff.

16. An important case has been made by Alan Tormey, *The Concept of Expression: A Study in Philosophical Psychology and Aesthetics* (Princeton: Princeton University Press, 1971), pp. 97ff., who states that we cannot simply speak about expression as if it were a continuation of feeling; there exists also a discontinuity between the artist and the product.

17. Cf. the case made by Lionello Venturi, *History of Art Criticism* (New York: Dutton, 1936), p. 301: "the only reality of art is the personality of the artist as it is manifested in his work of art."

18. In this trend, a study not of art but of man's reaction to art has come into being; cf. C.E. Osgood, G. Suci, and P.H. Tannenbaum, *The Measurement of Meaning* (Urbana, IL: University of Illinois Press, 1957) measuring people's reactions to art with scientific methods in scientific control groups.

19. One has to be very careful in using this term "expression," since dance, for instance, demands a different use of "expression" than sculpture; see R. Arnheim, "The Gestalt Theory of Expression," in James Hogg, *Visual Thinking* (Berkeley: University of California Press, 1969).

20. Paul Ziff, "The Task of Defining a Work of Art," *Philosophical Review* LXIII (1953), 68ff.; Morris Weitz, "Can Art be Defined?" in Morris Weitz, *Problems in Aesthetics* (New York: Macmillan, 1970) and Joseph Margolis, "Mr. Weitz and the Definition of Art," *Philosophical Studies* IX (1958), 88ff.

21. Hans Sedlmayr, *Kunst und Wahrheit* (Hamburg, 1958), pp. 156ff., wants to create a "true time" instead of a phony time (*Wahre Zeit* against *Scheinzeit*) in his constant and excessive polemic against modern art. One of

the extreme statements of exclusive concepts of art in Gerardus van der Leeuw, *Sacred and Profane Beauty: The Holy in Art* (New York: Holt, Rinehart and Winston, 1963), p. 272: "art, like everything holy, is only art when it does not know that it is."

22. See Kenyon Cox, *The Classic Point of View* (New York: Scribner's, 1911).

23. The attacks against modern art in Hans Sedlmayr, *Verlust der Mitte, die bildende Kunst des 19. und 20. Jahrhunderts als Symtom und Symbol unserer Zeit* (Salzburg, 1951) from a conservative Catholic point of view, and H.R. Rookmaaker, *Modern Art and the Death of a Culture* (Downers Grove, IL: Intervarsity Press, 1970) from a militant Protestant point of view.

24. Eva Cockcroft, John Weber, James Cockcroft, *Toward a People's Art: The Contemporary Mural Movement* (New York: Dutton, 1976), pp. 169ff.: out of the gallery and into the streets.

25. Hans Richter, *Dada: Art and Anti-Art* (London, 1965), p. 88, states flatly that the ready-mades became art because Duchamp said they were. Cf. George Dickie, *Aesthetics: An Introduction* (New York: Irvington, 1971), p. 101: a work of art is an artifact on which someone, acting on behalf of the art world, has conferred the status of candidate for appreciation. Cf. *Journal of Aesthetics and Art Criticism* XXXIV (1976), 441ff.

26. Desmond Morris, *The Naked Ape* (New York: McGraw-Hill, 1967), p. 114: "These principles apply from one end of the scale to the other, whether you are considering an infant playing in the sand or a composer working on a symphony."

27. Erwin Panofsky, "Style and Medium in the Motion Pictures" in Harold Spencer, *op.cit.*, vol. II, pp. 427ff., and the article by Alexander Sesourke, "Aesthetics of Film, or a Funny Thing happened on the Way to the Movies," *Journal of Aesthetics and Art Criticism* XXXI (1974), 51ff.

28. Even extreme statements on art distinguish it from life. See Arthur Danto, "Artworks and Real Things," *Theoria* XXXIX (1973), 15, who claims that a necktie painted blue by Picasso would qualify as art, while a necktie painted by Cézanne would probably not.

29. On the *driftwood case* see Jack Glickman, "Creativity in the Arts," in Joseph Margolis, *Philosophy Looks at the Arts,* pp. 158ff. and Paul H. Schiller, "Figurative Preferences in the Drawings of a Chimpanzee," Charlotte M. Otten, *op.cit.*, pp. 5ff.

30. On computer art, A.H. Noll, "Human or Machine: A Subjective Comparison of Piet Mondrian's *Compositions with Lines* (1917) and a Computer Generated Picture" *Psychological Record* XVI (1966), repr. in James Hogg, *op.cit.,* pp. 302ff.

31. Herbert Read was surely correct when he stated that a lingua franca of visual symbols no longer exists, *Art and Alienation* (London, 1967). Cf. also André Malraux, *The Metamorphosis of the Gods* (Garden City: Doubleday, 1960), p. 23: "the word 'art' conjures up for every individual, if imprecisely, his own ideal art museum."

32. While Goethe saw in the Last Judgment of the Sistina a superb work of art, Berenson described it as depicting overtrained athletes. See Derek Clifford, *Art and Understanding* (Greenwich, CT: New York Graphic Society, 1968), pp. ixff. To Kenyon Cox (*op.cit.,* pp. 20ff.) impressionist and cubist trends seemed like "sheer madness," yet "all the world knows that even a single line can arouse emotion," stated Piet Mondrian, *Plastic Art and Pure Plastic Art* (New York: Willenborn, 1937). Gustave Caillebotte's *Place de l'Europe on a rainy day* in the Chicago Art Institute was rejected by the Louvre on his death in 1894.

33. Theodor W. Adorno, *op.cit.,* pp. 11ff.

34. Max Dvorak, *Kunstgeschichte als Geistesgeschichte* (Munich, 1928).

35. The task of art history in Mark Roskill, *What Is Art History?* (London, 1976); the task of esthetics and a philosophy of art in Dagobert Frey, *Bausteine zu einer Philosophie der Kunst* (Darmstadt, 1976).

36. Ernst H.J. Gombrich, *op.cit.*

37. E. Kris, *Psychoanalytic Explorations in Art* (New York: Schocken, 1952); Sarah Kofman, *L'enfance de l'art* (Paris, 1970), for whom art is a text to be deciphered, p. 20, against Adorno's protest that such reading precisely cannot be done.

38. Monroe Beardsley, *The Possibility of Criticism* (Detroit: Wayne State University Press, 1970), and above all Joseph Margolis' "robust relativism," *Journal of Aesthetics and Art Criticism* XXXV (1976), 37ff.

39. Richard Wollheim, *On Art and the Mind* (London, 1973), p. 280. This extremely perceptive book claims that we can hold different interpretations about a work of art but not "conflicting interpretations." I am not even sure about the second, because I have seen plenty of research where a competent

scholar moves from one use of a concept to a second one (the difficulty is to distinguish between *different* and *conflicting*): Rudolf Bultmann's use of the word *myth,* Barth's use of the word *word.* The entire ancient world certainly held conflicting interpretations of the word *God* (as personal, impersonal; immanent, transcendent) and many modern thinkers have followed suit.

40. Cf. the passionate polemic by Jindrich Chalupeky, "Nothing but an Artist," *Studio International* 189 (1973), 31ff., against any kind of interpretation of Duchamp, which of course would go diametrically against Jack Burnham's *The Structure of Art,* 2nd ed. (New York: Braziller, 1973), pp. 44, 164.

41. Ernst H.J. Gombrich, "The Use of Art for the Study of Symbols," in James Hogg, *op.cit.,* pp. 149ff. Only through art can some of us still recapture the meaning of certain symbols, p. 159.

42. Ernst H.J. Gombrich, *Meditations on a Hobby Horse* (New York: Phaidon, 1971) warns against the misunderstanding "that the private unconscious meaning of a work communicates itself to the unconscious of the public" (p. 33), diametrically opposed to the psychoanalytic art interpretation (Ernest Jones, *Papers on Psychoanalysis* [London, 1948]. Cf. Susan Sontag, *Against Interpretation* [New York:Farrar, Strauss and Giroux, 1966]).

43. For instance Arnold Hauser, *The Social History of Art,* 2 vols. (New York: Knopf, 1951). It is from such fear that art historians are often reluctant to approach the problems posed to them by philosophers of art, as Kurt Bauch pointed out, "Die Kunstgeschichte und die heutige Philosophie," in *Martin Heideggers Einfluss auf die Wissenschaften* (Bern, 1949).

44. The sociological studies on art sharpen the dilemma, see M. Guyau, *L'art du point de vue sociologique* (Paris, 1926), and G.V. Plekhanov, *Art and Society* (New York: Oriole, 1974).

45. What complicated the interpretative issue further is the fact that since Byzantine times, a kind of interpretative art has emerged in which the problem between direct expression and cognitive expression is not only a matter for the observer but for the artist himself (Robert Byron and David Talbot Rice, *The Birth of Western Painting* [London, 1930], p. 25).

46. See Chapter 6.

47. Thomas Munroe, "The Marxist Theory of Art History," *Journal of Aesthetics and Art Criticism* XVII (1960), 430ff.; Lee Baxandall, "Marxism and Aesthetics: A Critique of the Contribution of George Plekhanov," *ibid.*

XXV (1967), 267ff.; and Miroslav Beker, "Marxism and the Determinants of Critical Judgment," *ibid*. XXIX (1970), 33ff., and the Hegelian base to the Marxist dialectic, also in the same journal; Gay Shapiro's "Hegel's Dialectic of Artistic Meaning" XXXV (1976), 23ff.; and Gustav E. Mueller, "The Function of Aesthetics in Hegel's Philosophy," *ibid*. V (1946), 49ff.

48. Erwin Panofsky, *Idea: A Concept in Art Theory* (New York: Harper and Row, Icon Editions, 1974), p. 126.

49. The notorious article by Morris Weitz, "The Role of Theory in Aesthetics," *Journal of Aesthetics and Art Criticism* XV (1956), 25ff. claimed that any art theory is wrong in principle. See Frank Sibley, "Aesthetic Concepts," *Philosophical Review* LXVIII (1959), 421ff., and the countercase against Sibley by Joseph Margolis in his "Robust Relativism," *Journal of Aesthetics and Art Criticism* XXXV (1976), 45, also arguing against Monroe Beardsley's "Possibility of Criticism." See also J. Margolis, "Objectivity of Aesthetics," *Proceedings of the Aristotelian Society,* Suppl. XLII (1968), 31ff. A fascinating contribution by Ramana Cormier, "Indeterminacy and Aesthetic Theory," *Journal of Aesthetics and Art Criticism* XXXIII (1975).

50. Joseph Margolis, *Value and Conduct* (London, 1971).

51. Jean Duvignaud, *The Sociology of Art* (New York: Harper and Row, 1972), pp. 23ff., speaks about the myths of esthetic theory, but at the end concludes with what is surely a group of esthetic theories ("artistic imagination involves a participation which can never be realized. . ."), p. 143.

52. It must be emphasized that in art and art history, as in philosophy, religion, and history, dissertations *must* be written with such limitations. Least of all at an introductory level can we deal with all the fields at the same time.

53. In spite of the often emotional polemic against Paul K. Feyerabend, his insights are exceedingly important in regard to the crypto-mythic and crypto-religious tendencies of academia, and above all about the scholar's inability to admit them, *Against Method* (Atlantic Highlands, NJ.: Humanities Press, 1974).

54. The idealistic positions in Benedetto Croce, *Nuovi saggi di estetica* (Bari, 1926).

55. Herbert Read, *Art and Society* (New York: Schocken, 1966).

56. Jack Burnham, *op.cit.,* especially pp. 32ff. on time continua.

57. Jean Duvignaud, *op.cit.,* pp. 144f., art as a way of anticipating real experience, as a wager for the future.

58. George Kimball Plochmann, "Plato, Visual Perception and Art," *Journal of Aesthetics and Art Criticism* XXXV (1977), 189ff.

59. An example is Jean Gimpel, *The Cult of Art* (New York: Stein and Day, 1969) for whom fine arts are prehistoric animals to be replaced by film and television, p. 158.

60. Hans Richter, *op.cit.*

61. F.W. Dillistone and James Waddall eds., *Art and Religion as Communication* (Atlanta: John Knox, 1974).

62. F.B. Blanshard, *Retreat from Likeness in the Theory of Painting* (New York: Columbia University Press, 1940).

63. Franz Brommer, *Die Wahl des Augenblickes in der griechischen Kunst* (Munich, 1960).

64. Eric Gill, *Sacred and Secular* (London, 1940), p. 61; cf. Prall, *op.cit.,* pp. 138ff. as opposed to George Santayana, *The Sense of Beauty* (New York: Scribner, 1896), p. 41.

65. Walter Biemel, *Die Bedeutung von Kants Begründung der Aesthetik für die Philosophie der Kunst* (Cologne, 1959), which probably would fall under Gombrich's indictment of "hidden Platonism," *Meditations on a Hobby Horse,* pp. 3f.

66. Erich Neumann, *Art and the Creative Unconscious* (Princeton: Princeton University Press, 1969).

67. Ernst Cassirer, *An Essay on Man* (New Haven: Yale University Press, 1944).

Chapter 4

1. On May 24, 1546, a play about Hercules was prohibited in Geneva, *Corp. Ref.* XXI. 385 (although some plays were allowed later on).

2. S.G. Brandon, *Man and God in Art and Ritual* (New York: Scribner's, 1975).

3. Hugo Koch, *Die altchristliche Bilderfrage nach den literarischen Quellen* (Göttingen, 1917), pp. 31ff. The problem of images cannot be answered merely according to the literary source. Koch is indicative for a whole generation of scholars who deal with the problem of art merely in verbal and literary categories.

4. E.E. Urbach, "The Rabbinical Laws of Idolatry in the Second and Third Centuries in the Light of Archeological and Historical facts," *Israel Exploration Journal* 9 (1959), 149ff., 229ff.

5. Tertullian, *De Idolatria,* P.G. Van der Vat, ed. (Leiden, 1960); Werner Weismann, *Kirche und Schauspiele* (Würzburg, 1972).

6. J. Geffcken, "Der Bilderstreit des heidnischen Altertums," *Archiv für Religionswissenschaft* 19 (1919), 296ff.

7. Leslie Barnard, *The Graeco-Roman and Oriental Background of the Iconoclastic Controversy* (Leiden, 1974) and G.B. Ladner, "The Concept of the Image in the Greek and Byzantine Fathers, and the Iconoclastic Controversy" (*Dumbarton Oaks Papers* VII [1953]), 1ff.; John Phillips, *The Reformation of Images* (Berkeley: University of California Press, 1973).

8. The ambivalence of classical Hebrew culture vis-à-vis art reappears in Islam as well; see K.C. Cresswell, "The Lawfulness of Painting in Early Islam," *Ars Islamica* 11-12 (1946), 159ff.

9. Joseph Gutmann, *No Graven Images: Studies in Art and the Hebrew Bible* (New York: Ktav, 1970), and his article "The Second Commandment and the Image in Judaism," in Joseph Gutmann, *Beauty in Holiness: Studies in Jewish Ceremonial Customs and Arts* (New York: Ktav, 1970).

10. J. Warnke, *Bildersturm: die Zerstörung des Kunstwerks* (Munich, 1973).

11. On the absolute sexual control and domination of women in nomadic culture, see Mary Douglas, *Purity and Danger* (New York: Praeger, 1966), pp. 142ff. and M. Meggitt, "Male-Female Relationships in the Highlands of Australian New Guinea," *American Anthropologist* 2.66 (1964), 204ff.

12. Gerhard von Rad, "Das Bilderverbot im Alten Testament," *Theologisches Wörterbuch zum Neuen Testament* II, 378ff.

13. Horst Bredekamp, *Kunst als Medium sozialer Konflikte Bilderkämpfe von der Spätantike bis zur Hussitenrevolution* (Frankfurt, 1975). Bredekamp

shows extremely well how *Bild* and *Bildersturm,* the creation of the image and the destruction of images, belong together.

14. Elvira, *Canon* 60.

15. *Barnabas* 12:5-17, John 3:14, already Philo *Leg.All.* 2:77ff.

16. Joseph Gutmann, ed., *The Image and the Word* (Missoula: Scholars Press, 1977), stresses rightly the political aspect of the Deuteronomic reform and is certainly correct in emphasizing that the documentation of the iconoclastic controversy is incomplete (ch. 7).

17. Sprague Allen, *Tides in English Taste* (Cambridge: Harvard University Press, 1973).

18. Despite all wrong historical constructs and erroneous conclusions, Freud's *Moses and Monotheism* must be considered in any debate on the iconic problematic of Judaeo-Christianity.

19. Leonard Swidler, *Women in Judaism* (Metuchen, NJ: Scarecrow, 1976).

20. Karl Heinz Bernhardt, *Gott und Bild, ein Beitrag zur Begründung und Deutung des Bilderverbotes im Alten Testament* (Berlin, 1956).

21. See Paul C. Finney, "Antecedents of Byzantine Iconoclasm: Christian Evidence before Constantine," in Joseph Gutmann, ed., *op.cit.,* pp. 27ff.

22. Hugo Koch, *op.cit.,* pp. 41ff., Tert. *De Idolatria,* pp. 1ff.

23. Norman H. Baynes, "Idolatry in the Early Church," *Byzantine Studies and Other Essays* (Westport, CT: Greenwood, 1974). Leslie Barnard, *op.cit.,* pp. 80ff., and W. Elliger, *Die Stellung der alten Christen zu den Bildern in den ersten vier Jahrhunderten,* 2 vols. (Leipzig, 1930-1934) present an extensive debate on the theological and liturgical issues in the iconic problem.

24. Greek philosophers were anti-iconic (Leslie Barnard, *op.cit.,* pp. 83ff. and Hugo Koch, *op.cit.,* pp. 91ff.), hence the Christian dilemma was paralleled and influenced by Graeco-Roman society. Cf. E. Kitzinger, "The Cult of Images in the Age Before Iconoclasm," *Dumbarton Oaks Papers* VIII (1954), 83ff. G.B. Ladner, "Der Bilderstreit und die Kunst-Lehren der byzantinischen und abendländischen Theologie," *Zeitschrift für Kirchengeschichte* 1 (1931), 1ff. The *veneration* of images can only be documented since the fourth century (Aug. *De Mor. eccl. cath.* 1.34), but their *presence* is certainly documented two centuries earlier, whether or not "magic power" (Barnard, *op.cit.,* pp. 55ff.) was connected with them.

25. Tert. *Adv. Prax.* 1ff.; *Adv.Marc.* 1.3; Origen *Peri Archon,* I.1.5ff.; Clem.Alex. *Protr.* I.8; Iren. *Adv. haer.* III. 6.2ff. Cf. G.L. Prestige, *God in Patristic Thought* (London, 1965), R.A. Norris, *God and World in Early Christian Theology* (New York: Seabury, 1965), and Lloyd Patterson, *God and History in Early Christian Thought* (New York: Seabury, 1967).

26. Athanasius *De Inc.* 1ff.; Tert. *Adv. Prax.* 27; Clem. Alex. *Protr.* 11; Origen *Peri Archon* 2.25. It is important to notice that both sides of the polarity appear frequently in the same author.

27. Cf. the documentation in Chapter 6.

28. "The permanent tension between the Godward and the manward ends of the incarnational process": Gilbert Cope, "The Problem of Sacred Art," in *Christianity and the Visual Arts* (London, 1975), p. 19.

29. George Mercier, *L'art abstrait dans l'art sacré* (Paris, 1964).

30. Hebr. 10:14; Gal. 1:8; Iren. *Adv. Haer.* I.2ff.; III.11ff., 38ff.; Tert. *Praesc. Haer.* 20ff.

31. John 3:8; 16:7–8; Eus. H.E. V.16, 7ff.; *Didache* 7–10; Hippolytus *Apost. Trad.* 21ff.; Tertullian *De res. carn.* 11; Clem. Alex. *Paed.* 6; 26; 38ff.

32. H. Karpp, *Schrift und Geist bei Tertullian* (Gütersloh, 1955).

33. Stephen Gero, "Byzantine Iconoclasm and the Failure of a Medieval Reformation," in Joseph Gutmann, ed., *op.cit.,* pp. 49ff.

34. Justin Martyr, *Apol.* II.13.

35. Justin Martyr, *Apol.* I.46.

36. The problem is not only Christian, see Paul C. Finney, "A Note on the Jewish Orpheus, *Journal of Jewish Art* 4 (1977).

37. John Berger, *Art and Revolution* (New York: Pantheon, 1969); and in a different vein, James K. Feibleman, *The Quiet Rebellion* (New York: Horizon Press, 1972).

38. It does not matter whether this letter is authentic, as I believe, from Elvira Canon 36, or has been created by iconoclastic fanaticism: Adolf von Harnack, *Geschichte der altchristlichen Literatur* (Berlin, 1904), p. 127.

39. Horst Bredekamp, *op. cit.,* pp. 203ff.

40. Calvin, *Inst.* IX. 12; cf. *Corp. Ref.* XL.184 and XXVI.147ff.

41. William Domhoff, "But Why Did They Sit on the King's Right in the First Place?" *Psychoanalytic Review* 56 (1969-70), 586ff.

42. I.M. Lewis, *Ecstatic Religion* (New York: Penguin Books, 1971).

43. Cf. the polemic by Hans Haacke in *Studio International* 191/979 (1976), 117ff., against the "formalized ghettoization of art," against Greenberg and Hilton Kramer and David Bourdon of *The New York Times* and the *Village Voice,* against the "liberal myth that beauty is ideologically neutral." Cf. Richard Fitzgerald, *Art and Politics* (Westport: Greenwood, 1973), on the political power of cartoonists.

44. D.W. Gottschalk, *Art and the Social Order* (Chicago: University of Chicago Press, 1947) versus Edgar Wind, *Art and Anarchy* (New York: Vintage, 1969).

45. Desmond Morris, *The Naked Ape,* p. 130.

46. Mario Napoli, *Pittura antica in Italia* (Bergamo, 1960), p. 8. Cf. Cyril Richardson, "Some Reflections on Liturgical Art," *Union Seminary Quarterly Review* (1953) III.3.

47. Calvin's fear of the dance, *Corp. Ref.* XXIV.226 and XXVI.341.

48. Johan Bernitz Hygen, *Morality and the Muses: Christian Faith and Art Forms* (Minneapolis: Augsburg Publ. House, 1965).

49. Adrian Stokes, *Reflections on the Nude* (London, 1967).

50. Robert Landmann, *Ascona: Monte Verità, auf der Suche nach dem Paradies* (Zürich, 1973).

51. Cf. also Gyula von Végh, *Die Bilderstürmer* (Strassburg, 1915).

Chapter 5

1. Xenophanes, *Fragm.* 15, cf. C.I. Gulian, *Mythus und Kultur: zur Entwicklungsgeschichte des Denkens* (Vienna, 1971).

2. Cf. Richard Wollheim, *On Art and the Mind* (London, 1973), p. 263: "The question why art has a history does not itself fall within the domain of art history." It is this kind of perceptive observation that justifies placing the problem of art and religion into a larger perspective.

3. C.G. Jung and C. Kerényi, *Introduction to a Science of Mythology,* (London, 1951). Robert Campbell, *Myth, Dreams and Religion* (New York: Dutton, 1970). Mircea Eliade, *Myth and Reality* (New York: Harper and Row, 1963). Brevard S. Childs, *Myth and Reality in the Old Testament* (London, 1960).

4. Andrew Lang, *Custom and Myth* (London, 1893); Henry Frankfort, *The Intellectual Adventure of Ancient Man* (Chicago: University of Chicago Press, 1946), p. 7 (myth reveals a significant if unverifiable truth); Edmund R. Leach, *The Structural Study of Myth and Totemism* (London, 1967).

5. Peter Berger and Thomas Luckmann, *The Social Construction of Reality* (New York: Doubleday, 1967); Clyde Kluckhohn, *Culture and Behavior* (New York: The Free Press of Glencoe, 1962); Bronislaw Malinowski, *Magic, Science and Religion* (Boston: Beacon Press, 1948).

6. Sigmund Freud, *Moses and Monotheism* (New York: Vintage, 1939). The Freudian position in Norman O. Brown, *Life against Death* (Middletown: Wesleyan University Press, 1958); the Jungian in Robert Campbell, *The Masks of God* (New York: Penguin, 1964).

7. Werner Bartsch, ed., *Kerygma and Myth* (London, 1953); Ernst Cassirer, *The Philosophy of Symbolic Forms,* 2 vols. (New Haven: Yale University Press, 1953, 1955).

8. Claude Lévi-Strauss, *Myth and Meaning* (Toronto: University of Toronto Press, 1978), Jane Harrison, *Ancient Art and Ritual* (London, 1913).

9. Andrew Greeley, *The Mary Myth* (New York: Seabury Press, 1977). From a Protestant viewpoint, Heiko Obermann, *The Virgin Mary in Evangelical Perspective* (Philadelphia: Fortress, 1971); from a broad spectrum of Roman Catholic positions, Hermann Josef Brosch and Heinrich M. Köster, *Mythos und Glaube* (Essen, 1972).

10. Martin L. Gross, *The Psychological Society* (New York: Random House, 1978); Paul Feyerabend, *Against Method* (Atlantic Highlands: Humanities, 1975).

11. Cf. also Hans-Georg Gadamer, *Truth and Method* (New York: Seabury Press, 1975); Henry A. Murray's collection of essays on myth, *Myth and Mythmaking* (Boston: Beacon Press, 1960); and Alfred North Whitehead, *Symbolism: Its Meaning and Effect* (New York: Capricorn, 1959).

12. G.S. Kirk, *Myth: Its Meaning and Function in Ancient and Other Cultures* (Berkeley: University of California Press, 1973).

13. A very important point is made by George Devreux, "La Naissance d'Aphrodite," in J. Pouillon et P. Maranda eds., *Mélanges offerts à Claude Lévi-Strauss* (Paris, 1970), p. 1230: myth is "surdéterminé," it has more than a single explanation.

14. G.S. Kirk, "On Defining Myth," *Exegesis and Argument* (Assen, 1973), p. 65.

15. Robert Graves, *Greek Myths*, 2 vols. (New York: Penguin, 1955).

16. Hermann Gunkel, *The Legends of Genesis* (New York: Schocken, 1964); Gerhard von Rad, *Genesis, a Commentary* (Philadelphia: Westminister, 1961).

17. José Dörig, Olaf Gigon, *Der Kampf der Götter und Titanen* (Olten, 1961); Lee W. Gibbs and W. Taylor Stevenson, *Myth and the Crisis of Historical Consciousness* (Missoula: Scholars Press, 1975).

18. Erich Auerbach, *Mimesis* (Princeton: Princeton University Press, 1953).

19. Michael N. Nagle, *Spontaneity and Tradition: A Study in the Oral Art of Homer* (Berkeley: University of California Press, 1974).

20. Klaus Koch, *The Growth of the Biblical Tradition* (New York: Scribner's, 1969). Cf. Edmund R. Leach, *Genesis as Myth and Other Essays* (London, 1969).

21. Alexander Heidel, *The Gilgamesh Epic and Old Testament Parallels* (Chicago: University of Chicago Press, 1946); W.H. Lambert and A.R. Millard, *Atra-Hasis, The Babylonian Story of the Flood* (Oxford, 1969).

22. E.R. Dodds, *The Greeks and the Irrational* (Berkeley: University of California Press, 1971) has challenged the notion that the Homeric epic is void of religious quality. But what Dodds, for instance in his fascinating chapter on "Agamemnon's Apology," demonstrates is precisely the psychological transformation of mythic models. The awareness of "divine madness" is no longer part of the naïve religious consciousness.

23. Linda Lee Clark, *Helen, the Evolution from Divine to Heroic in Greek Epic Tradition* (Leiden, 1976). Julian Jaynes, *The Origin of Consciousness in the Breakdown of the Bicameral Mind* (Princeton: Princeton University Press, 1977).

24. J. Huizinga, *Homo Ludens* (Boston: Beacon Press, 1955). Chr. Voigt, *Überlegung und Entscheidung, Studien zur Selbstauffassung des Menschen bei Homer* (Meisenheim, 1972).

25. On the role of myth in Greek poetry, see Werner Jaeger, *Paideia* (Oxford, 1939), pp. 248ff; *Mythopoiesis: Mythic Patterns in the Literary Classics* (Detroit: Wayne State University Press, 1970).

26. Vergil B. Otis, *A Study in Civilized Poetry* (Oxford, 1964).

27. A view of the Song of Deborah in Martin Buber, *The Prophetic Faith* (New York: Harper and Row, 1949), pp. 8ff.

28. See Bernhard W. Anderson, *Creation Versus Chaos: the Reinterpretation of Mythical Symbolism in the Bible* (New York: Association Press, 1967).

29. The collapse of tribal security is ignored in many of the constructions operating with *Heilsgeschichte,* cf. Eric Voegelin, *Order and History,* Vol. 1 (Baton Rouge: Louisiana State University Press, 1966).

30. Excellent observations on this tragic aspect of art in John W. Dixon, *Nature and Grace in Art,* p. 20.

31. "Mad is the man who sacks a city," cried Euripides in the *Trojan Women,* p. 95.

32. Abraham Heschel, *The Prophets,* 2 vols. (New York: Harper and Row, 1969, 1971).

33. Morton Smith, *Palestinian Parties and Politics That Shaped the Old Testament* (New York: Columbia University Press, 1971).

34. Theodor H. Gaster, *Thespis: Ritual, Myth and Drama in the Ancient Near East* (New York: Harper and Row, 1961).

35. Humphrey Kitto, *Greek Tragedy* (New York: Barnes and Noble, 1966). George Thomson, *Aeschylus and Athens* (New York: Grosset and Dunlap, 1968).

36. "Mortal you cannot pollute the heavens," says Euripides in his *Heracles.* Man is the problem, not the gods.

37. Jan Kott, *The Eating of the Gods* (New York: Vintage, 1974). Julia Kristeva, "Distance et anti-représentation," *Tel Quel* 32 (1968), 49ff.

38. Friedrich Nietzsche, *The Birth of Tragedy* (New York: Random House, 1967).

39. Cf. E.R. Dodds' transmutation from the shame culture to the guilt culture, *The Greeks and the Irrational* (Berkeley: University of California Press, 1951), 28ff.

40. To be sure, the *Oresteia* ends with a solution (which "may be the reason why Hegel liked the play so much," quipped Kott, *op.cit.*, p. 14) but in the Sophoclean tragedy the hero is alienated from mankind altogether (p. 43), perhaps with the exception of *Oedipus at Colonus*.

41. The process is paralleled in the political realm; see W.G. Forrest, *The Emergence of Greek Democracy* (New York: McGraw-Hill, 1966).

42. Norman Austin, *The Greek Historians* (New York: Van Nostrand-Reinhold, 1969).

43. C.N. Cochrane, *Thucydides and the Science of History* (London, 1929).

44. Olaf Gigon, *Der Ursprung der griechischen Philosophie von Hesiod bis Parmenides* (Basel, 1945); Ruhi Afnan, *Zoroaster's Influence on Anaxagoras, the Greek Tragedians and Socrates* (New York: Philosophical Library, 1965).

45. William C. Greene, *Moira, Fate, Good and Evil in Greek Thought* (New York: Harper, 1944), pp. 89ff.

46. Heinrich Dörrie, *Der Mythos und seine Funktion in der antiken Philosophie* (Innsbruck, 1972) and Willem Koster, *Le mythe de Platon, de Zarathoustra et des chaldéens* (Leiden, 1951).

47. E.R. Dodds, *The Ancient Concept of Progress and Other Essays on Greek Literature and Belief* (Oxford, 1973).

48. Iris Murdoch, *The Fire and the Sun: Why Plato Banished the Artists* (Oxford, 1977).

49. Whitney Oates, *Plato's View of Art* (New York: Scribner's 1972). Constantine Cavarnos, *Plato's Theory of Fine Art* (Athens, 1973) tries to defend Plato.

50. For the Greek overall development, see F.H. Cornford, *Greek Religious Thought from Homer to the Age of Alexander* (New York: AMS Press, 1979).

51. I have dealt with this issue at length in my chapter on Nicaea in *The Serpent and the Dove* (Nashville and New York: Abingdon, 1966).

52. Nahum N. Glatzer, *The Dimensions of Job* (New York: Schocken, 1969).

53. C.G. Jung, *Answer to Job,* in *Collected Works,* vol. 11 (Princeton: Princeton University Press, 1969).

54. Karl Schefold, *Griechische Kunst als religiöses Phänomen* (Hamburg, 1961).

55. This aspect is strongly emphasized in Arnold Hauser, *The Social History of Art,* vol. 1.

56. Vitruvius, *The Ten Books on Architecture* (New York: Dover, 1960).

57. C. Dawson, *Religion and the Rise of Western Culture* (Garden City: Doubleday, Image Books, 1958); Gilbert Murray's classic *Five Stages of Greek Religion* (New York: Doubleday, 1955); John H. Finley, *Four Stages of Greek Thought* (Stanford: Stanford University Press, 1966).

58. F.E. Peters, *The Harvest of Hellenism* (New York: Simon and Schuster, 1970), pp. 185ff.

Chapter 6

1. Heinz Kähler, *Die spätantiken Bauten unter dem Dom von Aquileia und ihre Stellung innerhalb der Geschichte des christlichen Kirchenbaus* (Saarbrücken, 1957).

2. Luisa Bertacchi, "La basilica postteodoriana di Aquileia," *Aquileia Nostra* 43 (1972), 62ff.

3. Luisa Bertacchi, "La torre campanaria di Aquileia," *Aquileia Nostra* 44 (1973), 1ff.

4. G. Brusin and P.L. Zovatto, *Monumenti paleocristiani di Aquileia e di Grado* (Udine, 1957), pp. 20-140; Gian Carlo Menis, *I mosaici cristiani di Aquileia* (Udine, 1965); Giuseppe Bovini, *Le antichità cristiane di Aquileia* (Bologna, 1972), with a recent bibliography, pp. 239ff.

5. Mirabella Roberti, "Considerazione sulle aule teodoriane di Aquileia," *Studie Aquileiese* (Aquileia, 1953), 209ff.; Luisa Bertacchi, "Il mosaico teodoriano scoperto nell'interno del campanile di Aquileia," *Aquileia Nostra* 32/33 (1961/62), 27ff.; Heinz Kähler, *Die Stiftermosaiken in der konstan-*

tinischen Südkirche von Aquileia (Cologne, 1962), p. 14, dates the mosaics a decade later, in the year 326.

6. Most of the older scholars, Brusin-Zovatto, *Monumenti,* pp. 22ff.; C. Cecchelli, "Gli edifici e i mosaici paleocristiani nella zona della basilica," *La Basilica di Aquileia* (Bologna, 1963), pp. 107ff.; G.C. Menis, *op.cit.,* pp. 19ff. More recent excavations seem to have proven at least the unity of the Northern section (L. Bertacchi, "Un decennio di scavi e scoperte di interesse paleocristiano ad Aquileia," Atti del III Congresso Naz. di Archeologia Cristiana, *Antiquità Crist.* VI (Trieste, 1974), 68-71.

7. Mark Roskill, *What Is Art History?* (New York: Harper and Row, 1975).

8. Erwin Panofsky, *Meaning in Visual Arts* (Garden City: Doubleday, 1955) and above all Rudolf Arnheim, *Art and Visual Perception* (Berkeley: University of California Press, 1974). Also Anton Ehrenzweig, *The Hidden Order of Art* (Berkeley: University of California Press, 1967).

9. There exists of course an important illustrative activity of the religious artist (K. Weitzmann, *Illustration in Roll and Codex,* [Princeton: Princeton University Press, 1947]). But such illustrative function is only one among many others. As Brandon asserts constantly in his last opus, *Man and God in Art and Ritual,* art furnishes "evidence in its own right" (p. 3).

10. André Grabar, *Christian Iconography, A Study of Its Origins* (Princeton: Princeton University Press, 1968), states the cross-disciplinary problem to which I address myself. He claims that "it is not the task of the historian to judge the relative effectiveness of the image-sign of paleo-Christian art as a means of iconographic expression" (p. 9). Why not? In regard to *words,* scholars have certainly asked: How did they work? Why did they create conflict? What was the matter with their effectiveness? For instance, Roman imperial cults failed because words and cultic deeds were no longer effective, and such an insight has become part of a historical description of Roman imperial religion. To ask for meaning, role, function and hence effectiveness is, of course, an exceedingly difficult enterprise. Its difficulty does not invalidate the task.

11. Kähler, *Spätantike Bauten,* suggests three stages: a house church, the Northern church, the Constantinian basilica. Josef Fink, *Der Ursprung der ältesten Kirchen am Domplatz von Aquileia* (Münster/Cologne, 1954) suggests a pagan sanctuary to Hermes as the original Northern aula.

12. The church discovered near the cemetery, dating from the end of the fourth century, has nonobjective mosaics, tessellate, polychrome, geometric (G. Brusin, *Gli Scavi di Aquileia* [Udine, 1934], pp. 187ff.)

13. Similar mixed imagery, pastoral scenes, good shepherd, portraits, animals are in the Cal sanctuary of Aquileia: Irma Bartolotto, *Il sacello paleocristiano della Cal ad Aquileia* (Udine, 1973).

14. Bovini, *op. cit.*, pp. 72ff.

15. Aquileia was an important seaport (G. Brusin, "Il simbolo delle pesche di Aquileia," *Aquileia Nostra* 23 [1952], 37ff). The juxtaposition of pastoral scenes, portraits, seasons, and scenes from the sea was part of the Aquileia symbolism. See L. Bertacchi, "Nuovi mosaici figurati di Aquileia," *Aquileia Nostra* 34 (1963), 20ff.

16. Jonah and the Good Shepherd appear together in the sarcophagus of Santa Maria Antiqua. See Grabar, *op. cit.*, ill. 22. The demon (Menis, *op. cit.*, ill. 71) reminds us of the Paulus exorcista in the Callixt catacombs.

17. The suggestion by Brusin that the Cyriacus inscription has been inserted later is hard to substantiate (Kähler, *Stiftermosaiken,* p. 19). The Januarius inscription also has been dated in the fifth century, see S. Stucchi, "Le basiliche paleocristiane di Aquileia," *Riv. di Arch. Christ.* 22/23 (1947/48), 169ff.

18. Josef Fink, *op. cit.*, pp. 44ff.

19. Against Fink, scholars love to talk about "crypto-Christian" meanings in the northern aula. A theological interpretation of these mosaics by E. Marcon, *La 'Domus Ecclesiae' di Aquileia, Ipotesi e Indagini* (Cividale, 1958).

20. J. N. D. Kelly, *Early Christian Creeds* (London, 1960).

21. Material in Pierre du Bourguet, *Art paléochrétien* (Amsterdam/Lausanne, 1970), pp. 39, 78, 83, 94, 102–111.

22. André Grabar, *op. cit.,* ill. 3, 4, and 22.

23. Pierre du Bourguet, *op. cit.,* pp. 9–10, 53–54, 111–113.

24. J. Wordsworth, *Bishop Serapion's Prayer Book* (London, 1923).

25. R. Krautheimer, *Early Christian and Byzantine Architecture* (New York: Penguin, 1979).

26. Samuel Laeuchli, *Power and Sexuality, The Emergence of Canon Law at the Synod of Elvira* (Philadelphia: Temple University Press, 1972), p. 35.

27. Cf. Bovini, *op. cit.,* p. 58; Menis, *op. cit.,* pp. 13ff. emphasized that the cycle of Aquileia does not merely represent a local curiosity but must be seen in the context of ancient Christian Venetia and Istria. Important for our case is the analysis of the portraits by Heinz Kähler (*Stiftermosaiken,* pp. 9ff.) who sees in them figures of the imperial family. He even thinks he can identify Constantine, Faustina, the sons, etc. The church was located close to the imperial palace (Brusin-Zovatto, p. 42). Hence a direct tie to the imperial power structure is indicated from several sources.

28. The importance of the basilica in regard to the imperial house is also stressed in the analysis of Fink, who sees in the old aula a very different sanctuary (*op. cit.,* pp. 58f.)

29. Fink, *op. cit.,* pp. 71ff.

30. Socrates, *Hist. eccl.* 1.8 (Opitz, *Urkunde* 22).

31. The process was started by Constantine himself, see Socrates, *Hist. eccl.* 1.9.17ff. (Opitz, *Urkunde* 25).

32. See the letter by Eusebius of Nicomedia from exile, Socrates, *Hist. eccl.* 1.14.2ff (Opitz, *Urkunde* 31).

33. The seeming Athanasius-Alexandrian victory of Nicaea led, in fact, to the deposition of Eustatius (Socrates, *Hist. eccl.* 1.23.8ff.), to the anti-Alexandrian council of Tyre (Sozomen, *Hist. eccl.* 2.25.3ff.) and to the exile of Athanasius (Socrates, *Hist. eccl.* 1.35.1ff.)

34. Even if one were to accept Fink's theory about an original Hermes sanctuary (based among other data on the mosaic of the battle between the rooster and the turtle [*op. cit.,* pp. 25ff.]), the acceptance of such pagan symbolism by the builders of the southern basilica was a remarkable deed.

35. Marcon, *op. cit.,* pp. 9ff. See also F. Luzzato, "Gli Ebrei in Aquileia," *Rassegna mensile di Israele* 16 (1950), 1ff. and L. Ruggini, "Ebrei ed orientali nell'Italia settentrionale fra il IV et VI secolo d. C.," *Stud. et Doc. Hist. et Juris* 25 (1959), 186ff.

36. Extensive material in du Bourguet, *op. cit.,* pp. 9–10, 21–22, 41, 53–54.

37. E. R. Goodenough, *Jewish Symbols in the Greco-Roman Period* (Princeton: Princeton University Press, 1964), vol. XI, plates 82–86. Pausanias, 9.22.1 (Bartolotto, *op. cit.,* pp. 41ff.); F. Gerke, *Christus in der spätantiken Plastik* (Mainz, 1948), pp. 6ff. Walter Elliger (*Zur Entstehung*

und frühen Entwicklung der altchristlichen Bildkunst [Leipzig, 1934]) claimed that the evolution of early Christian art had to be seen in connection with theology and piety and not with art (p. 270). The data of Aquileia, ignored in Elliger's book, do not bear out such a theory.

38. Michael Gough, *The Origins of Christian Art* (London, 1973), p. 76. Putti exist in Domitilla (*Amor and Psyche,* Grabar, ill. p. 77) and in the catacombs of the Via Latina (A. Ferrua, *Le pitture della nuova catacomba in Via Latina* [Città del Vaticano, 1960]).

39. The fishing scene, comments Gough, could pass as pagan were not the deliverance of Jonah included in it (*op. cit.,* p. 71). On the inclusiveness of Aquileia's imagery, see Bartolotto, *op. cit.,* pp. 72ff.

40. Grabar speaks of "a single language of visual forms," *op. cit.,* p. 32.

41. Tertullian *De Idol.* 1ff.

42. The remnants of paleo-Christian churches in the Adriatic region around Aquileia shows how widespread the symbolic world of that floor was; the material in Gian Carlo Menis, *La basilica paleocristiana nelle diocesi setten-trionali della metropoli d'Aquileia* (Città del Vaticano, 1958).

43. Bovini, *op. cit.,* p. 189.

44. Athanasius, *Contra Arianos* 1.14.

45. Cf. Eusebius' report on Nicaea, Socrates, *Hist. eccl.* 1. 8 (esp. 5–6).

46. Athanasius, *Contra Arianos* 1.15ff.; 1.41; 1.58; 2.19ff., 34ff. etc.

47. Hence we can look at a patristic problem from the aspect of theology (J. N. D. Kelly, *Early Christian Doctrine* [New York: Harper and Row, 1958]), philosophy (Harry A. Wolfson, *The Philosophy of the Church Fathers* [Cambridge: Harvard University Press, 1956]), or sociology.

48. We cannot detect alterations. In consecutive centuries, iconic corrections *were* made and we still can see the changes, as has been carefully shown by Luisa Bertacchi in the Good Shepherd mosaic near the cathedral: "Il mosaico aquilese del Buon Pastore 'dall'abito singolare'," *Antichità Altoadriatriche* 12 (1977), 429ff.

49. Cf. Jonah lies under the tree like Endymion (for instance, the one in the Naples museum; see Grabar, *op. cit.,* pp. 14 and 32, ill. 31), with almost identical gestures.

50. Grabar observed that it is "sometimes difficult to distinguish one from another," i.e. a pagan from a Christian Good Shepherd (*op. cit.,* p. 36, ill. 88–89).

51. Compare the Christ-Orpheus in the Domitilla catacombs (du Bourguet, *op. cit.,* p. 53), the Good Shepherd in the Louvre (p. 54) and the Shepherd in the Domitilla ceiling (p. 10).

52. Kähler, *Stiftermosaiken,* p. 9; Bovini, *op. cit.,* pp. 164ff. On games and circus images in paleochristian art, see Grabar, p. 16.

53. Brusin-Zovatto, *Monumenti,* pp. 44ff. and Fink, *Der Ursprung,* pp. 38ff.; Bovini, *Le antichità cristiane,* pp. 92ff.

54. I question whether one should speak about "deliberate ambiguity" (Grabar, *op. cit.,* p. 9). The theologians of the post-Nicene times did not like to hear (although Aetius and others pointed it out to them) how much their categories were part of the metaphysical dilemma of contemporary philosophy; they were not happy about Arius' statement that their creed was Manichaean, and gnostic (Athanasius, *De Syn.* 16, Opitz *Urkunde* 6). Hence it is hard to imagine that the group of artists, clergy, and donors of Aquileia was more aware than the theologians of the Christian ambiguity vis-à-vis the classical world. Individuals might well have felt the intricate relationship between Christian and pagan culture but the official proclamations certainly never expressed a commonality such as we find in the iconic material of Aquileia.

Chapter 7

1. Thomas Aquinas, *Summa* I.35.5.

2. See Jane Dillenberger's second chapter in *Style and Content in Christian Art* (Nashville: Abingdon, 1965), pp. 15ff.

3. A systematic separation of esthetics from ethical and theoretical considerations does not come until the eighteenth century. See Erwin Panofsky, *Idea* (Columbia: University of South Carolina Press, 1968), p. 4.

4. Dedo Müller, "Die Musik ist dämonisches Gebiet," in *Bild und Verkündigung* (Berlin, 1962), pp. 132ff.

5. Richard Wollheim in *On Art and the Mind,* p. 218, comments on the fact that Freud did not share the popular and easy notion of the artist as neurotic.

However, see Herbert Read, *Art and Society,* p. 85, on the psychotic aspect of the artist.

6. Léon Wencelius, *L'ésthétique de Calvin* (Paris, 1937).

7. The Thomistic categories (univocal, equivocal, and analogical) in modern transformation by William F. Lynch, *Christ and Apollo* (New York: Sheed and Ward, 1960).

8. William S. Rubin, *Modern Sacred Art and the Church of Assy,* pp. 64ff.

9. Cf. Günther Rohrmoser, *Herrschaft und Versöhnung, Aesthetik und die Kulturrevolution des Westens* (Freiburg i. Br., 1972), pp. 22ff.

10. Art not only unites but divides, Mukerjee, *The Social Function of Art,* p. 21.

11. The detective work by Lotte Brand Philip, *The Ghent Altarpiece and the Art of Jan Van Eyck* (Princeton: Princeton University Press, 1972).

12. See also Peter Sely, "The Aesthetic Theories of Kandinsky and Their Relationship to the Origin of Non-Objective Painting," in Harold Spencer, *Readings in Art History* (New York: Scribner's, 1969), pp. 357ff.

13. Karl Löwith, *Meaning in History* (Chicago: University of Chicago Press, 1949).

14. Carl Georg Heise, "Intuition und Kunstwissenschaft," in *Festschrift für Hanns Swarzenski,* (Berlin, 1973), pp. 41ff.

15. Vitruvius, IV.2ff.

16. The material for the following in Richard Krautheimer, *Early Christian and Byzantine Architecture* (New York: Penguin, 1965), and John Beckwith, *Early Christian and Byzantine Art* (New York: Penguin, 1970).

17. Friedrich Deichmann, "Basilica," *Realenzyklopädie für Antike und Christentum,* vol. I, col. 1225ff.

18. Carlo Cecchelli, *I mosaici della basilica di Santa Maria Maggiore* (Turin, 1956).

19. Karl Schefold, *Römische Kunst als religiöses Phänomen* (Hamburg, 1964) and also his *Myth and Legend in Greek Art* (New York: Abrams, 1966).

20. On the two-dimensional, rather three-dimensional, character of the

Roman temple, see Mortimer Wheeler, *Roman Art and Architecture* (New York: Praeger, 1964), pp. 89ff.

21. The causes for this development have been analyzed by E. R. Dodds, *Pagan and Christian in an Age of Anxiety* (Cambridge: Cambridge University Press, 1965).

22. Pausanias, *Guide to Greece* (New York: Penguin, 1971).

23. Religious architectural states can remain unchanged for centuries: Jean Bayet, *Idéologie et Plastique,* (Rome, 1975), p. 775.

24. Elvira, Canon 50.

25. E. H. Swift, *Roman Sources of Christian Art* (Westport, CT: Greenwood Press, 1970) and Hans Peter L'Orange, *Art Forms and Civic Life in the Late Roman Empire* (Princeton: Princeton University Press, 1965).

26. An example of such cross-disciplinary research on Ravenna is Otto Von Simson's, *The Sacred Fortress* (Chicago: University of Chicago Press, 1948).

27. The pagan prototypes in D. V. Ainalov, *The Hellenistic Origins of Byzantine Art* (New Brunswick: Rutgers University Press, 1961).

28. Peter Hammond, *Liturgy and Architecture* (New York: Columbia University Press, 1962).

29. See Otto H. Senn, "Church Building and Liturgy in the Protestant Church," *Lucerne International Conference on Church Architecture and Church Building* (Geneva, 1962). See also Katherine Kuh, *Break-Up, The Core of Modern Art* (Greenwich, CT: New York Graphic Society, 1965).

30. Rudolf Schwarz, *Kirchenbau* (Heidelberg, 1960).

31. Ferdinand Pfammatter, *Betonkirchen* (Zürich, 1948).

32. Pietro Bargellini, *L'arte Cristiana* (Florence, 1959).

33. Jane Dillenberger, *op. cit.,* sees, for instance, in a Richier sculpture a new iconography emerge (p. 225).

34. A good example is Titus Burckhardt, *Sacred Art in East and West* (London, 1967), who views patristic art as ideal and modern art as decadent and unholy.

35. Cf. Donald J. Bruggink and Carl H. Droppers, *Christ and Architecture.*

36. Cf. the article by Otto Brendel, "Art and Freedom in Evolutionary Perspective," in David Bindley, *The Concept of Freedom in Anthropology* (The Hague, 1963), pp. 245ff.

37. John W. Dixon, *Nature and Grace in Art,* p. 11, is quite correct when he observes that the Christian church has never really solved the place of imagery in its life. The ambiguous attitude toward art is a direct result from and analogue to the social and intellectual ambiguities in which a religious movement grows, and does not grow.

38. Ed. L. Miller, *God and Reason* (New York: Macmillan, 1972), on the problem of analogy in Christian thought.

39. Augustine, *Confessions* X.19; X.24.

40. Jean Piaget and Albert Morf, *Logique et Perception* (Paris, 1958), pp. 71–73: there exists in man a perceptive power to unite and to separate.

41. A good article on this point by Paul Bohannan, "Artist and Critic in an African Society," reprinted in Charlotte M. Otten, ed., *Anthropology and Art,* pp. 172ff.

42. We study pictures, and we see things in a picture, Ernst H. J. Gombrich, *Art and Illusion,* p. 24.

43. Rudolf Bultmann, *Jesus Christ and Mythology* (New York: Scribner's, 1958).

44. Cf. the account by Natalia Sokolowa about the discovery of the Sistine Madonna in Manfred Bachmann, *Dresdener Gemäldegalerie* (Leipzig, 1978), p. 14f.

45. This process differs, of course, from the Renaissance type of artistic "progress" as in E. H. Gombrich, *Norm and Form in the Art of the Renaissance* (London, 1978), pp. 1ff.

46. It is a more dramatic and also more physical form of the processes outlined in Rudolf Arnheim, *Art and Visual Perception: A Psychology of the Creative Eye* (Berkeley: University of California Press, 2nd ed. 1974).

47. This confrontation does not necessarily open modern art for us but it might give us an access. In fact it will, if not eliminate, lessen the kind of old-maidish polemic against the contemporary art world which we read in Oswald Spengler's *Decline of the West* (New York: Knopf, 1926), p. 294. Spengler did

not look at it nor did he hear any of it, or if he did, his eyes and his ears were closed.

48. John Macmurray, *Religion, Art and Science: A Study of Reflective Activities in Man* (Liverpool, 1961).

49. Ernst Murbach, *The Painted Romanesque Ceiling of St. Martin in Zillis* (New York: Praeger, 1967).

50. Nelson Goodman, *Languages of Art* (Indianapolis: Bobbs-Merrill, 1968), p. 25, distinguishes between saying what a picture denotes and what kind of a picture it is. The distinction is an analogue to the Bultmannian distinction mentioned above.

51. Karl Löwith, *Meaning in History,* starts from the present and goes back through history.

52. Lucy R. Lippard, *Changing: Essays in Art Criticism* (New York: Dutton, 1971). ("Contemporary art criticism is not the place for someone who hopes to be right all or even most of the time," p. 26, and "immaculate conception is entirely absent from art history," p. 27). Lippard's delightful case is addressed as much to the rest of academia as to the people interested in art history.

Chapter 8

1. The relationship between religion and art has not only been problematic since the age of emancipation but has always been loaded with hidden or overt tensions. See Fritz Kaufmann, *Das Reich des Schönen, Bausteine zu einer Philosophie der Kunst* (Stuttgart, 1960), p. 180.

2. Laslo Mahalny-Nagy, *Painting, Photography, Film* (Cambridge: M.I.T. Press, 1969).

3. See chapter 2.

4. Cf. the old study by J. P. Dabney, *The Musical Basis of Verse* (London, 1901).

5. See Roland Barthes, *Image-Music-Text* (New York: Hill and Wang, 1978) and John L. Fisher, "Art Styles as Cognitive Cultural Maps," in Charlotte M. Otten, ed., *Anthropology and Art,* pp. 141ff.

6. René Gilles, *Le Symbolisme dans l'art religieux: architecture, couleurs, costume, peinture, naissance de l'allégorie* (Paris, 1943).

7. For instance Craig S. Harbison, *The Last Judgment in Sixteenth Century Northern Europe: A Study of the Relation between Art and the Reformation* (New York: Garland, 1976).

8. Gustav Friedrich Hartlaub, *Kunst and Religion, ein Versuch über die Möglichkeit neuer religiöser Kunst,* (Leipzig, 1919).

9. Abbé Brémont, *Prière et poésie* (Paris, 1926).

10. The fascinating approach by Lucien Goldmann, *Le Dieu caché* (Paris, 1955), *The Hidden God* (London, 1964).

11. The chapters on religion and dance in van der Leeuw, *Sacred and Profane Beauty,* pp. 9ff.

12. Joseph A. Jungmann, *Liturgie der christlichen Frühzeit* (Freiburg i.Br., 1967).

13. C.R. Morey, *Christian Art* (New York: Norton, 1958).

14. Cf. the Kabbalistic understanding of holistic life, of "sleeping" and "smelling" as part of religious expression, Gershom G. Sholem, *Zohar: The Book of Splendour* (New York: Schocken, 1949), pp. 68f. A great deal of traditional academic work, especially from the Protestant wing, assumes a verbal primacy: cf. Hans-Eckehard Bahr, "Das Geheimnis der göttlichen Selbstkundgabe in Rede und Antwort verweist uns darauf, dass der Mensch, sein spezifisches Wesen im Wort hat," *Poiesis,* p. 230.

15. Gisele Brelet, "Music and Silence," in Suzanne Langer, *Reflections on Art* (New York: Penguin, 1958), pp. 103ff.

16. See Anton Ehrenzweig, "A New Psychoanalytic Approach to Esthetics," in James Hogg, *Psychology and the Visual Arts,* p. 113: the unconscious structure of art is not consciously observed.

17. Hans Peter L'Orange, *Studies in the Iconography of Cosmic Kingship in the Ancient World* (Cambridge: Harvard University Press, 1953).

18. Martin Buber wanted to separate "experience" and "relation." (See Joseph D. Bettis, *Phenomenology of Religion,* pp. 223ff.) In the confrontation with art, this distinction is no longer as certain as the philosopher imagines.

The work of art, to be sure, cannot talk back, but it makes a statement to which I am frequently forced to respond.

19. Cf. the symposium on *Perception and Personality,* J. S. Bruner and D. Krech, eds. (New York: Greenwood, 1968).

20. Lucius Gavin, "The Paradox of Aesthetic Meaning," *The Journal of Phenomenology* I (1947), 99ff.

21. A sensitive interpretative study by Theo Sundermaier, *Maler Sehen Christus* (Wuppertal, 1963).

22. The word "organic" does not imply that in man's struggle with society the conflict between natural and cultural forces is eliminated, as Herbert Read's passionate romanticism sometimes implies (*Education Through Art* [London, 1948], p. 168) but that art has the force to return us to basic human values without which, as Read warns over and over, our civilization turns into a gigantic holocaust.

23. Ernst H. J. Gombrich speaks about the "poverty of linguistic categories and concepts for a description of the inner as opposed to the external world," in Gombrich-Hochberg-Black, *Art, Perception and Reality* (Baltimore: Johns Hopkins University Press, 1972), p. 37.

24. Art as an act of the entire being, Julie Braun-Vogelstein, *Art, the Image and the West* (New York: Pantheon, 1952), pp. 1ff.

25. Willy Michel, *Marxistische Aesthetik, Aesthetischer Marxismus* (Frankfurt, 1971).

26. The presence of polar experiences does not eliminate viewpoints, in literature or in visual art. See Brecht's *Galilei,* George Bernard Shaw's *St. Joan,* Eliot's *Murder in the Cathedral,* Daumier, Goya, Toulouse-Lautrec, Barlach.

27. Elie Wiesel's *Night* is both a tour de force of recall and of distancing (Jacob Gladstein, Israel Knox and Samuel Margoshes, *Anthology of Holocaust Literature* [New York: Athenaeum, 1973]).

28. The American television production of "Holocaust," although not a brilliantly done work of art, made such an impact on the German audience because it enabled the people to distance themselves from their tragic past, and thereby to confront it.

29. As I considered whether or not the Dachau museum might be called art, I was reminded of Duvignaud's "esthetic of total communion" which might differ from what we consider as "art" today, *The Sociology of Art,* p. 67.

30. The cross-displinary task enables us to confront approaches to art which are radically different from ours, as might be the case in Thomistic circles; see Etienne Gilson, *Painting and Reality* (New York: Pantheon, 1957).

31. Michel Foucault, *Madness and Civilization* (New York: New American Library, 1971).

32. Cf. for instance Reinhard Lieske, *Protestantische Frömmigkeit im Spiegel der kirchlichen Kunst des Herzogtums Würtemberg* (Stuttgart, 1973).

33. Satia Berner, *Myth and Religion in European Painting,* 1200–1700 (New York: Braziller, 1973).

34. See chapters 4 and 5.

35. It is valuable for students to confront both of these options. For a solid religion view, see John W. Dixon, *Nature and Grace in Art,* pp. 31ff., 83ff.; for a critical view toward religion, see Bela Kiralyalvi, *The Aesthetics of György Lukàcs* (Princeton: Princeton University Press, 1975).

36. Hanna Closs, *Art and Life* (Oxford, 1936), p. 137 protested against art's being merely seen as amusement. Nevertheless, the polarity between play as expression and play as entertainment is built into the artistic world.

37. Cf. Fritz Saxl, *A Heritage of Images* (London, 1976), pp. 13ff.

38. Trigant Burrow, *Preconscious Foundations of Human Experience* (New York: Basic Books, 1964).

39. The critique of Thomistic totality in Martin Heidegger, *Holzwege* (Frankfurt, 1977), pp. 19ff., and his *The End of Philosophy* (New York: Harper and Row, 1973).

40. One possible cross-disciplinary method is David W. Bolam and James L. Henderson, *Art and Belief* (New York: Schocken, 1970). The two partners present their case to each other.

41. Léon Wencelius, *Calvin et Rembrandt* (Paris, 1937).

42. Alan Wilde, *Art and Order* (New York: New York University Press, 1964).

43. André Grabar, *Christian Iconography;* W. F. Volbach, *Early Christian; Art* (New York: Abrams, 1962); Erich Dinkler, *Das Apsismosaik von S. Apollinare in Classe* (1964).

44. Cf., for instance, with the artistic material the textual one: Bindley-Green, *The Ecumenical Documents of the Faith* (London, 1960).

45. Cf. the striking distinction by Bernard Tschumi, "Questions of Space: The Pyramid and the Labyrinth on the Architectural Paradox," in *Studio International,* vols. 190, 976 (1975), 142, between the "pyramid of concepts" and the "labyrinth of experience."

46. Percy Dreamer, *Art and Religion* (London, 1924), p. 24, demanded a reconciliation between art and religion lest our age become one of organized savagery.

47. Pluralism in art (Solom Fishmann, *The Interpretation of Art* [Berkeley: University of California Press, 1963], pp. 163ff.) does not mean *eo ipso* total relativism of judgment (Herbert Read, *The Grass Roots of Art* [New York: Wittenborn, 1947], p. 10).

48. Art helps to restore the holistic life. See Robert Ornstein, *The Psychology of Consciousness* (San Francisco: Freeman, 1972), pp. 67, 226. Cf. also Roberto Assagioli, *Psychosynthesis* (New York: Viking Press, 1971).

49. In its modern form art presents a serious challenge to the traditional theological categories since it refuses to deal with life in these categories. See John Killinger, *The Failure of Theology in Modern Literature* (New York: Abingdon, 1963).

50. The material in my chapter on Nicaea in *The Serpent and the Dove,* pp. 50ff.

51. See George Mehlis, "The Aesthetic Problem of Distance," in Suzanne Langer, *Reflections,* pp. 79ff. "Voir c'est avoir à distance," said Maurice Merleau-Ponty, *L'Oeil et l'esprit,* (Paris, 1964), p. 26.

52. Cf. Jacques Maritain, *Art and Scholasticism* (New York: Scribner's, 1962), with Sanchez Vasquey, *Art and Society* (New York: Monthly Review Press, 1974).

53. Duvignaud, *The Sociology of Art,* p. 34: art exists on its own and cannot be explained by theories of evolution, primitivism, or the sacred.

54. Harold G. Cassidy, *The Sciences and the Arts: A New Alliance* (New York: Harper and Row, 1962).

55. Franz Brommer, *Die Wahl des Augenblickes in der griechischen Kunst.*

56. There is an ascetic aspect to the creation of space. See Eugénie de Kayser, *Art et mesure d'espace* (Brussels, 1970). Even Gombrich who does not like to talk about reduction, talks about "restraint, negation, and renunciation," *Meditations on a Hobby Horse,* p. 21.

57. The negative views toward the synthesis (the essays in Alan S. C. Ross, ed., *Arts versus Science* [London, 1967]) stand beside the positive ones (Adrian D. Stokes, *Art and Science* [London, 1949], on Piero della Francesca and Giorgione).

58. Gustav Aulén, *The Drama and the Symbols* (Philadelphia: Fortress, 1970).

59. The Barthian position (pictures of Christ are "intolerable," Karl Barth, *Kirchliche Dogmatik,* IV.2, 133f.) repeated for instance by Heinrich Vogel, *Der Christ und das Schöne* (Berlin, 1955).

60. God had a special access to Mozart, claimed Barth; see *Wolfgang Amadeus Mozart 1756/1956* (Zollikon-Zürich, 1956), p. 16.

61. Nietzsche's dictum that life without music is "ein Irrtum, eine Strapaze, ein Exil" (*Letter to Peter Gast,* Jan. 15, 1888, Vol. VIII. p. 65) would apply very much to Karl Barth and to many other theologians who would not appropriate this insight into their theology.

62. Paul Klee, *Das Bildnerische Denken* (Basel, 1956). Rudolf Arnheim, *Visual Perception* (Berkeley: University of California Press, 1974).

63. One cannot confine oneself to methodological discussions, said Maurice Mandelbaum; see *The Problem of Historical Knowledge* (New York: Liveright Publications, 1967), p. 305.

64. Maurice Merleau-Ponty stated that the philosophical task does not lie in a reflection on a pre-existent truth but, like art, in the act of bringing truth into being (*op. cit.*, p. 29).

65. Cf. the presidential address by Melvin Rader, "Imaginative Modes of Awareness," *Journal of Aesthetics and Art Criticism* XXXIII (1974), 131ff. An excellent collection of essays in Don Bothwell, ed., *Beyond Aesthetics* (London, 1976), with an introductory essay by C.H. Waddington.

66. A survey in Edgar Mitchell, *Psychic Exploration* (New York: G. P. Putnam's Sons, 1974); George Santayana, "Understanding, Imagination and Mysticism," in his *Interpretations of Poetry and Religion* (New York: Harper, 1957). Thomas Merton, *Seeds of Contemplation* (Norfolk, CT: New Directions, 1949).

67. Arthur Koestler, *The Act of Creation* (New York: Macmillan, 1964); Aldous Huxley, *The Doors of Perception* and *Heaven and Hell* (New York: Harper and Row, 1963); Robert E. L. Masters and Jean Houston, *The Varieties of Psychedelic Experience* (New York: Holt, Rinehart and Winston), 1966.

68. I. H. Schultz, *Das Autogene Training* (Stuttgart, 1976).

69. Jacques van Lennep, *Art et Alchimie* (Paris/Brussels, 1966); Kim Malville, *A Feather for Daedalus, Explorations in Science and Myth* (Menlo Park: Cummings, 1975).

70. R. M. Ogilvie, *The Romans and Their Gods in the Age of Augustus* (New York: Chatts & Windus, 1969).

Index of Subjects and Authors